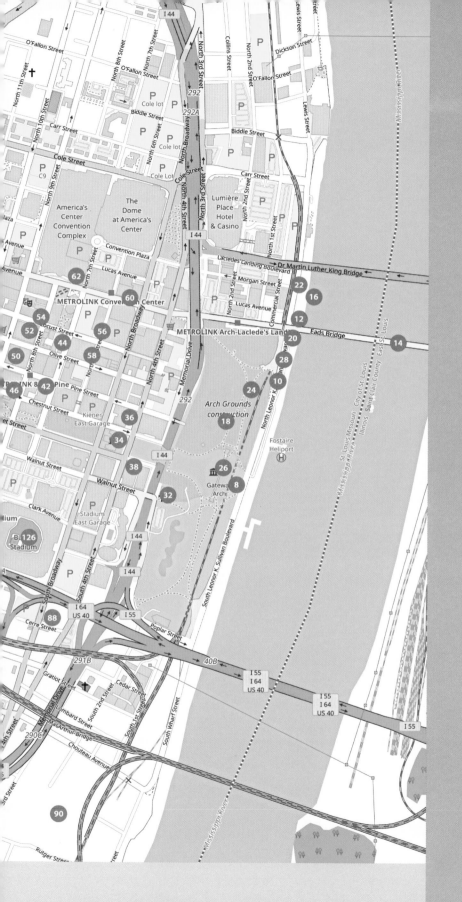

ST. LOUIS THEN AND NOW

You can find most of the sites featured in the book on this outline map*

Numbers in red circles refer to the pages where sites appear in the book.

* The map is intended to give readers a broad view of where the sites are located. Please consult a tourist map for greater detail.

ST. LOUIS
THEN AND NOW®

ACKNOWLEDGMENTS

I am grateful to many people for their generous assistance in my research for the 2016
additions and revision of Elizabeth McNulty's marvelous *St. Louis Then and Now*—Jaime
Bourassa, Dennis Northcutt and Molly Kodner of the Missouri Historical Society Library in St.
Louis; Ruth Keenoy, Rick Rosen and Susan Tschetter of the Landmarks Association of St. Louis;
Adele Heagney and Kirwin Roach of the St. Louis Public Library; Dr. Robert Moore, Jr. of the
Jefferson National Expansion Memorial and Ryan McClure of the City, Arch, River Foundation.
I want to thank Frank Hopkinson, publisher of Salamander Books for inviting me tackle this
project. I am honored to contribute in a small way to the expanding pictorial context of St.
Louis history, which began with the 1886 publication of *The Annals of St. Louis in Its Early Days*
by Frederic L. Billon and the illustrations by C. Heberer, which were drawn under his direction.
Without these, the remarkable village that seeded the modern city of St. Louis would be visually
lost to us. I am also honored to have provided verbal context for Karl Mondon's stunning Now
photographs. Finally I want to thank my husband Tom Kavanaugh for his patience and support
as I spiraled into the deep well of research for a third book this year. Home cooking is about
to resume and the teetering stacks of references including Billon's *Annals of St. Louis*, *Historic
Photos of St. Louis* by Adele Heagney and Jean Gosebrink, and Rockwell Gray's *A Century of
Enterprise St. Louis 1894-1994* scattered throughout the house are about to retake their places
in our own and the St. Louis Public libraries. I promise.

ST. LOUIS
THEN AND NOW®

MAUREEN KAVANAUGH

WITH

ELIZABETH MCNULTY

NOW PHOTOGRAPHS BY KARL MONDON

PAVILION

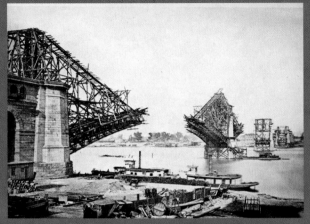
Eads Bridge, c. 1872 p. 12

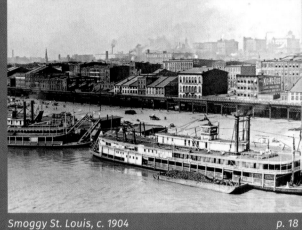
Smoggy St. Louis, c. 1904 p. 18

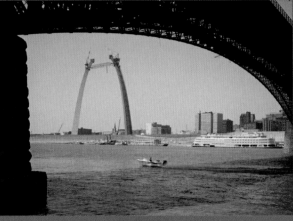
Jefferson National Expansion Memorial, 1964 p. 26

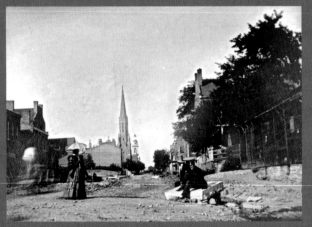
Ninth Street, 1852 p. 40

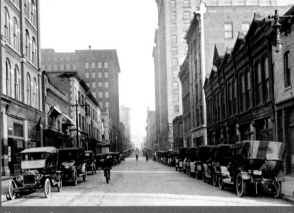
Chestnut Street, c. 1914 p. 46

Old Post Office, 1965 p. 52

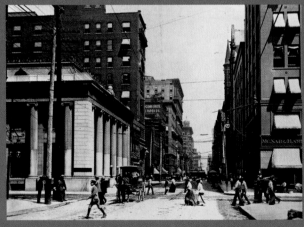
Locust Street Looking East p. 54

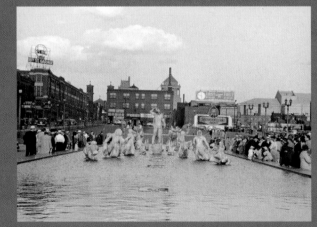
Meeting of the Waters, 1940 p. 74

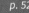
Market Street, c. 1912 p. 78

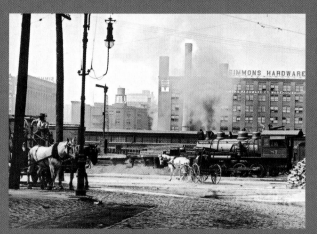

Cupples Station, c. 1905　　　　p. 86

Great Cyclone of 1896, 1896　　　　p. 90

East Gate, Tower Grove Park, 1870　　　　p. 104

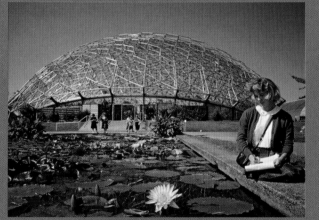

Missouri Botanical Gardens, c. 1963　　　　p. 106

Scott Joplin House, c. 1975　　　　p. 116

Sportsman's Park, 1944　　　　p. 126

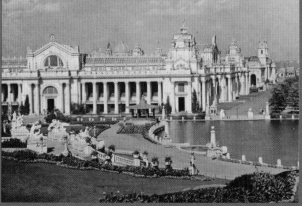

World's Fair, 1904　　　　p. 130

Palace of Fine Arts, 1904　　　　p. 132

1904 Olympics, 1904　　　　p. 136

ST. LOUIS
THEN AND NOW INTRODUCTION

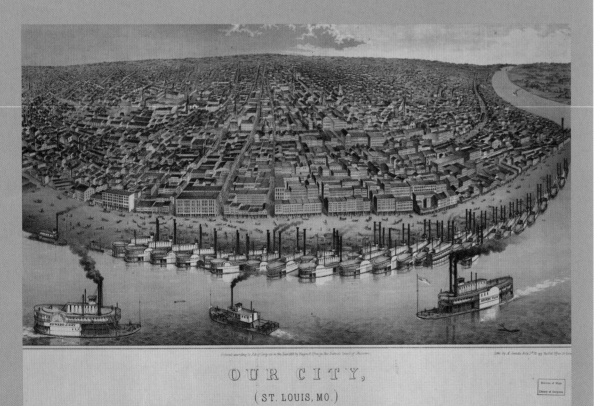

OUR CITY,

(ST. LOUIS, MO.)

"There is something in having passed one's childhood beside the big river, which is incommunicable to those who have not" wrote modernist poet T. S. Eliot, born and raised in St. Louis. "The strong brown god of the mighty muddy Mississippi races past the city with fierce current, yet calm demeanor, drawing thoughts ever with the lure of the dreamy adventure and the promise of easy reward." Huck and Jim floated along this river whose dangers their creator, riverboat pilot Mark Twain, knew only too well. The "Old Man River" Mississippi, with all its travails, is St. Louis' defining feature.

It was up this river in 1764 that New Orleans-based, French fur-trader Pierre Laclède sent his stepson, August Chouteau, from Fort de Chartres with a crew of men to begin construction on an outpost for his ventures. Upriver 1,200 miles from New Orleans, in a spot Laclède had chosen, the men stepped off the boat onto the Mississippi's western bank. The spot possessed a natural sand levee, sheltering limestone bluffs, and a convenient location less than twenty miles downriver from the confluence with the Missouri. In April 1764, Laclède arrived and named the settlement Saint Louis in honor of Louis IX, one of the patron saints of France; believing that by its locality and central position, St. Louis was to become "one of the finest of cities."

Of course, the French were not the first to find the area amenable. Centuries before, an advanced culture of Mound Builders inhabited the upper Mississippi Valley, farming the fertile land and creating one of the most populous cities in North America. For some reason, after 1400 AD they drifted away from the site. When the French arrived in the eighteenth century, the land that would become St. Louis was dotted with ritual burial mounds, the largest of which were used as

navigational landmarks by riverboats, earning St. Louis the nickname, "Mound City."

After dramatic growth as a French-settled fur-trading center, in 1804 St. Louis entered the American era, when United States President Thomas Jefferson purchased the Louisiana Territory from France. He sent Lewis and Clark to St. Louis to head up an expedition to explore the new lands, seeking a northwest passage to the Pacific. As the western edge of American civilization, but also the second largest inland port, St. Louis thereafter became chief provisioner for westward-bound explorers and adventurers like Fremont, Parkman and countless other pioneers and gold-rush fortune-seekers. All westward journeys began in St. Louis, establishing the city's reputation as "Gateway to the West."

While it was journey's beginning for some, St. Louis was journey's end for others. Travelers' accounts of the bustling "Queen of the West" or "Lion of the Valley" drew swarms of easterners seeking opportunity. Famine in Ireland and a failed revolution in Germany created a flood of mid-nineteenth century immigrants. St. Louis was the original American boom town, her population doubling, sometimes quadrupling, decade by decade.

The arrival in St. Louis of the *Zebulon Pike* in 1817 had announced the steamboat era on the Mississippi. By the 1850s, steamboats were sometimes stacked three deep for a full mile along the St. Louis levee. River trade in both passengers and freight was booming when the Civil War broke out in 1861. Soon after, trade with the South along the lower Mississippi was completely blockaded. Although a slave state, Missouri did not secede, but St. Louis was

too far south to be an effective trade hub for the Union. St. Louis' arch rival, Chicago, was left to capitalize on these northern routes.

After the war, as the South recovered slowly, the steamboats were steadily losing business to railroads. St. Louis turned instead to the booming American Southwest, developing an extensive railway trade. The later nineteenth century presented a continuing reign of prosperity for St. Louis, as transportation connections made the city a natural center for warehousing and wholesaling, and civic boosters touted St. Louis as "The Future Great City of the World." By the turn of the century, St. Louis was the fourth largest city in the nation and could boast of being among the nation's largest producer of apparel, cotton, bricks, tobacco and beer. It seemed like a good time to celebrate.

For seven months in 1904, St. Louis hosted the Louisiana Purchase Exposition, the World's Fair commemorating the centennial of Jefferson's historic purchase. The city created in Forest Park a wonderland of fanciful plaster palaces, complete with perfumed fountains and an artificial canal system for gondola rides. The whole nation sang, "Meet Me in St. Louis, Louis," and visitors came from around the world. Several quintessential American foods had their debut here; hot dogs, ice-cream cones and iced tea. To the strains of marching bands and Scott Joplin's ragtime, the Fair marked the end of the American Gilded Age.

The twentieth century was one of ups and downs for St. Louis, true to her boom town roots. Today, St. Louis is an amazing blend of cultures, ethnicities, and history; where quaint historic neighborhoods of nineteenth-century

red-brick townhouses sit a few minutes from soaring late twentieth-century skyscrapers; where a neoclassical 1850s courthouse is beautifully framed by a strikingly modern, stainless steel monument. The Gateway to the West is still a major transportation hub, now for trucks and planes, as well as for barges and rail, and a headquarters for major corporations in the biotech, healthcare, aerospace, and of course, brewing industries.

The "strong brown god" as Eliot called the Mississippi, has raced alongside the St. Louis settlement for over 250 years; photography has existed for only the most recent 170 years. *St. Louis Then and Now* pairs images from as far back as 1850 up to the 1970s to show the evolution of a city from a frontier trading post on the edge of "civilization" to the twenty-first-century city of St. Louis.

OPPOSITE: A birds-eye view lithograph of St. Louis from 1859, before the Eads Bridge spanned the Mississippi.

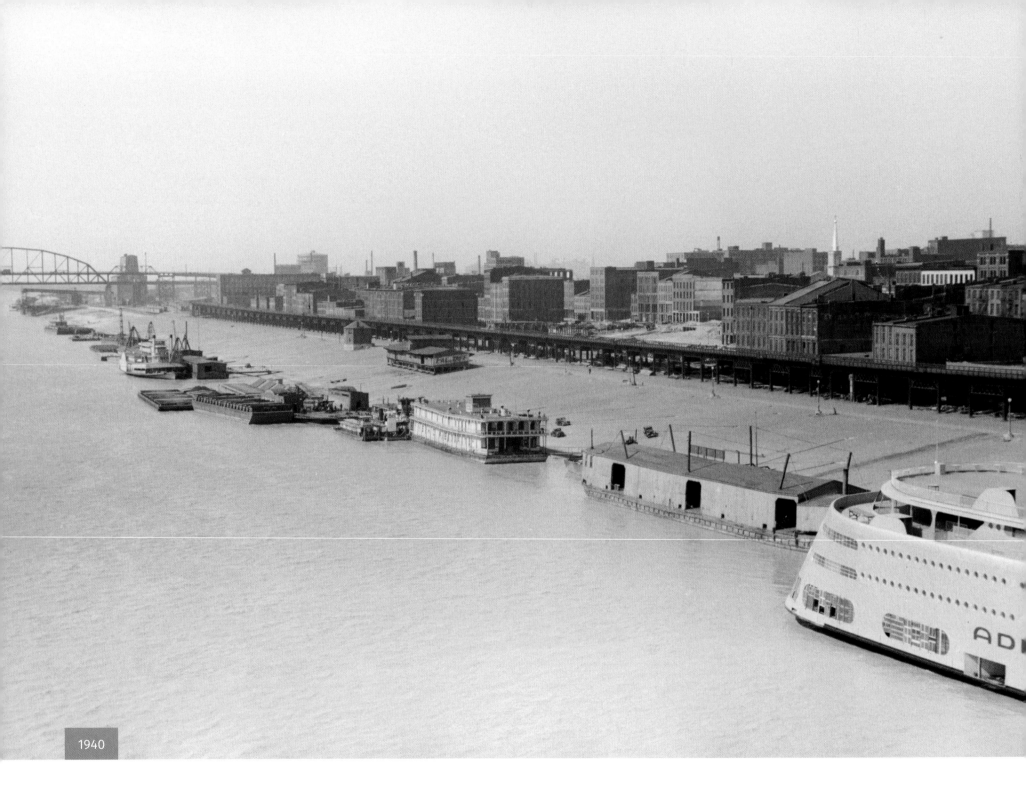

1940

CITYSCAPE

The famous St. Louis levee was on the brink of major change

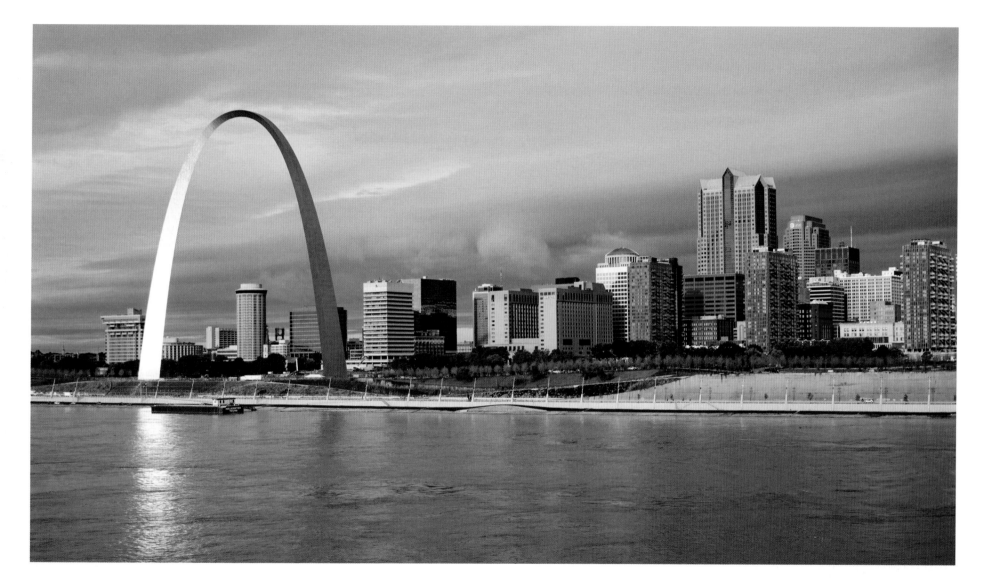

LEFT: Viewed from the Eads Bridge in 1940, the shiny hull of the SS *Admiral* recently reborn from the framework of the railroad transfer boat *Albatross*, is moored alongside the levee next to a railroad trestle and four- and-five-story buildings that are about to disappear. The steeple of the Old Cathedral can barely be made out, though it will shortly stand on the riverfront with only the Old Rock House for company. The wharf, with its meager showing of excursion boats and one solitary showboat suggest that the levee will never crowd with river traffic and travelers as it did in the nineteenth century. St. Louis has undergone a nearly complete conversion from a river-based commercial city to a railway-based industrial center.

ABOVE: Today, the Gateway Arch, monument to St. Louis' historic role in westward expansion, dominates the skyline. The Old Courthouse and Old Cathedral are respectively blocked and dwarfed by surrounding skyscrapers. The formerly commercial waterfront is now a park at the foot of the Arch. To the right of the Gateway Arch and further up the bluffs, the Metropolitan Square building with its green, gabled roof soars to forty-two stories as St. Louis' tallest building. Limited in height to 600 feet (just thirty below the Arch), it honors a municipal law that no building downtown can top the Gateway Arch. The north floodwall is visible on the right.

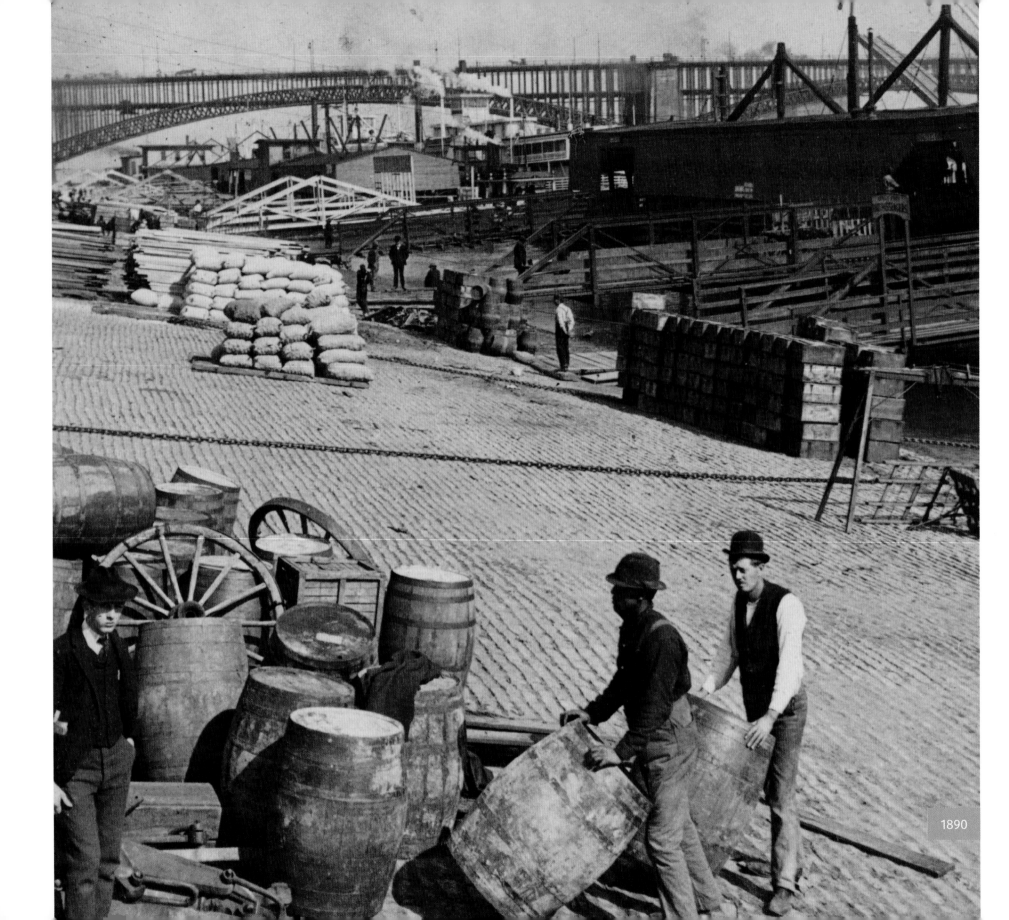

1890

LEVEE NEAR EADS BRIDGE
The engine of St. Louis' commercial success before the coming of the railroad

LEFT: The arrival of the *Zebulon M. Pike* at St. Louis in 1817 had initiated the steamboat era, but it found nowhere to dock. It could only pull in alongside the four-story bluff that fronted the river. St. Louisans then chipped away the first terrace of limestone protecting the town from the river to create a proper levee. By Mark Twain's time on the Mississippi in the 1850s, steamers were stacked three deep and a mile long on the levee, and antebellum St. Louis was the nation's third-largest port. By 1890, railroads had surged to the fore, and although triple-decker steamboats still ran on the river, low-slung barges were the frontrunners in freight hauling, as they allowed easier loading into rail cars.

ABOVE: In the 1930s, the city razed much of the warehouse district, which had become badly rundown. The railroad tracks were moved underground and plans were made for a Jefferson National Expansion Memorial commemorating the Louisiana Purchase and westward settlement. Today, to the north and south of the Grand Arch Staircase the levee is lined by floodwalls, which became necessary after the original bluffs were modified. The pink-grey cobblestones of the wharf, quarried from Iron County Missouri, slope into the muddy Mississippi, a vestige of the riverfront's commercial past.

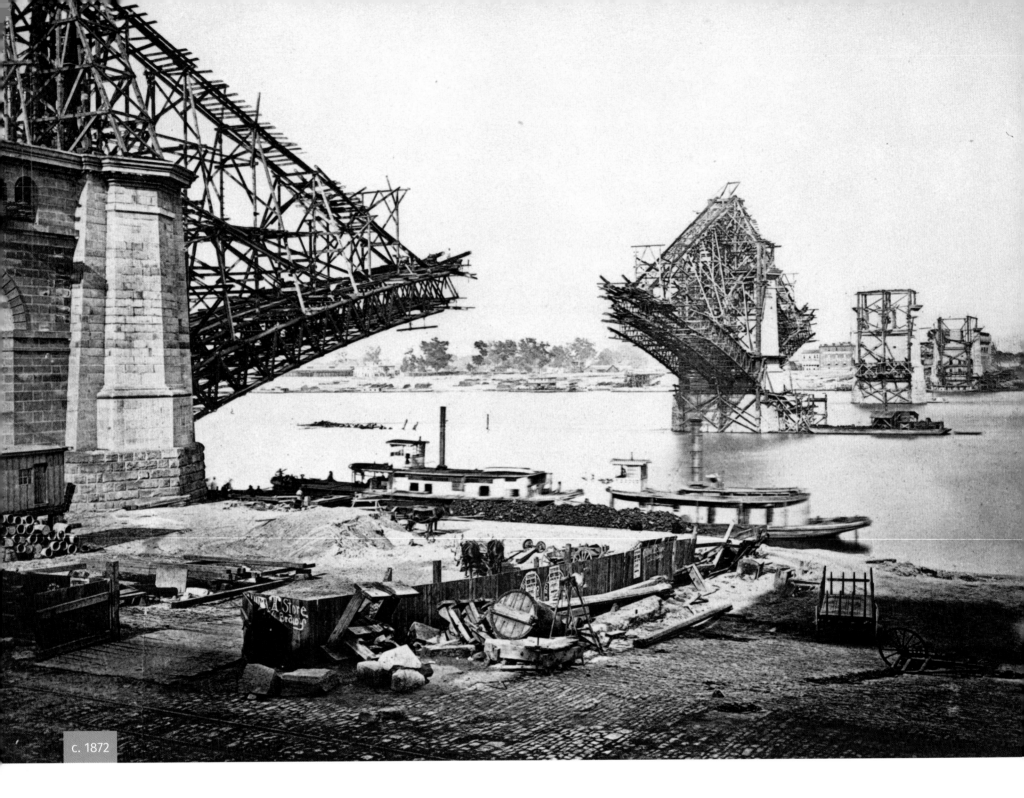

c. 1872

EADS BRIDGE

A marvel of engineering that didn't disrupt river trade

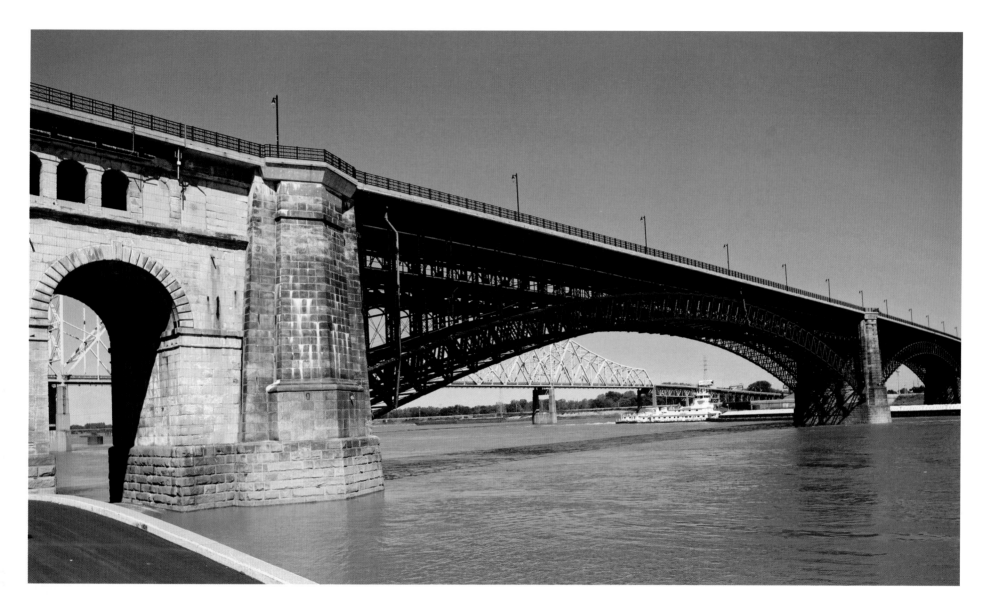

LEFT: St. Louis had recognized the need for a bridge as early as 1839, but plans for spanning the Mississippi River were cost prohibitive, and steamboatmen opposed anything that might block up the already crowded waterway. Eventually the Civil War intervened, and thus for most of the nineteenth century, the only way across the Mississippi at St. Louis was by expensive and delay-ridden ferry. The city finally agreed on a bridge design by river salvage expert and battleship engineer James B. Eads, and construction began in late 1867. The bridge was to be a pioneering feat of engineering in several respects.

ABOVE: On May 24, 1874, the bridge opened to the public, and 25,000 people crowded the upper deck in celebration. Today, the Eads Bridge is still a marvel of engineering. Eads designed the world's first steel trusses (steel was then an experimental metal), allowing him to cross the river in just three spans. He further accommodated boat traffic by foregoing construction scaffolding with a novel plan: spans were built out from central piers simultaneously in both directions. Thus balanced, there was no need for scaffold. Pneumatic caissons, the first used in the United States, allowed sound mooring of piers on the bedrock beneath the river's shifting sands.

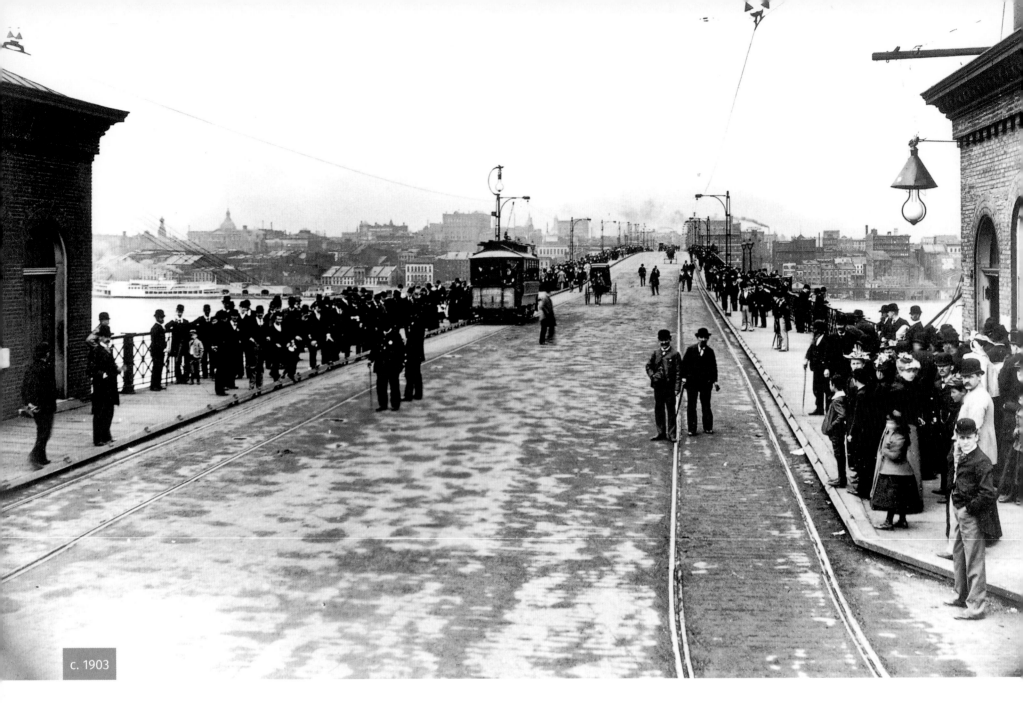

c. 1903

EADS BRIDGE
People flocked to see the first steel bridge across the Mississippi

ABOVE: Eastern end of the Eads Bridge looking west toward St. Louis, circa 1903. Almost thirty years after its construction, the Eads Bridge was busier than ever. Beneath this pedestrian/streetcar level, the bridge supported a double railroad track that ran from the east, through a tunnel under Washington Avenue out to the industrial Mill Creek Valley area. The waterfront was lined at that time with commercial warehouses, with the Old Courthouse dominating the horizon on the left. Eads Bridge is seen here after the repair made necessary by the worst tornado in St. Louis history, which tore 300 feet from this, the Illinois side of the bridge.

c. 1880

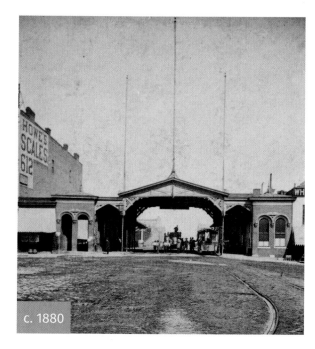

c. 1880

ABOVE: Over time the Eads Bridge has been used by a variety of trolley and streetcars, from horse-drawn to electric.

ABOVE: Eads Bridge was St. Louis' first rail bridge, but several others followed it, including the MacArthur and the McKinley, competing for traffic. Eventually, trains became too heavy for the aging bridge and too wide to fit through the Mill Creek Valley tunnel. Eads was closed to train traffic in 1974, exactly one hundred years after its opening. The pedestrian level is long gone, but the tracks and tunnel have been put to good use by the St. Louis public transit light-rail, the MetroLink. Today, Metro Transit, one of the oldest interstate agencies in the U.S. transports over 55 million passengers each year. Trains cross the Eads Bridge daily connecting St. Louis-Lambert International Airport in Missouri to the Shiloh-Scott Station in Illinois. They're carried over two light rail lines that connect to 75 bus routes and some 9000 bus stops, 14 transit centers, and 34 park-and-ride lots with a daily ridership of about 140,000 passengers. In October of 2016, Metro Transit St. Louis celebrated its completion of a four-year, $48 million rehabilitation (the first full-scale since construction) of the Eads Bridge.

AVIATION
St. Louis has an enduring link with the pioneers of flight

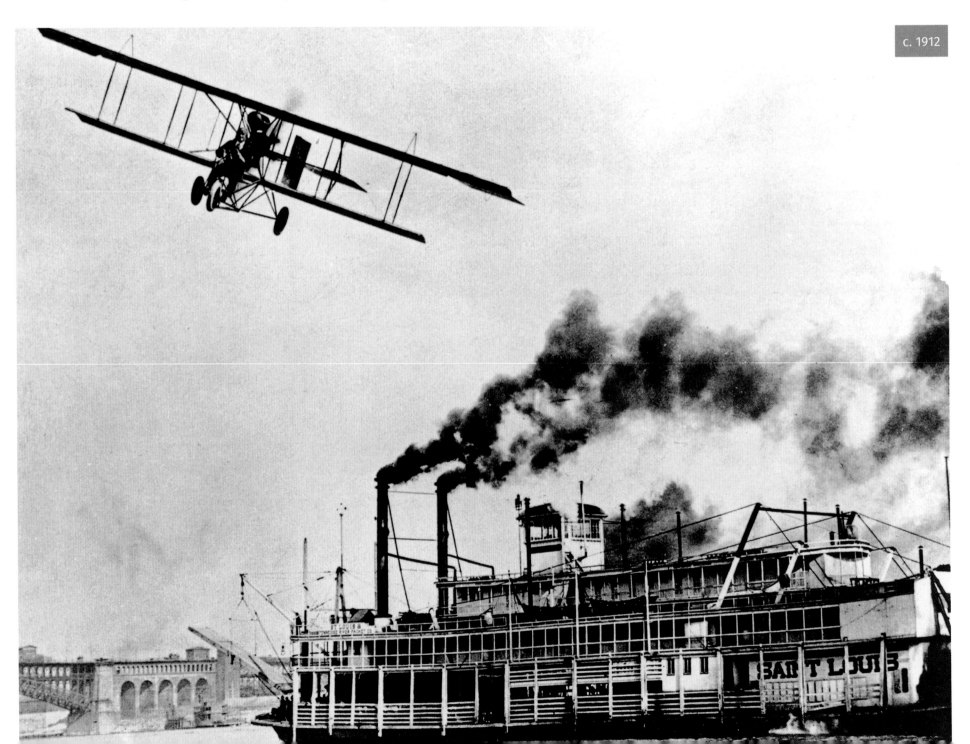

c. 1912

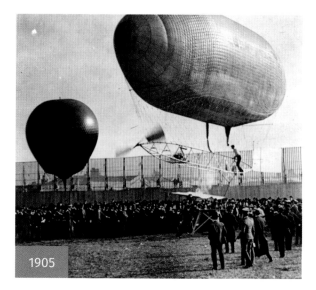

1905

LEFT: The first airplane flight over the Mississippi River occurred in St. Louis in 1910, when Thomas Scott Baldwin flew his plane the Red Devil over and under the Eads and McKinley bridges. The history of aviation was again linked to St. Louis when a consortium of St. Louis businessmen, headed by Albert Bond Lambert, raised the money for a transatlantic flight attempt by an unassuming airmail pilot. Lambert, who managed his family's successful pharmaceutical company, which had developed the antiseptic mouthwash Listerine, was one of the city's earliest promoters of aviation. A founding member of the St. Louis Aero Club in 1907, he bought his first plane from the Wright brothers who taught him to fly and developed a field in northeast St. Louis, which would become home to an international airport bearing his name.

BELOW: Charles Lindbergh flying the mail route between St. Louis and Chicago won the support of Lambert and other local backers to attempt a record-breaking transatlantic flight. The aircraft they financed bore the name, "Spirit of St. Louis" and Lindbergh flew it from New York all the way to Paris, becoming on May 21, 1927, the first aviator to cross the Atlantic solo. Today, the jets of many different airlines fly high above the Mississippi as they make their way west to land at the newly-renamed St. Louis-Lambert International Airport. The only steamboats seen on the riverfront today are local excursion boats and pleasure cruisers making their way through the Port of St. Louis.

ABOVE LEFT: Pioneers of aviation were drawn to St. Louis. "Aeronaut" Roy Knabenshue demonstrates the "California Arrow" in St. Louis in 1905.

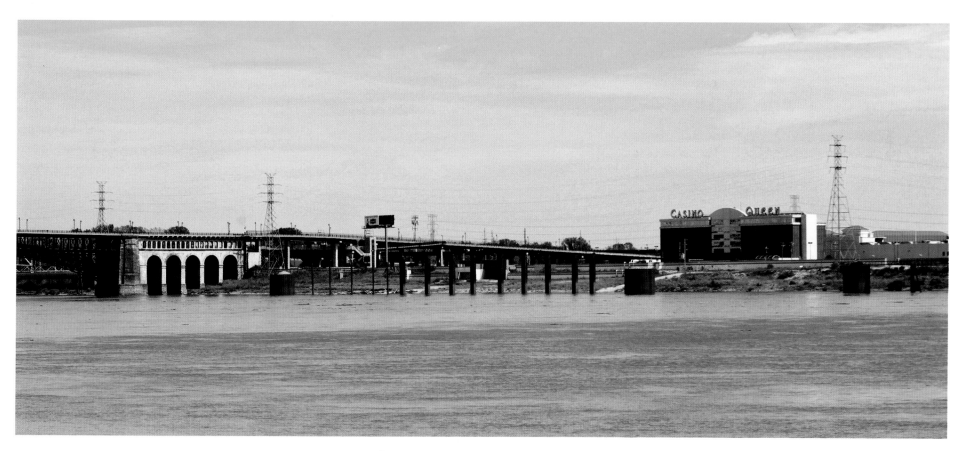

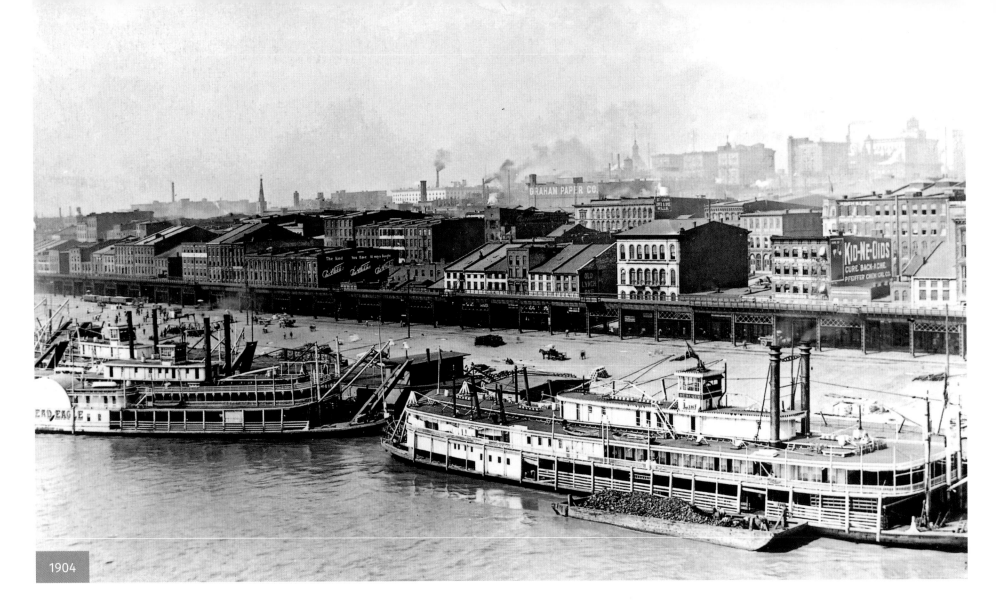

1904

SMOGGY ST. LOUIS

Although riverboats burned coal, the nadir of St. Louis' smog wouldn't come until 1939

ABOVE AND RIGHT: Photos taken from the Eads Bridge in 1904 show freight-bearing steamboats and barges positioned for the transfer of goods to and from rail cars. The flag-flying cupola of the Old Courthouse is barely visible in the midday smoke. By the turn of the century, soft black Illinois coal (note the off-loaded pile on the foreground barge) took its toll on the city's air quality. Those who could moved west, away from the smog. Finally, on Tuesday November 28, 1939, the city witnessed "midnight at noon," and local papers reported that no one knew what time the sun had risen, if it had at all.

1904

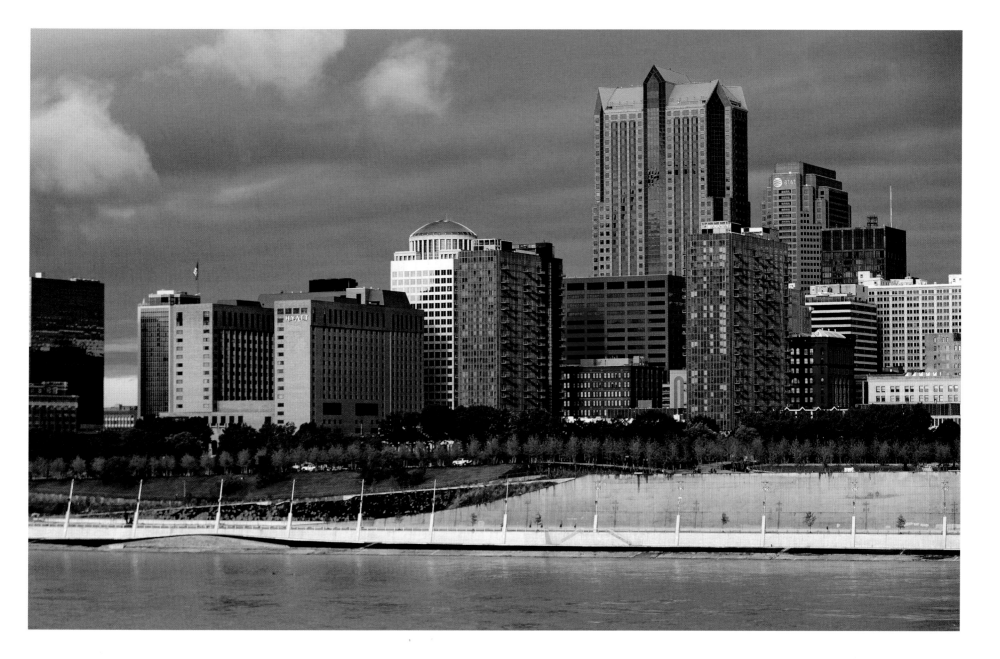

ABOVE: "Black Tuesday," as it was called, goaded the politicians into action, and air quality measures were finally enacted. Today, St. Louis ranks substantially below the national average for air pollution. The once bustling industrial waterfront is now recreational, transformed in the 1960s into lush green parklands, protected by floodgates and crowned by the Gateway Arch, a ribbon of which is seen reflected in the east windows of the Metropolitan Square Building. The pastel cobblestones of the levee are barely visible above the waters of the Mississippi, which frequently cover them completely. A shaft of sunlight brightens the Eagleton Federal Courthouse dome and Bank of America tower.

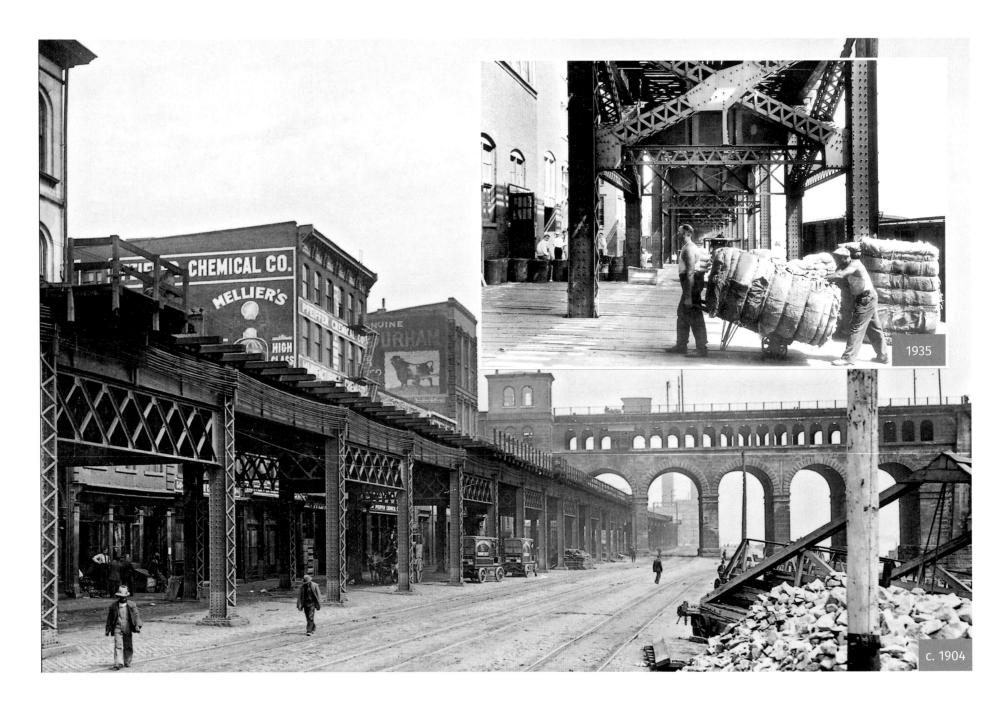

1935

c. 1904

WHARF STREET

Where W. C. Handy met the woman who inspired a blues classic

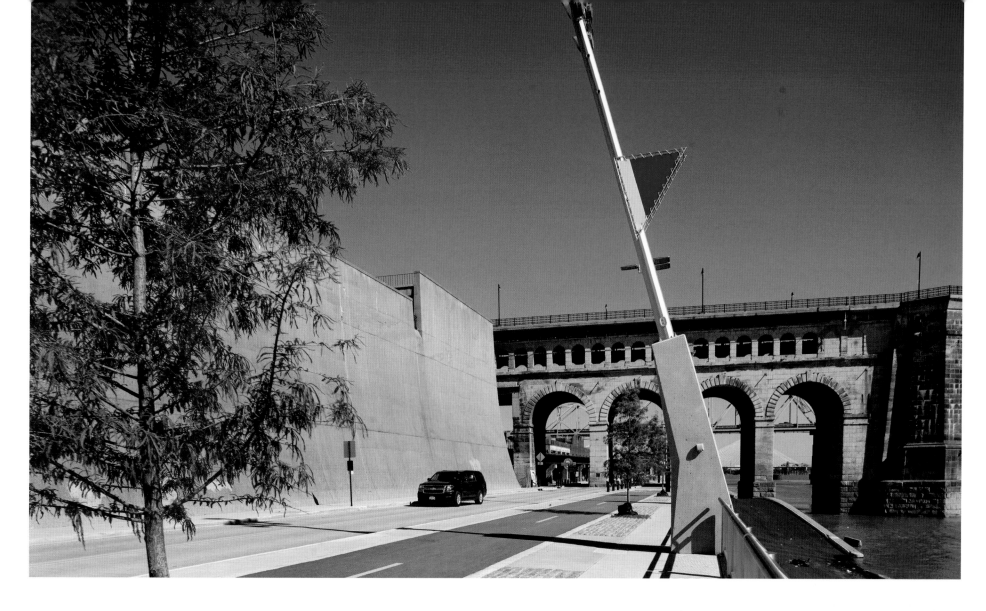

LEFT: Wharf Street or Front Street (as it's also known) was often underwater. Despite a terrible tornado and growing pains as the city's economy shifted from raw materials to light manufacturing, business was booming on the turn-of-the-century waterfront. Big piles of rubble everywhere were signs of construction and paving, as the city cleaned up for the World's Fair. In the early 1890s musician W.C. Handy encountered a woman along Wharf Street near Eads' Bridge who bemoaned the loss of her man. Her wailing would later inspire Handy's most famous work, *The St. Louis Blues*. The inset photo shows that even in 1935, cotton bales were still transported manually from freight cars thanks to local cotton compression facilities.

ABOVE: The elevated tracks of the Terminal Railroad Association that paralleled the waterfront were moved underground in 1949 as part of the waterfront redevelopment project. Today, a giant floodwall stands in their place. The classic curves of the Eads Bridge still grace the wharf, although the bridge today hosts the city's light rail transit system. Beyond it stands the Martin Luther King Bridge (formerly Veterans' Bridge), opened in 1950 and in the distance the white cables of the Stan Musial Veterans Memorial Bridge, which opened in 2014 can be seen through the Roman arches of James Eads Bridge. In a custom dating to Colonial times St. Louisans have given the new landmark a nickname, calling it simply the Stan Span.

LACLÈDE'S LANDING
Named for the Frenchman who helped found St. Louis

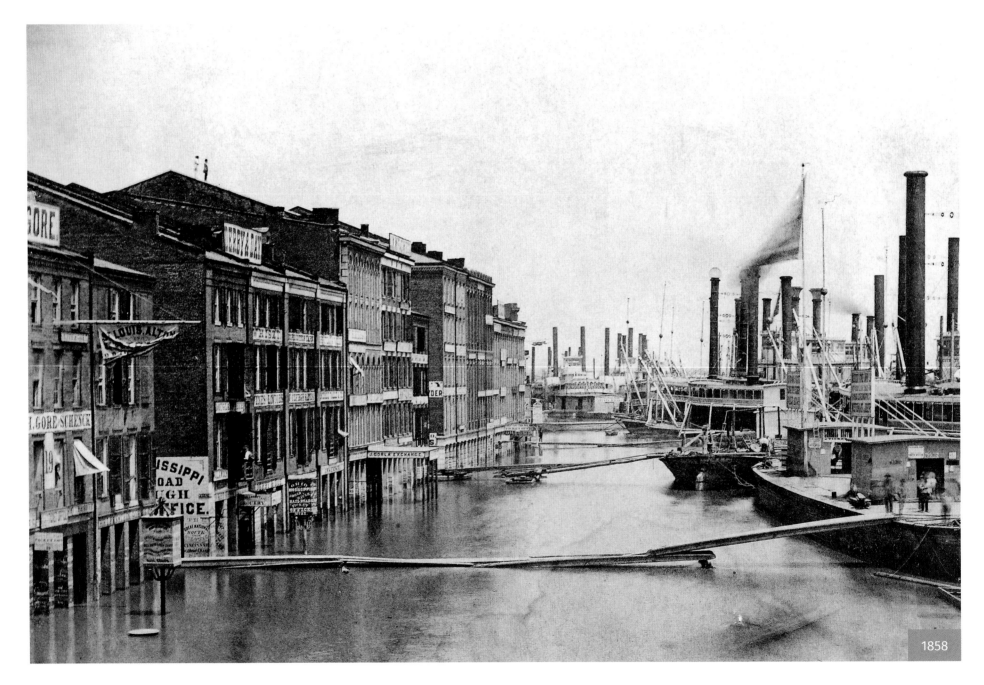

1858

LEFT: High water at St. Louis, June 15, 1858. The capricious river that gave St. Louis her fortune as a trading center, frequently threatened to overflow the city as well. The city's limestone bluffs initially afforded some measure of protection; however, by the mid-1800s, the soft stone had been cut almost entirely away for construction of a proper levee. Here, the steamers are practically tying up to the buildings on First Street as two men on the rooftop look on. Fourteen years earlier, during the Great Flood of 1844, the river created something of a freshwater sea, stretching twelve miles wide and rising even beyond Second Street. The first great flood in the mid-Mississippi River Valley was recorded in 1785, *L'Annee Grandes Eaux.*

BELOW: Before the advent of modern engineering, St. Louis was completely at the mercy of the "Mighty Mississippi," but even the floodwall installed during the Arch construction does not always contain the river. During the Flood of 1993, the waters crested that August at 49 feet, 7 inches, just a few inches below the floodgate's edge. Eleven times the volume of Niagara Falls was flowing under the Eads Bridge; enough to fill the former Busch Memorial Stadium every sixty-five seconds. Today, this area north of the Eads Bridge is home to Laclède's Landing, a three-by-three block stretch that preserves the waterfront's original Creole street layout and historic nineteenth-century warehouse district buildings.

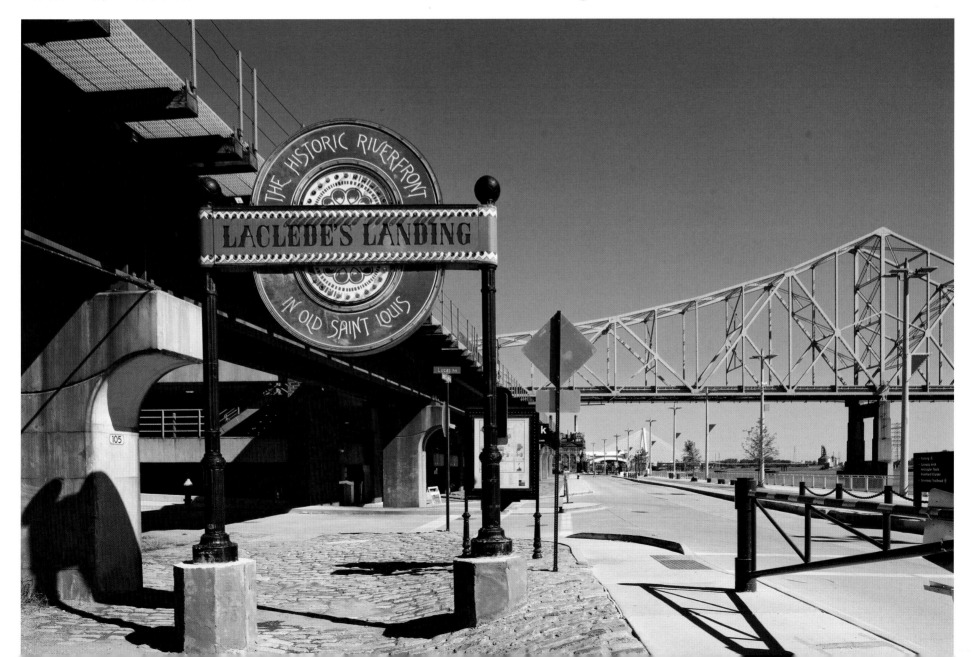

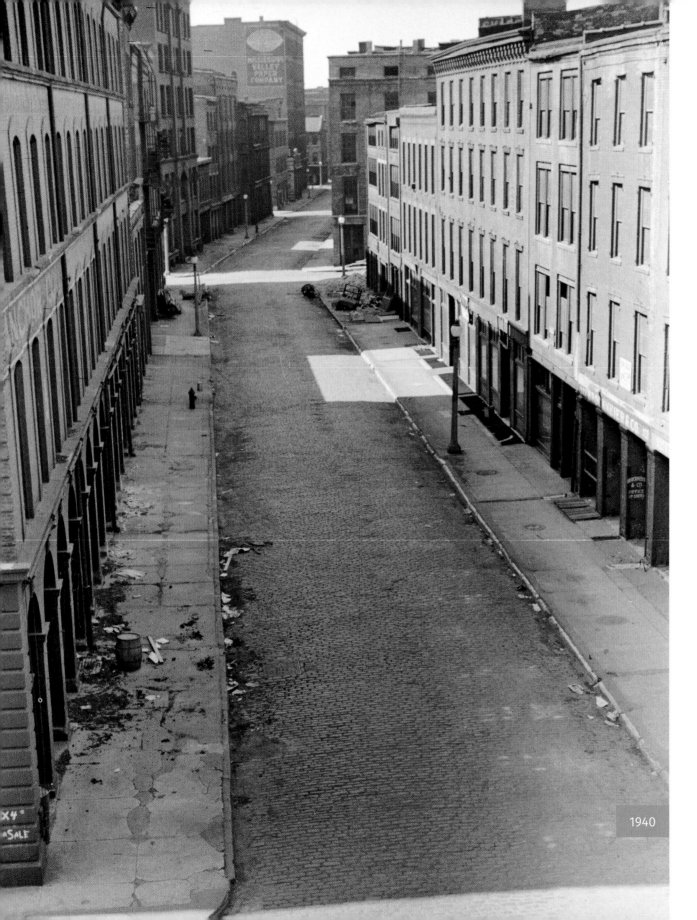

1940

RIVERFRONT CLEARANCE
Revealing Laclède's original layout

1940

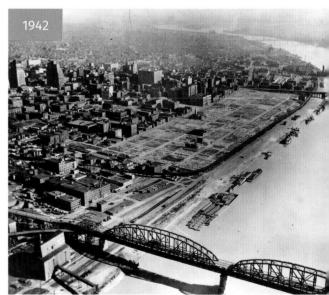

1942

TOP: Although the riverfront had grown seedy and obsolete as a commercial center it contained many historic and handsomely designed buildings and façades that were lost forever.

ABOVE: This remarkable aerial view of the St. Louis riverfront revealed Pierre Laclède's original layout for the village.

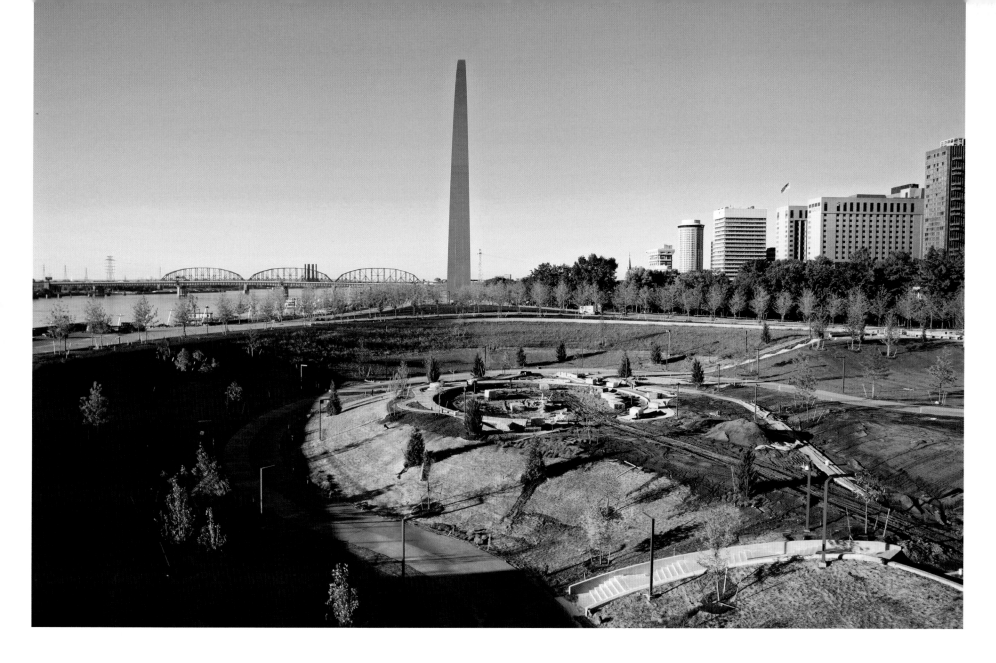

LEFT: The St. Louis riverfront with its empty streets and vacant businesses resembles a ghost town. Demolition of hundreds of buildings like these, covering forty city blocks began on October 10, 1939, when Mayor Bernard F. Dickmann ceremoniously pried a brick from the first building to be razed for the creation of a national park and memorial to President Thomas Jefferson and the pioneers who settled the West. Conceived by long-time St. Louis attorney Luther Ely Smith, the project would be plagued with legal disputes initiated by property owners, business people, and the many remaining residents of the area but only the Old Courthouse, the Old Cathedral, and the Old Rock House, where trader Manuel Lisa had sold furs, survived the clearance. What was left of the Old Rock House became part of an exhibit in the Old Courthouse.

ABOVE: The grounds of the Jefferson National Expansion Memorial looking south from Eads Bridge. Beyond the north leg of the Gateway Arch, construction takes place on a garden area and playspace for children, to be seeded with plants recorded by Lewis and Clark on their journey to and from the Pacific Ocean. It is one piece of a stunning redesign of the park by Michael Van Valkenburgh Associates of Brooklyn. The broad pedestrian path that wends around it, enabling ascent from the Mississippi riverfront up to Third Street, is intended to reconnect downtown St. Louis with its riverfront.

JEFFERSON NATIONAL EXPANSION MEMORIAL

The Gateway Arch is as wide as it is tall

BELOW The Gateway Arch seen from the Illinois base of Eads Bridge shortly before completion in 1965. Slated to be dedicated in 1964 during the Bicentennial Celebration of the Founding of St. Louis and the 160th anniversary of the Louisiana Purchase, the Jefferson National Expansion Memorial was almost a year behind schedule. The steeple of the Old Cathedral can be seen between the arch's legs, the portico and columns of the Old Courthouse are barely visible beside the tall buildings on the right. A handful of river craft are docked along the levee. They include the double-decker, *Goldenrod* Showboat moored just south of the SS *Admiral*. Constructed in 1909 the *Goldenrod* presented minstrel shows, vaudeville acts, and plays. Eero Saarinen, who designed St. Louis' and the nation's great steel arch, died in 1961 at the age of 51 and never got to see his architectural vision realised.

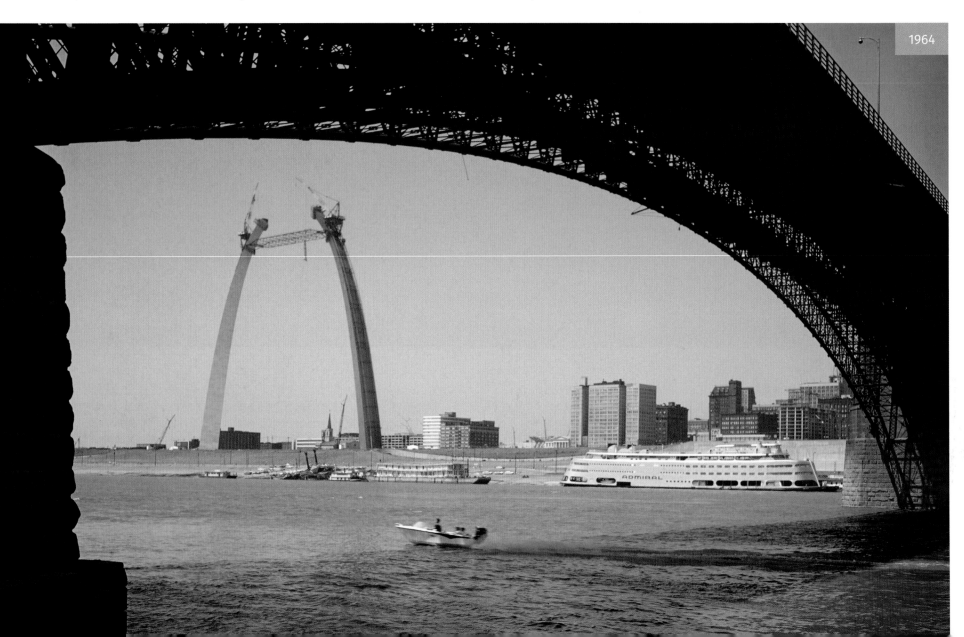

1964

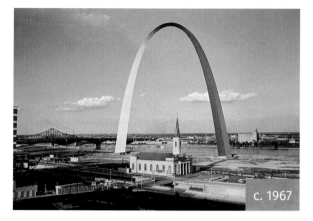

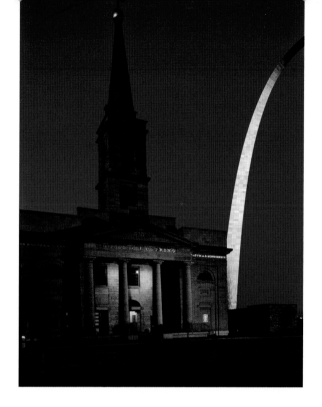

RIGHT: The Gateway Arch illuminated at night. Lighting was proposed as early as 1966, but lacked funding. A temporary solution was put in place for the visit of the Pope to St. Louis in 1999. Permanent lights were installed from November 2001.

BELOW: Today, Eero Saarinen's steely arch is seen in the bottom photo reflected in the waters of the Mississippi from the Illinois side of the Eads Bridge. More than fifty years after its completion it is still the tallest arch in the world. At 630 feet in height, the Gateway Arch is the tallest man-made monument in the U.S. and symbolizes the enormous impact of President Thomas Jefferson's acquisition—some 828,000,000 square miles of territory that doubled the size of the United States. The Arch spans 630 feet (identical to its height) of the second natural limestone terrace that fronts the Mississippi River at St. Louis. A trip to the observation deck in one of the trams inside the steel arch takes four minutes.

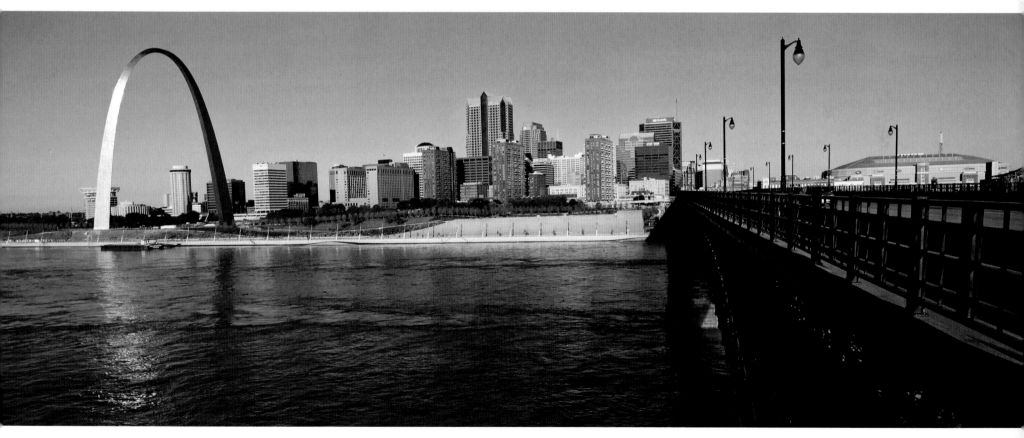

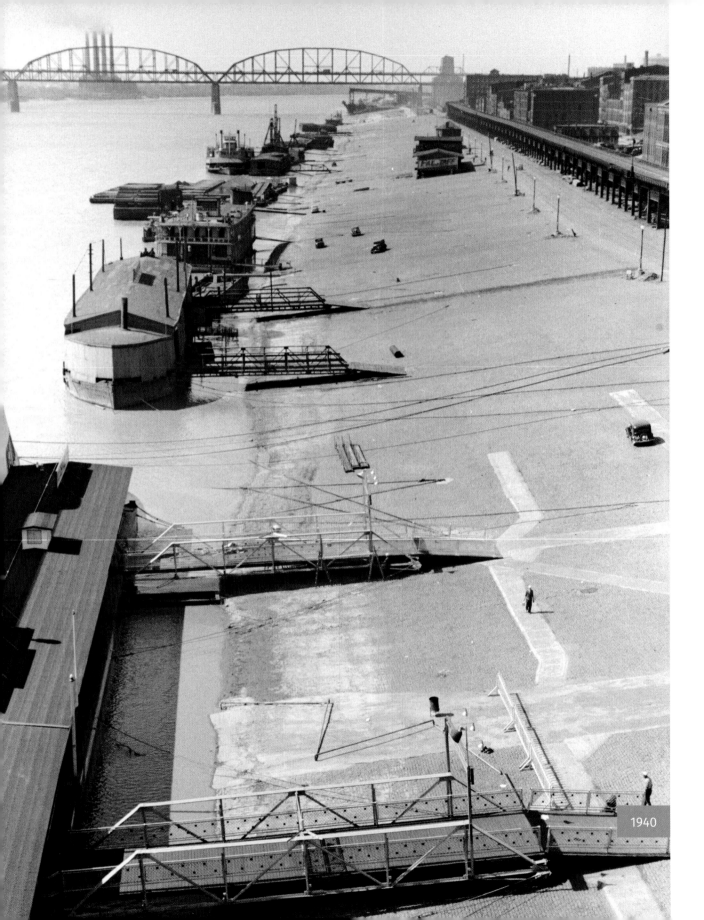

1940

GATEWAY ARCH
St. Louis created an instant tourist attraction in 1965

LEFT: By the 1930s, all the old warehouses seen here on the right side of the photograph had become (or at least were deemed) derelict and slated to be razed. The riverfront had been in decline since the early 1900s and many of the buildings stood vacant. Plans began as early as 1913 to redevelop the waterfront. But St. Louis sunk into the Depression in 1930 with the rest of the nation and the largest Hooverville (shanty town) in the U.S. began to take shape just south of the Municipal Free Bridge (seen in the distance) roughly between Chouteau Avenue and Rutger Street along the Mississippi riverfront. It became populated by 3,000 destitute St. Louisans living in some 500 make-shift shelters of wood, stone, and scrap metal. Federal funding in 1936 opened up public works projects that put many of these unemployed St. Louisans to work clearing the shanty town as well as the old buildings on the downtown riverfront. The Jefferson National Expansion Memorial was planned on the formerly industrial waterfront to commemorate the city's historic role as "Gateway to the West." In 1948, Finnish architect Eero Saarinen won a design competition with his modified catenary arch, roughly the shape made by a chain dangling from two points, a stunning steel-frame structure covered with stainless steel plates.

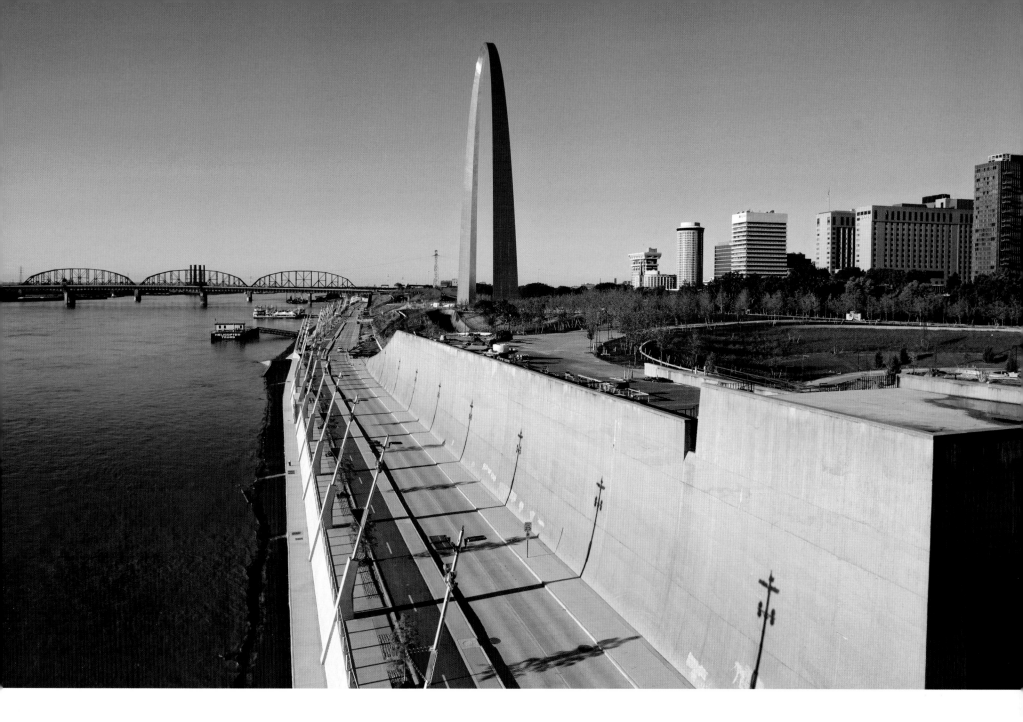

ABOVE: Today, the view is very different. The railroad trestle has disappeared along with the warehouses and a park, along with the city's 50-foot floodwall stand on the right. Reconstruction of Lenore K. Sullivan Boulevard—the official name for Wharf Street—that included raising it, with improved lighting, and bicycle paths has been completed. In the background are the flat deck and piers of the Poplar Street Bridge, built in 1967, and behind them the arches of the Municipal Free Bridge, renamed the MacArthur in 1942. Due to funding troubles, the Gateway Arch was not begun until 1963, when the necessary $13 million was raised. Upon completion in 1965, it became an almost instant, national tourist attraction. Trams run inside the stainless steel legs up to the viewing deck, 630 feet in the air. Below ground an expanded Museum of Westward Expansion is under construction while the park itself is being redesigned. The original museum opened in 1976, housing artifacts from Thomas Jefferson's historic purchase of the Louisiana Territory and the exploratory voyage of Lewis and Clark.

SS *ADMIRAL*

A familiar sight on the St. Louis riverfront until 2011

BELOW: The St. Louis riverfront seen from the Eads Bridge in 1940. The SS *Admiral* began life in 1907 as the steel-hulled steamer *Albatross*. But it was re-designed in grand Art Deco style by fashion illustrator Maizie Krebs who worked in St. Louis for the Famous-Barr company. It was converted between 1938 and 1940 by the Streckfus Steamer Company at a reputed cost of over a million dollars. Five decks high, 374 feet long, and 92 feet wide, the Admiral could hold 4,400 passengers and was the largest passenger cruiser on U.S. waterways. It made daily runs as far north as the Eads Bridge, downtown to the Jefferson Barracks several miles south, where it turned around. It was a magical place of arcades, dance floors, a sun deck and concession stands, with for a time the world's largest floating ballroom where sell-out crowds danced to the music of Dixieland, Count Basie, Bob Kuban, and later the Younger Brothers.

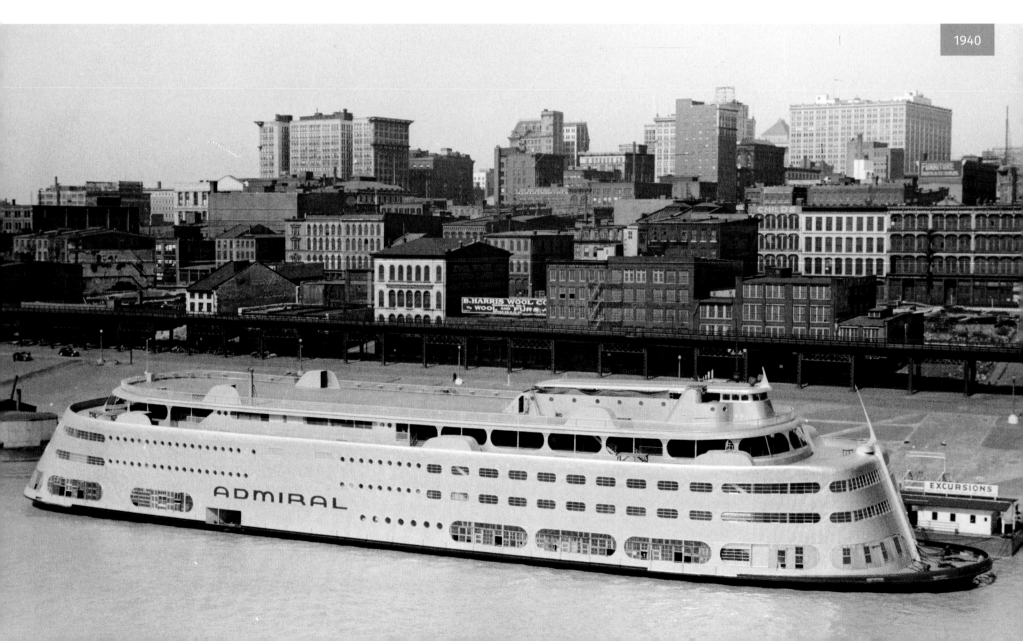

1940

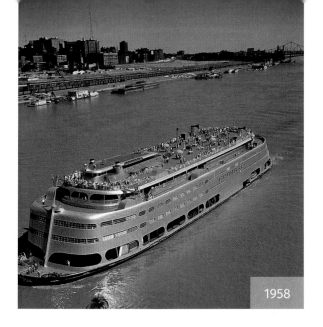

1958

BELOW: The SS *Admiral* dominated the Port of St. Louis in photographs long after its final excursion in 1979. After its engines were removed in 1979 it was moved north of Eads Bridge and entered a third lifetime moored to the bank as a gambling casino. No excursion boat on the scale of the *Admiral* had been permanently moored on the downtown St. Louis riverfront since just after the Great Flood of 1993, when the waters of the Mississippi reached halfway up the Grand Arch Staircase and river traffic came to a standstill. In 1998, *Admiral* survived a potentially disastrous accident. With 3000 people on board it was struck by barges that had broken loose from a river tow. With eight of its ten mooring lines broken it threatened to break loose and float off downstream but was pinned to the bank by the swift action of the tow captain in the river tug that had lost its barges. In its heyday the *Admiral* was docked where the north floodwall is visible on the right in the photo below. In July 2011, the Art Deco masterpiece was towed to Columbia, Illinois, and torn apart for scrap.

LEFT: The SS *Admiral* in 1958 viewed from the MacArthur Bridge.

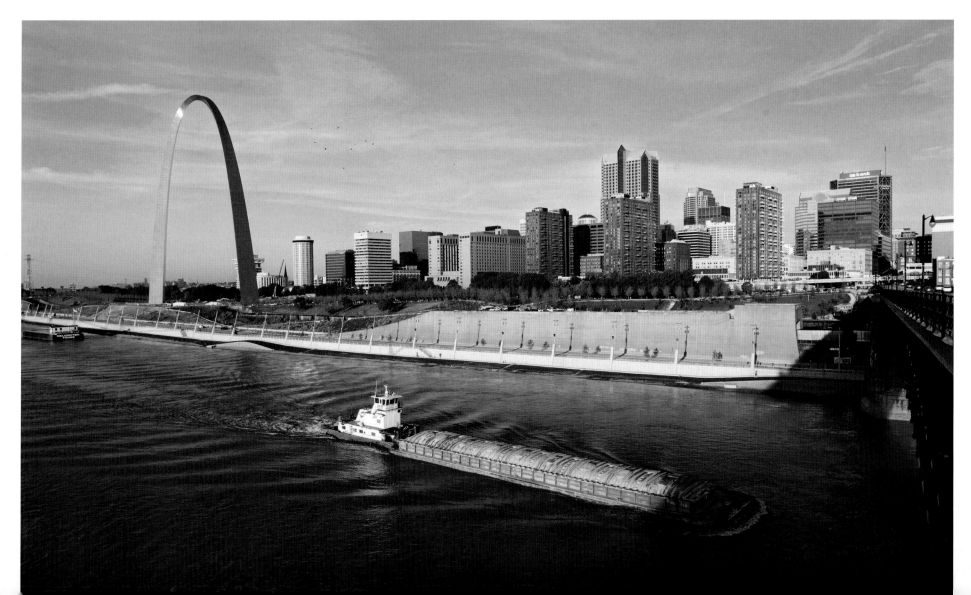

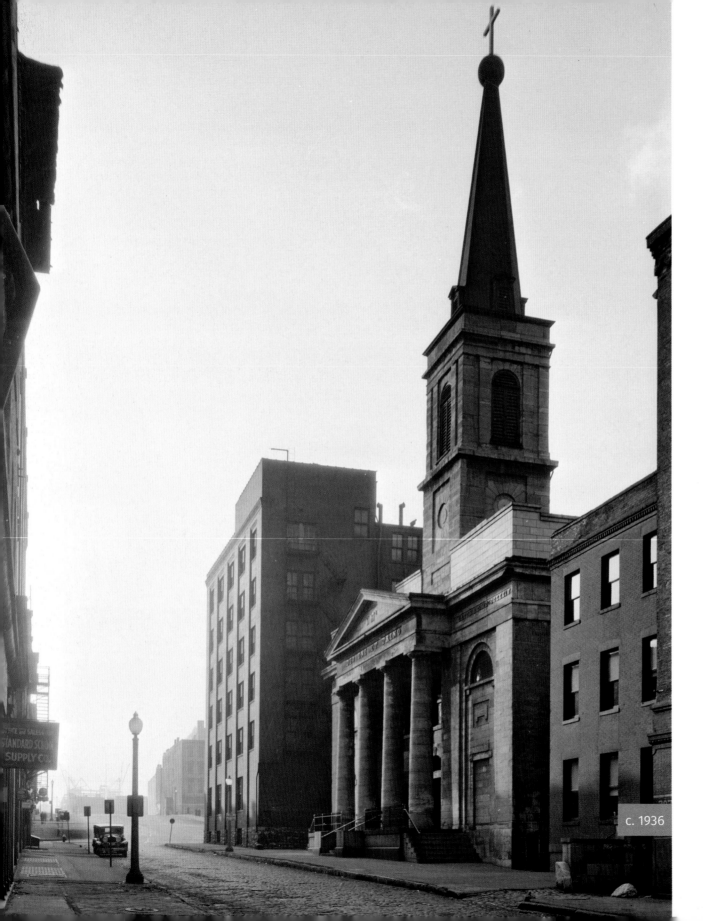

c. 1936

OLD CATHEDRAL
The land for this place of worship was set aside in 1764

LEFT AND BELOW: Cathedral of St. Louis, Walnut Street at Third (today Memorial Drive). This early example of Greek Revival architecture, designed by George Morton and Joseph Laveille was the first Catholic cathedral west of the Mississippi, completed in 1834. Pierre Laclède himself reserved the land for this purpose at the city's founding in 1764. The first church was a small vertical-post structure built in 1770; it was soon rebuilt in larger form. They stood alone on the church block with a house for the priest and the village cemetery. When Bishop Louis Dubourg arrived in 1818, the second wooden church was replaced with brick. Finally, in 1831, construction began on the stone church, built primarily of native Missouri limestone. One of the few buildings left standing after the Great Fire of 1849, it became crowded by the commercial buildings that went up in the fire's wake, some to defray the cost of its construction. The Old Cathedral stands on the only piece of land in St. Louis, which was never been bought or sold. The inscriptions on the façade read in French, Latin, English, and Hebrew.

1940

RIGHT: Today, the Old Cathedral, formally the Basilica of St. Louis, King of France, is the only historic building that remains on the Jefferson Memorial grounds. While commercial brick buildings crowd it in archive photos, today the church's verdigris steeple, gold ornaments, and geometric proportions are stunning against the backdrop of contemporary skyscrapers. From the church interior, the classically arched windows afford lovely views of the Gateway Arch. In 1914, the title "cathedral" ceased when the new St. Louis Cathedral was consecrated on the western edge of the city. However, in 1961, Pope John XXIII designated this historic church the Basilica of St. Louis. In a spirit of collaboration with the 2015 CityArchRiver initiative to reconnect the Arch grounds with downtown St. Louis, the Old Cathedral underwent a comprehensive restoration to the way it looked in the 1870s.

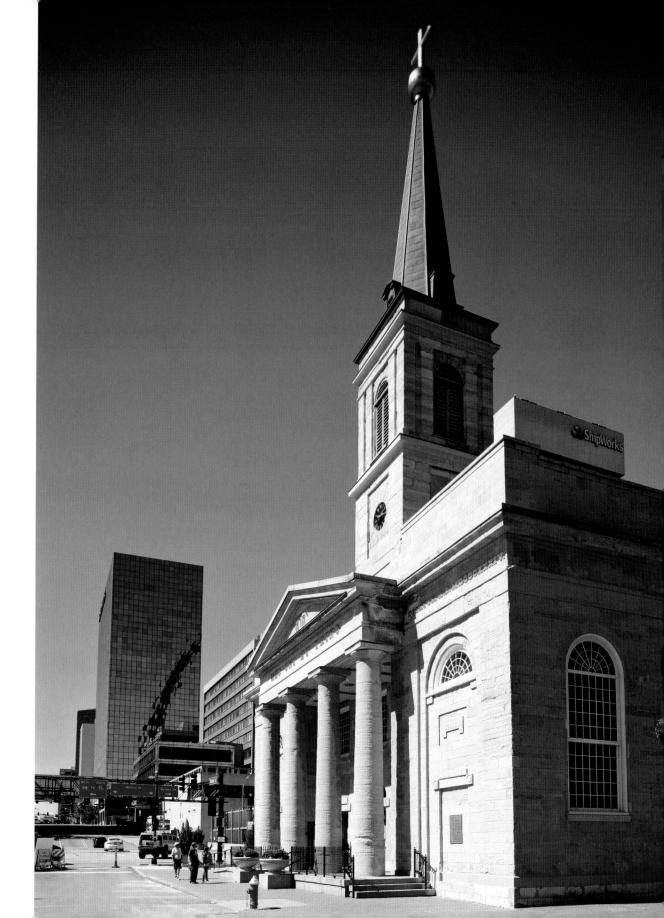

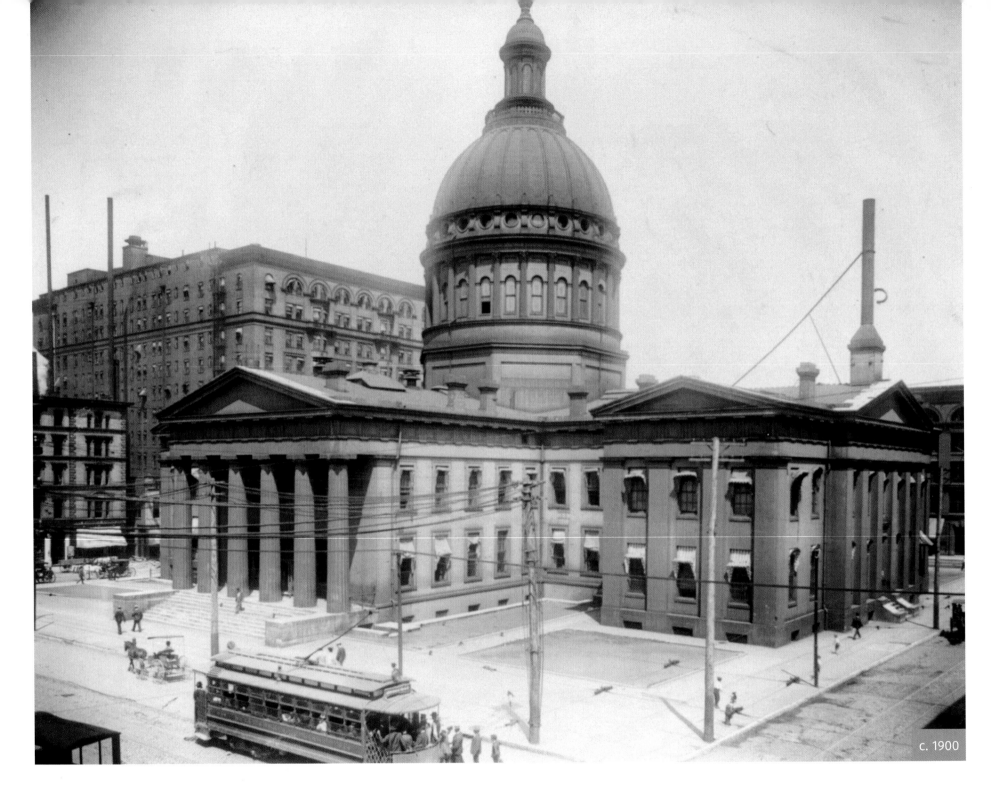

c. 1900

OLD COURTHOUSE

Slaves were sold from the courthouse door as late as 1862

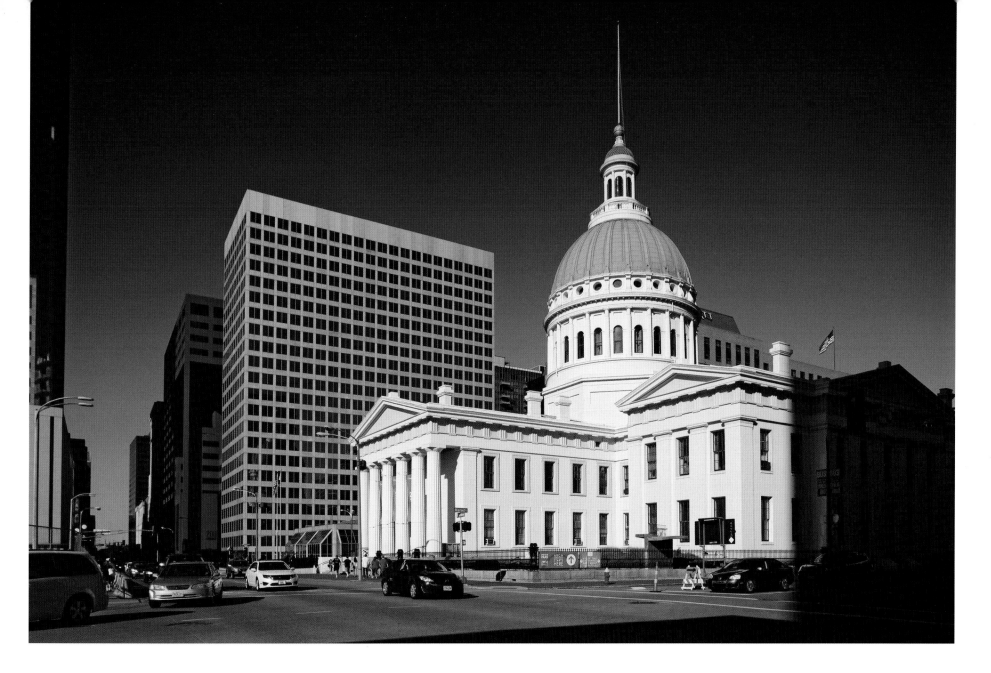

LEFT: The courthouse had been through several overhauls before it reached its eventual neoclassic "look." In 1839, architect Henry Singleton retained the original 1820s courthouse on the site as the east wing of his new cruciform Greek Revival style building. Wings were demolished and annexes added throughout the 1850s, then in 1860, William Rumbold designed the taller, sturdier Italian Renaissance dome. Considered an engineering marvel in its day for its pioneering use of an iron shell, the St. Louis dome was the precursor of the cast-iron dome placed on the U.S. Capitol in 1865, making it the oldest dome of its kind in the United States. Although many St. Louisans were opposed to slavery, when slaves were part of an estate that needed to be sold off by the court, they were auctioned from the steps and door of the courthouse until June 6, 1862.

ABOVE: Today, the Old Courthouse is a history museum and national heritage site operated by the National Park Service for the Jefferson National Expansion Monument. It was here that two trials of the Dred Scott Case were heard in 1847 and 1850. Scott, a slave, sued for his freedom on the grounds that he had once lived in a free territory. The case was appealed all the way to the U.S. Supreme Court, where it was decided in 1857 that Scott had never been free, despite living in a free territory, and thus had no right to sue in a U.S. court. The decision, which opened the door to slavery in the west, outraged anti-slavery Americans and directly hastened the Civil War. Another civil rights trial of a national scale took place here in 1873, the Virginia Minor case for women's suffrage. It, too, went to the U.S. Supreme Court where it was struck down.

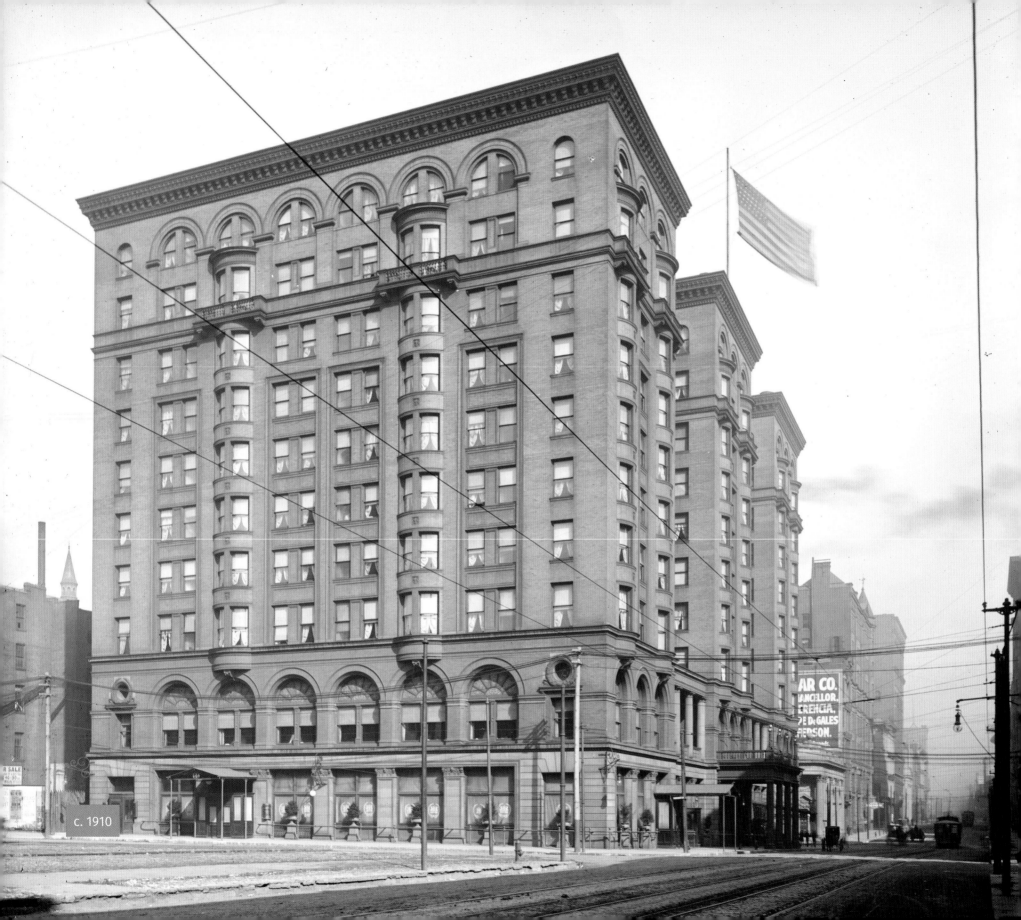

c. 1910

AR CO.
ANCELLOR,
ERENCIA,
DE DE GALES
FERSON.

PLANTERS HOTEL

One was abandoned, another burned,
and the third was razed

LEFT: Located across from the Old Courthouse, Planter's Hotel was a handsome, block-wide, E-shaped building designed by Isaac Taylor, supervising architect of the World's Fair of 1904. It was completed in 1891 as the third Planter's Hotel in St. Louis, the second on that site. The original was a frame building on the riverfront. The Planter's House Hotel that preceded it opened in 1840 as an elegant, five-story hotel with shops and offices at street level. It gained a national reputation for luxury and comfort and a local reputation for high-power business and political transactions. Wealthy planters from north and south wintered there with their families and their servants or slaves. Andrew Jackson, Abraham Lincoln, Jefferson Davis, Ulysses S. Grant, Buffalo Bill Cody, and Charles Dickens were among its guests. That building burned in 1891 and was replaced by the hotel left.

RIGHT: The Planters Hotel became the Cotton Belt office building in about 1922. In 1976, Hellmuth, Obata, & Kassebaum (HOK) replaced it with a twenty-two-story, aluminum and glass tower for Boatmens Bank. Like the Equitable Building, constructed on the south side of the courthouse in 1971, it signaled a departure from St. Louis' brick with sleek glass, steel, and concrete. Architects honored the historic significance of the Old Courthouse nearby by restricting the height of the towers' lobbies to one story directly across from the courthouse so as not to crowd it, and utilized massive amounts of glass to reflect its importance. Thus the dome of the Old Courthouse can be seen on the south face of what is now the Bank of America Building at 100 North Broadway. Rising above it to the left are the steep, green gables of Metropolitan Square, the architectural firm's world headquarters.

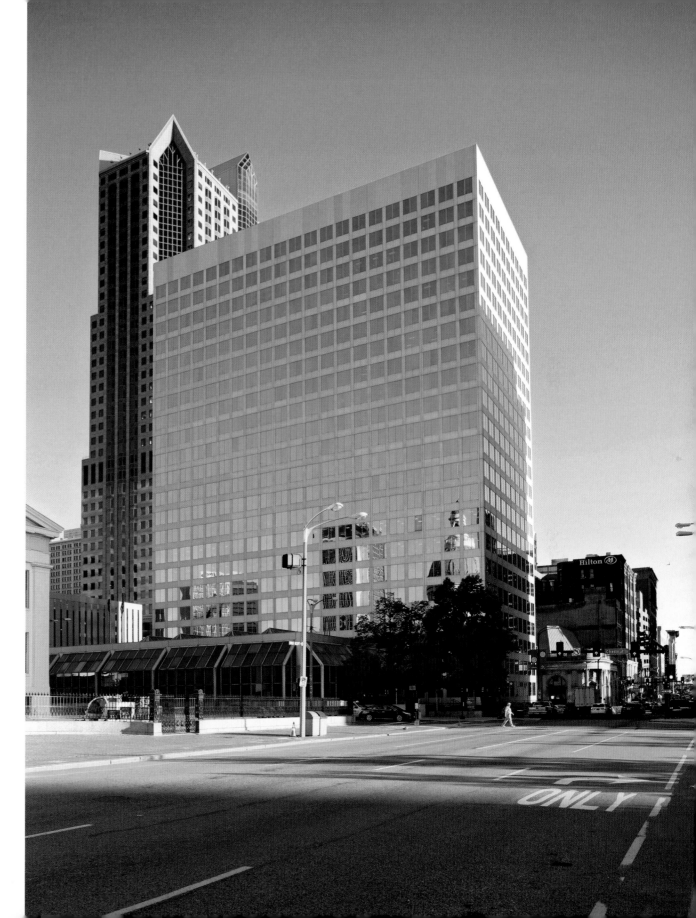

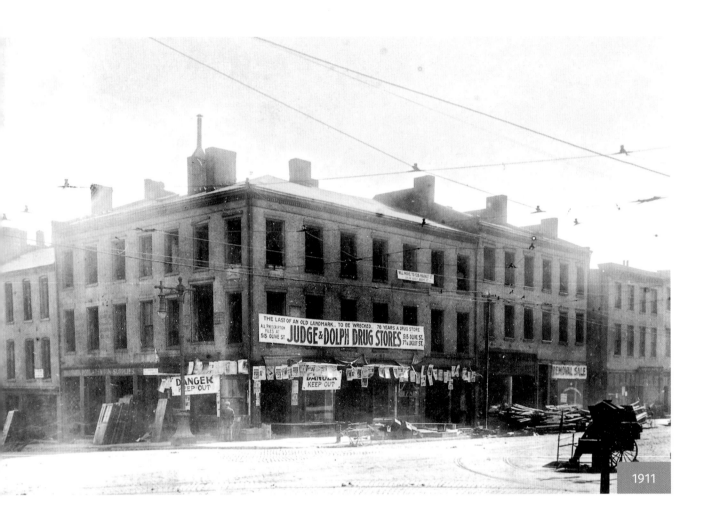

1911

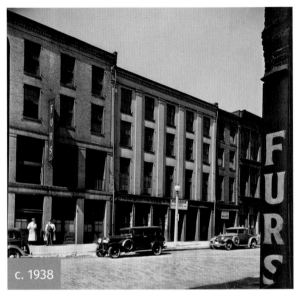

c. 1938

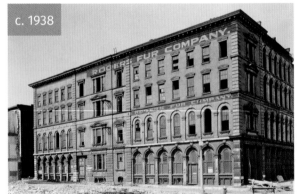

c. 1938

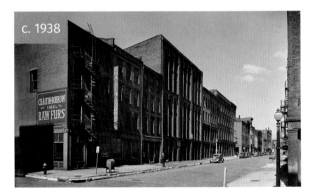

c. 1938

INTERNATIONAL FUR EXCHANGE

St. Louis continued as a fur center, long after beaver stocks declined

ABOVE: Fourth and Market, opposite the Old Courthouse, October, 1911. St. Louis was founded in 1764 as a commercial center for the lucrative western fur trade. The fur trade foundered in the nineteenth century after beaver stocks were depleted and fashions changed. However, at the turn of the century, St. Louis was still the nation's primary fur market. Since the 1830s, this corner had been home to a drug store, but following a resurgence in fur fashion, it was purchased by the newly formed International Fur Exchange.

TOP RIGHT: According to the 1998 National Park Service application to place the International Fur Exchange Building on the National Register of Historic Places, Second and Elm streets had been the center of the riverfront fur district.

MIDDLE RIGHT: In 1947, the Rogers Fur Company was located three blocks west of the riverfront at 416 S. Sixth Street.

RIGHT: One of many smaller brick auction houses that flourished when St. Louis was the leading market for North American raw fur in the late nineteenth century.

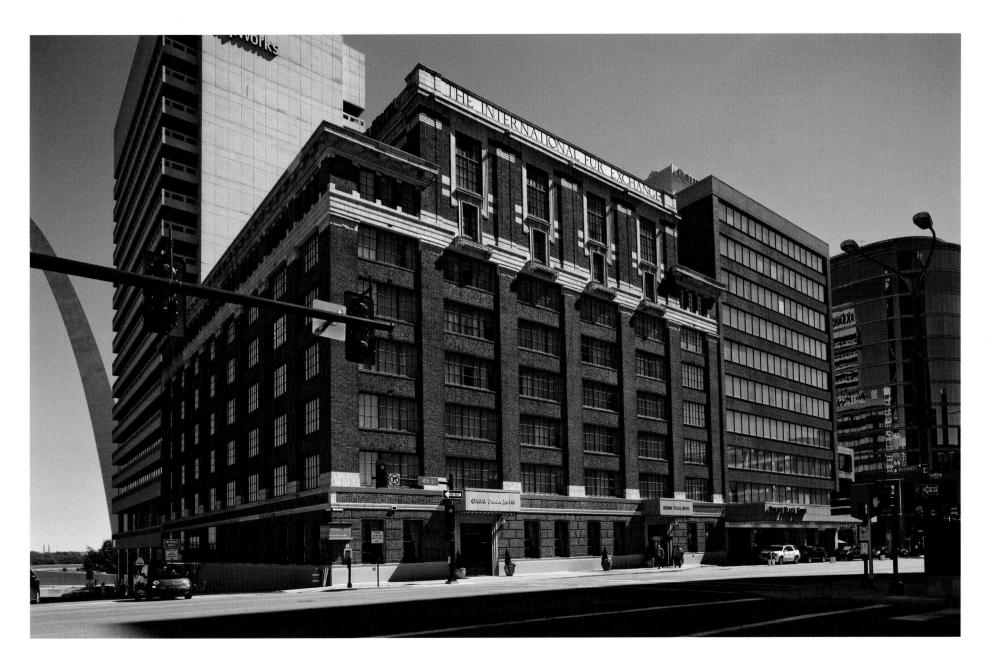

ABOVE: In 1919, New Orleans fur trader, and Exchange founder Philip Fouke commissioned George Hellmuth to design the seven-story International Fur Exchange Building seen here, complete with a two-story auction room at the top and "unexcelled lighting facilities" for buyers from around the world to examine goods. In 1997 hotelier Charles Drury rescued the Fur Exchange Building and its neighbors, the Thomas Jefferson and the American Zinc buildings, from demolition and converted them into the Drury Plaza Hotel, which opened in 2000. It is listed on the National Register of Historic Places, as a landmark symbolic of the city's prominence in the fur trade, starting around 1772-1775 when 600,000 lbs of fur and hides were shipped out of St. Louis.

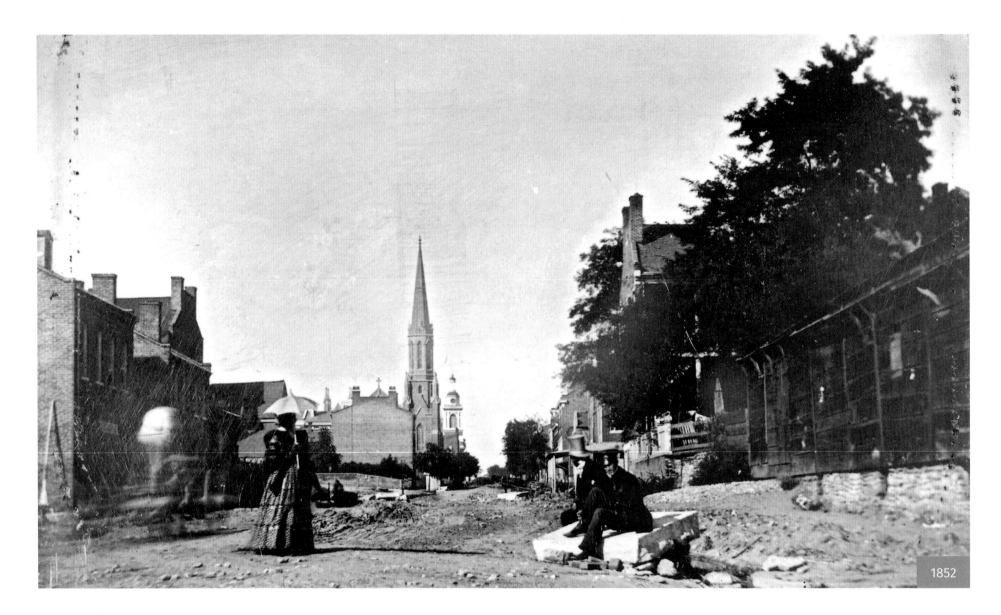

1852

NINTH STREET

Little business was conducted on Ninth Street in the 1850s

ABOVE: A Thomas Easterly daguerreotype of Ninth Street looking north from Chestnut, 1852. Antebellum St. Louis was a rapidly expanding boom town. Despite heavy losses from a terrible cholera epidemic and the departure of hundreds of young men for the California gold fields, from 1840 to 1850 St. Louis had increased in population by over 370 per cent to almost 78,000. In the early 1850s more than 13,000 buildings were under construction at any one time, and street-side construction rubble was so ordinary that pedestrians were accustomed to using chunks of granite slabs as public benches.

ABOVE: Today, the only recognizable feature is the street itself. In the 1850s, Ninth Street was mostly residential, a street where gentlemen in top hats rested along the walk and calico-clad ladies strolled toward church with parasols to protect the pallor of their skin. Now, Ninth Street is the heart of the business district. A glass-enclosed pedestrian overpass connects the One AT&T (left) and AT&T Data (right) centers of the former Southwestern Bell Telephone Company, headquartered in St. Louis for many years, and still maintaining large offices. At center right stands the Paul Brown Building and across the street on the left is the Mark Twain (originally Maryland) Hotel (1908) designed by Albert B. Groves with elaborate terra-cotta flourishes produced by Winkle Terra Cotta of St. Louis.

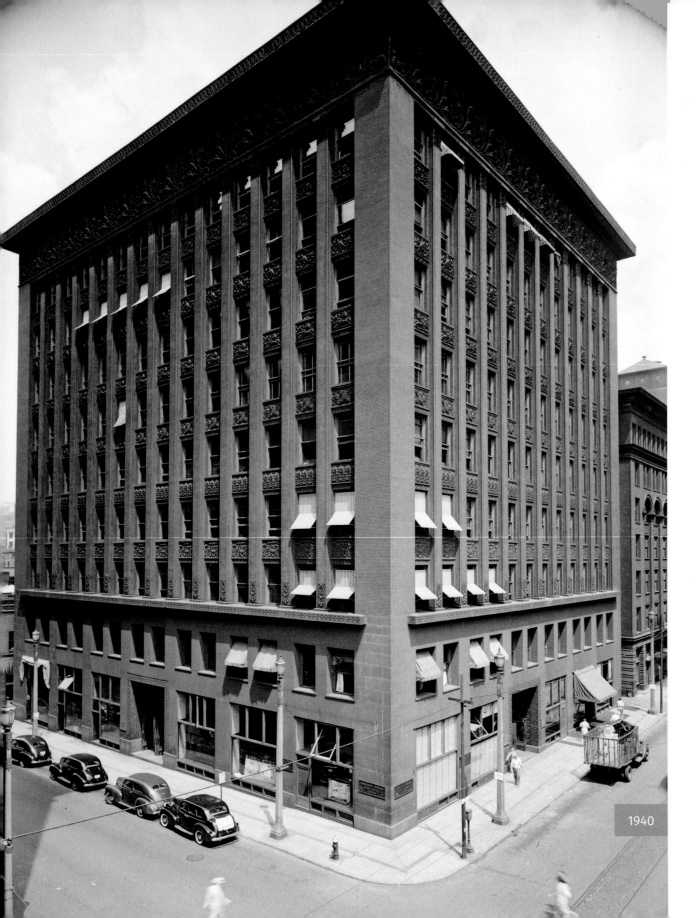

1940

WAINWRIGHT BUILDING
A classic building from Chicago's finest architectural firm

LEFT: St. Louis businessman Ellis Wainwright commissioned Chicago architect Louis Sullivan to design an office building in 1890. Until that time, commercial buildings had been constructed with masonry support or, even if framed in metal, preserved the look of masonry buildings. When completed in 1893, the Wainwright Building, with its all-steel internal frame and vertical upthrust, first captured the soaring spirit of the skyscraper. The façade is constructed of red sandstone and red Missouri granite, and is notable for its signature terra-cotta ornamentation.

BELOW: Exterior cornice detail of the terra-cotta work by the Chicago firm Adler & Sullivan.

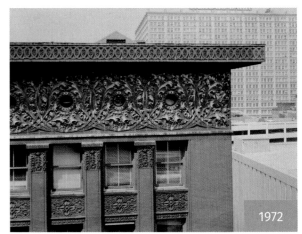

1972

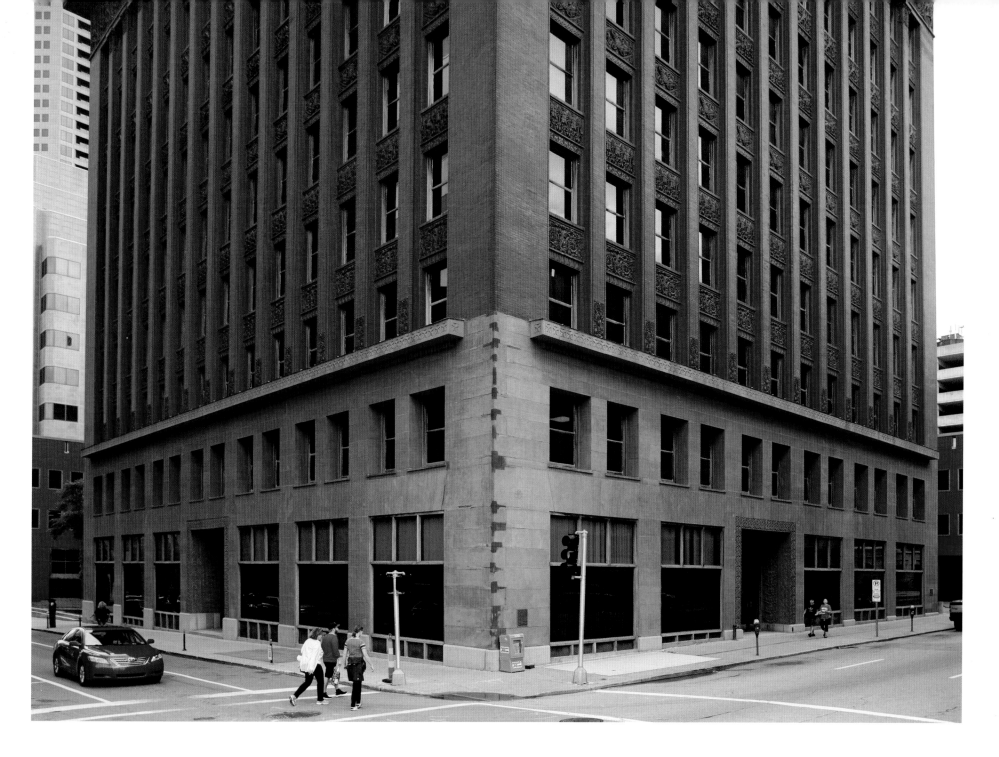

ABOVE: Frank Lloyd Wright, Louis Sullivan's apprentice, called the Wainwright Building and Union Station, St. Louis' finest structures. In the Wainwright, despite brandishing a few old-fashioned touches like the cornice, Sullivan managed to create, in the words of Wright, "the tall building as a harmonious unit." The Wainwright with its lyrical horizontal friezes separating the third through ninth stories was preserved by the state of Missouri in 1974; it now houses government offices.

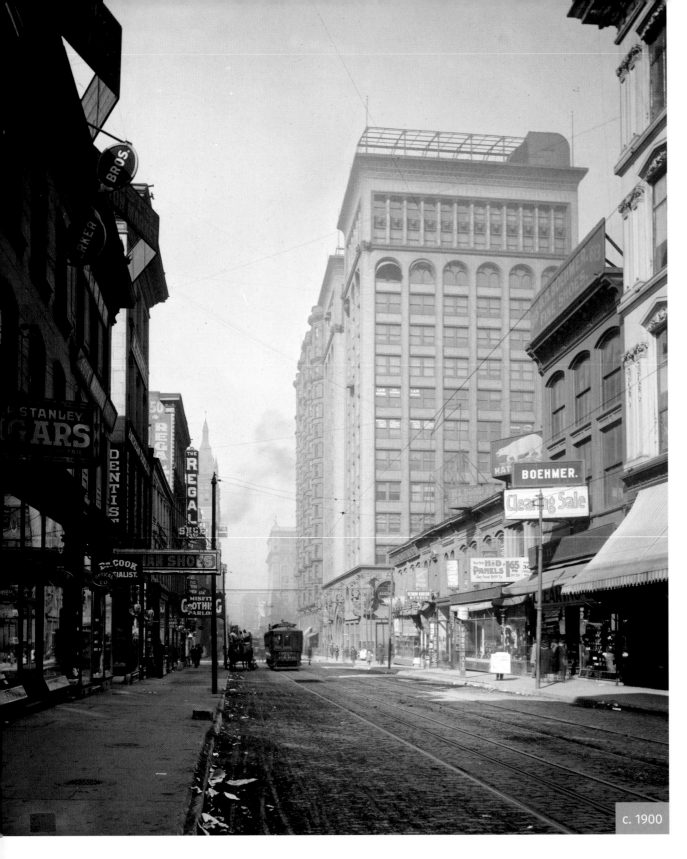

c. 1900

OLIVE STREET
Classic St. Louis skyscrapers have been retained on Olive

LEFT: Olive Street looking west from Sixth Street sometime between 1896 and 1908 when the low buildings in the right foreground came down and construction began on the Railway Exchange Building. The Union Trust Company Building (1893) looms at the corner of Eighth and Olive, its architects Louis Sullivan and Dankmar Adler of Chicago and Charles K. Ramsey of St. Louis. It features twin towers around a court of natural light and large, round windows on three sides on the second story, not to mention terra-cotta bear heads, griffins, and rampant lions. The top of one tower was for years the highest beer garden in St. Louis. The undulating façade of the Chemical Bank Building (1896) farther down the street provides a beautiful contrast to Sullivan's smooth verticals.

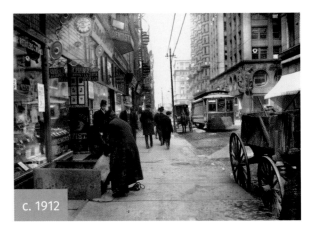

c. 1912

RIGHT: Today, the Railway Exchange and Chemical Bank buildings are virtually unchanged. The Union Trust, now the 705 Olive Building, still stands, though somewhat altered. A 1924 remodeling removed the second-floor round windows, the corner lions' heads, and a Roman-arched entrance. This stretch of Olive preserves several of its handsome turn-of-the-century buildings, but the street-level character has gone the way of the horse cart. The advent of the automobile altered the American cityscape in far-reaching ways. Parking garages now line much of the south side of Olive Street while the earlier bank and department store buildings on the north side are all under contract for renovation into hotels and apartments.

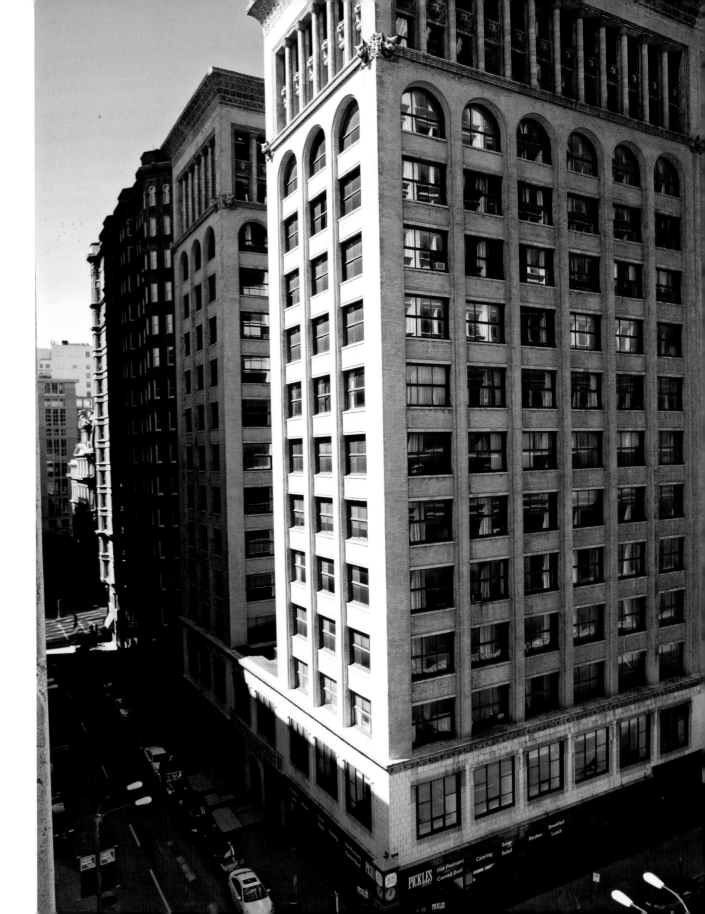

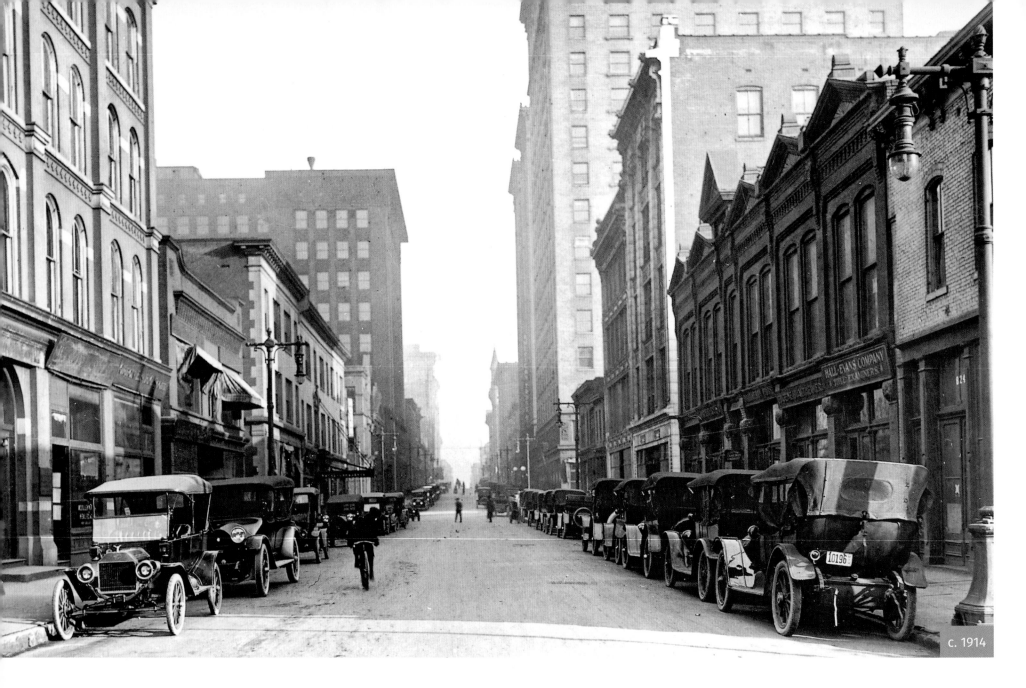

c. 1914

CHESTNUT STREET

Originally known as La Rue Missouri

ABOVE Chestnut Street looking east from Ninth, circa 1914. In 1826, the city voted to rename city streets based on the Philadelphia system, replacing all old French street names with numbers north-south and tree varieties east-west. Shortly thereafter, lower Chestnut was one of the first streets paved in the city; the blocks nearest the river were home to "Quality Row," a row of brick two-story town homes among the otherwise wooden structures. Vintage automobiles are seen parked on both sides of what was then a two-way street. The north wall of the Old Courthouse is barely visible three blocks east.

ABOVE: In 1918, St. Louis became the second city in the nation after New York to adopt city-wide, industrial/residential zoning. However, as we see in the 1914 photo, by that point in time business clearly dominated most of downtown. In a plan to reintroduce open space in the form of a grassy mall, almost all buildings lining the south side of Chestnut were torn down. Today, this stretch of Chestnut affords a glimpse of the Arch rising above a hotel tower in the distance. At left are the Bell Data Center and the Wainwright Building beyond it in shadow. Chestnut, originally La Rue Missouri in colonial times, is now a one-way street lined for parking and bicycle traffic, and the north wing of the Old Courthouse is clearly visible in the east thanks to the Gateway Mall.

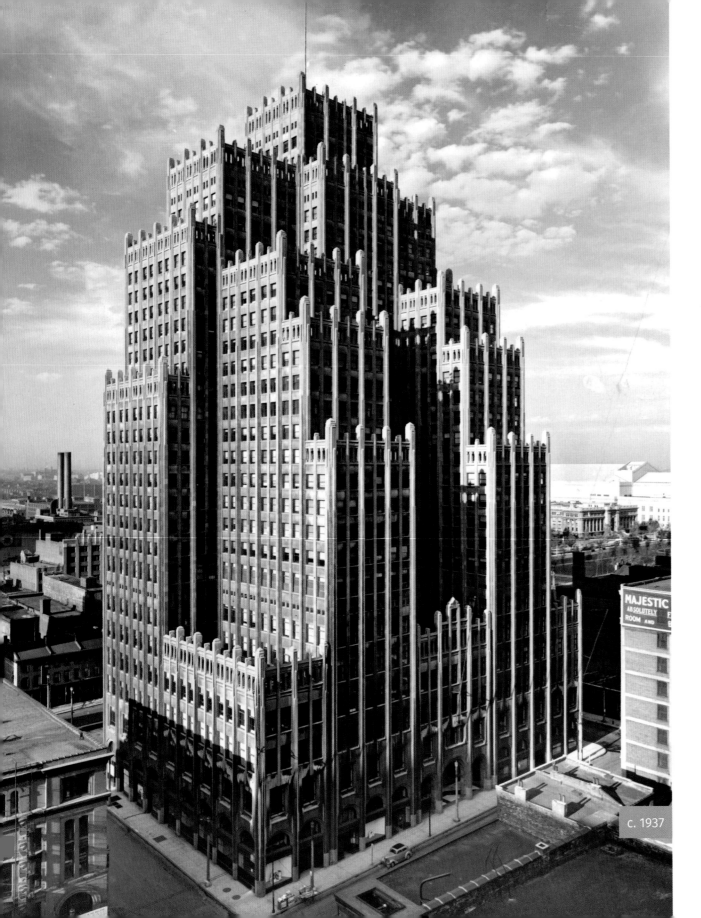

c. 1937

SOUTHWESTERN BELL BUILDING

A suitable office for Clark Kent

LEFT: The rise of the Southwestern Bell Building illustrated a tremendous expansion in the use of telephones in St. Louis between the late nineteenth and early twentieth centuries. After a modest 1878 start in a bank building several blocks east, a six-story red- brick and sandstone building was constructed in the Richardsonian Romanesque style in 1889 at 920 Olive Street to house the telephone network for St. Louis Bell. By 1923 construction had begun on the tallest building in Missouri and the first terraced skyscraper in St. Louis. It was opened in 1926. Designed in an Art Deco style referred to as "Skyscraper Gothic" it is sometimes called the "Superman Building" because one can imagine Clark Kent raising a window and taking flight from one of its seventeen separate rooftops.

RIGHT: Ninety years later the Southwestern Bell Building remains the historic anchor of AT&T Center in St. Louis. Not seen in the photograph above, but connected by the skywalk on the left, is One Bell Center, the largest building in Missouri, which the telecommunications company vacated in 2016. Bordering the Southwestern Bell Building on the left, almost like a shadow, is the outline of the Thomas F. Eagleton U.S. Courthouse, which stands three blocks south. The modest two-story building on the right houses the Gateway Metro Credit Union, which was formed in 1935 by Southwestern Bell employees to serve the people working at Bell. Gone are the low buildings seen directly behind the Southwestern Bell Building on the opposite page. They were replaced with a grassy, tree-lined section of the Gateway Mall that has been home since 1981 to Richard Serra's steel sculpture, *Twain*.

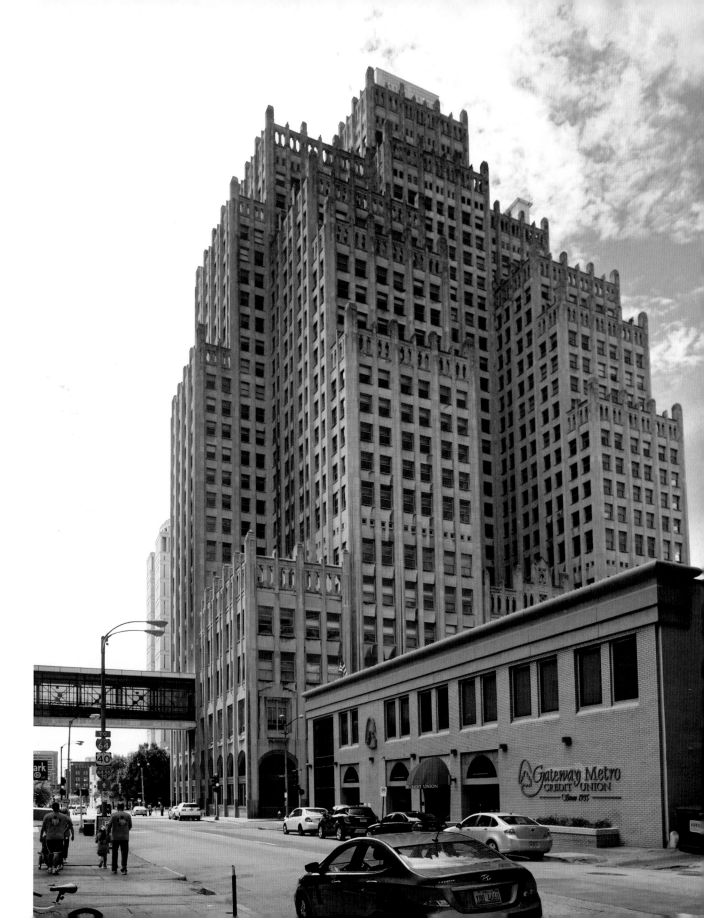

NINTH AND PINE STREETS

Buildings were swept aside for a 1925 development

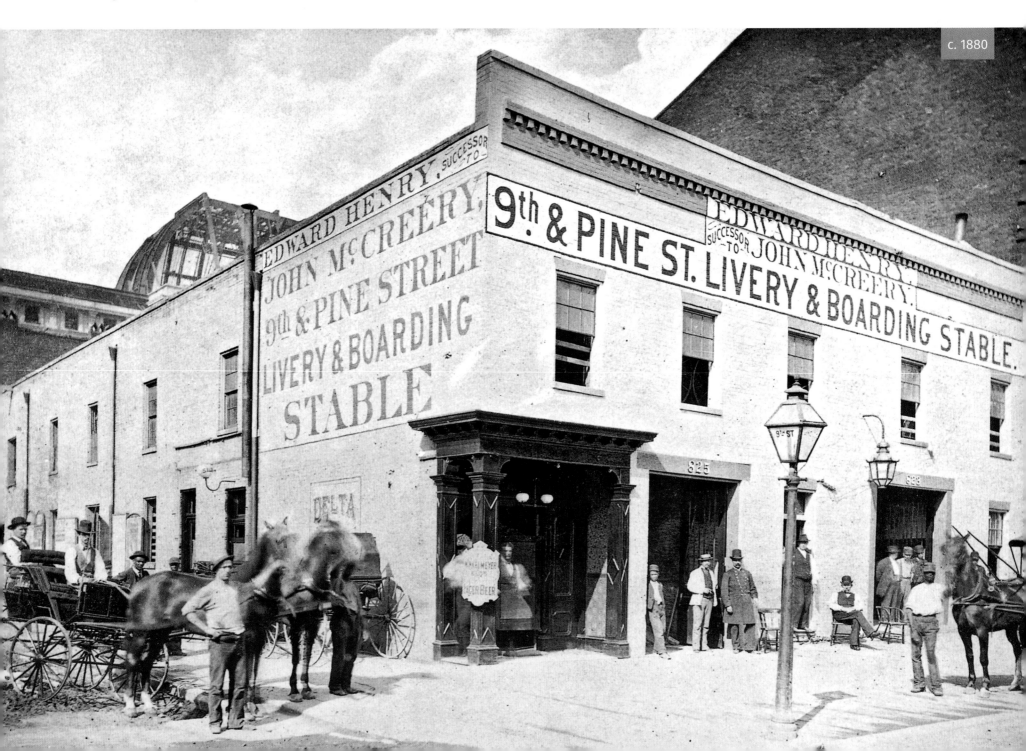

c. 1880

LEFT: Livery and boarding stable at Ninth and Pine streets, circa 1880. The growing pains of the post-Civil War period in St. Louis made for strange neighbors. Ninth Street was once a desirable residential district, but by the 1880s, the lack of a zoning concept combined with the all-too-human desire for convenient goods and services, found "undesirable" industry and commerce intruding onto formerly homes-only turf. Well-to-do citizens who inhabited the brick town houses on surrounding streets had to keep their equine transportation off-site at boarding stables.

BELOW: The recently completed U.S. Custom House and Post Office peeking over the stable in the archive picture was a sure sign that the neighborhood had crossed over from predominantly residential to predominantly business. Today, almost this entire block is taken up by the Paul Brown Building. Designed in 1925 by Preston J. Bradshaw for businessman Paul Brown, it fell vacant for several years during the 1990s but was restored and renovated between 2003-2006 by the Pyramid Construction Company into 222 loft apartments, an indoor parking garage, and retail space at street level.

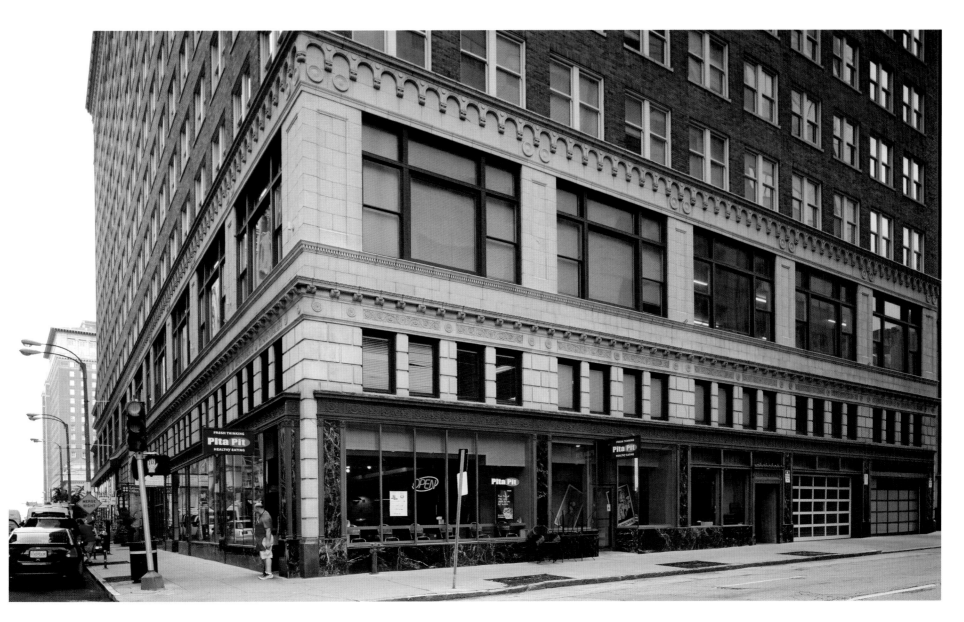

OLD POST OFFICE

The Great Cyclone of 1896 robbed the building of its grand tower

LEFT AND BELOW: Designed by notable federal building architect Alfred B. Mullet (designer of the Executive Office Building in Washington, D.C., among others), this U.S. Custom House and Post Office was built over a decade from 1873 to 1884. In the uncertain times of post-Civil War St. Louis, the French Second Empire design bore more than cosmetic similarities to a fortress; the building featured iron-shuttered windows with rifle barrel ports and underground tunnels, with a fresh water supply. The original tower, which had topped the Mansard cupola (seen in the far left photo) served as a weather observatory but eventually had to be removed after being damaged by the Great Cyclone of 1896.

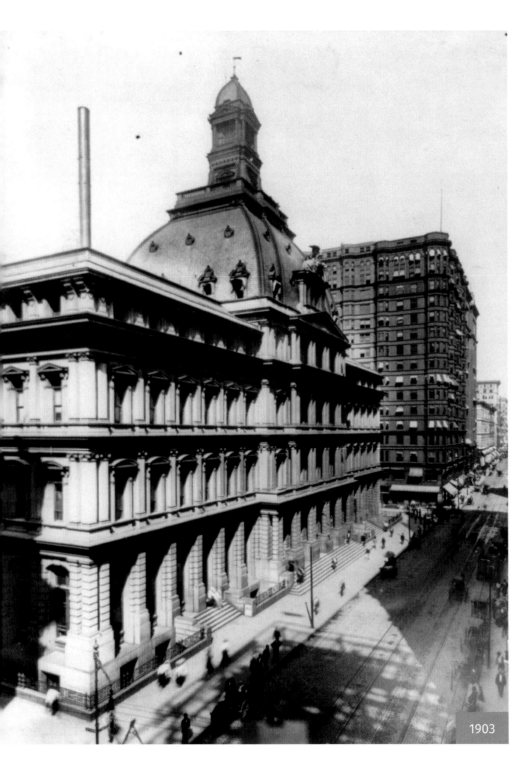

1903

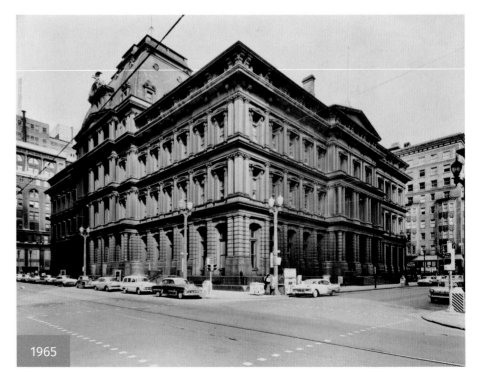

1965

52

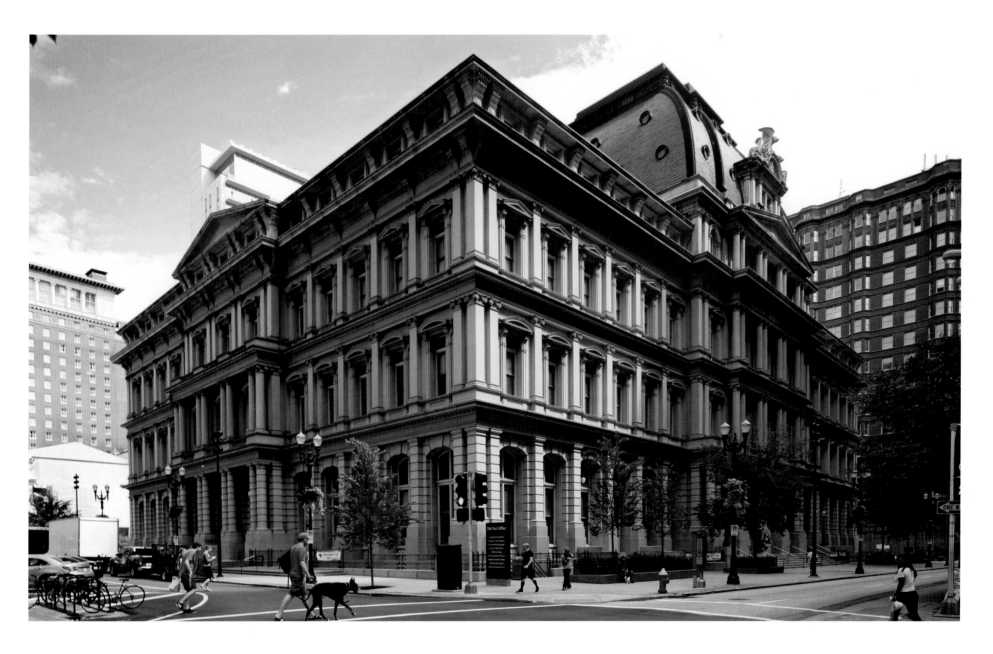

ABOVE: Today, the Old Post Office is a dramatic example of "adaptive re-use" and the center of a vibrant business district. Although the city tried to have the building torn down, it was instead restored in the 1980s and is now home to the *St. Louis Business Journal*, the Central Express Branch of the St. Louis Public Library, several offices of the State of Missouri, Lindenwood University's downtown campus, and the Missouri Court of Appeals for the Eastern District. The original 25-foot moat supplies natural light to the underground levels where classes are held. A polymer-concrete copy of Daniel Chester French's *Peace and Vigilance* now fronts the 67-foot mansard cupola. The original marble sculptures were moved inside for safekeeping and mounted to form the focal point of the north atrium. At right is the terra-cotta adorned Chemical Building (1896); in the left background, the Marriott St. Louis Grand Hotel, built as the Statler Hilton Hotel (1917).

LOCUST STREET LOOKING EAST

The Mercantile Trust building has gained an extra story

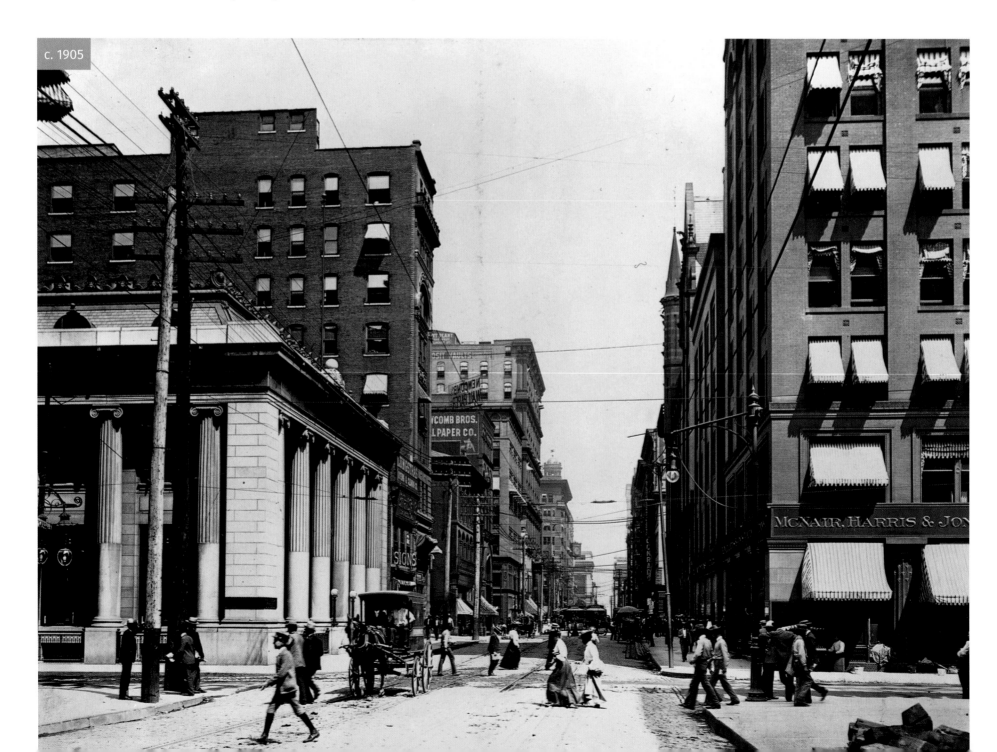

c. 1905

LEFT: Locust and N. Eighth streets, circa 1905. Shoppers and workmen cross N. Eighth Street between the Columbia Building on the right and the Mercantile Trust Company, established in 1855, on the left. The streets are still brick. Barely visible, two-and-a-half blocks east on the right is the Mercantile Library building, which replaced the original on that site in 1889. Founded by civic-minded merchants in 1846 it's the oldest circulating library west of the Mississippi. The Missouri Constitutional Convention met in Mercantile Library Hall in 1861 deciding not to secede from the Union. Four years later they reconvened and voted to abolish slavery in Missouri. Mark Twain, Ralph Waldo Emerson, and Oscar Wilde lectured there. The sidewalk in the right foreground surrounds the new U.S. Custom House and Post Office completed in 1884.

BELOW: The only building remaining from the archive photograph is the Mercantile Trust, now U.S. Bank building, with its Doric columns and to which a parapet has been added. Seen in the far distance on the left is the Federal Reserve Bank on Broadway. In 1926, the Ambassador Theater Building went up just the other side of Mercantile Trust, a movie palace with an office building above it. That was razed in 1997 for the Mercantile Plaza with its 35-foot tower notched at the corners and connecting to the original bank.

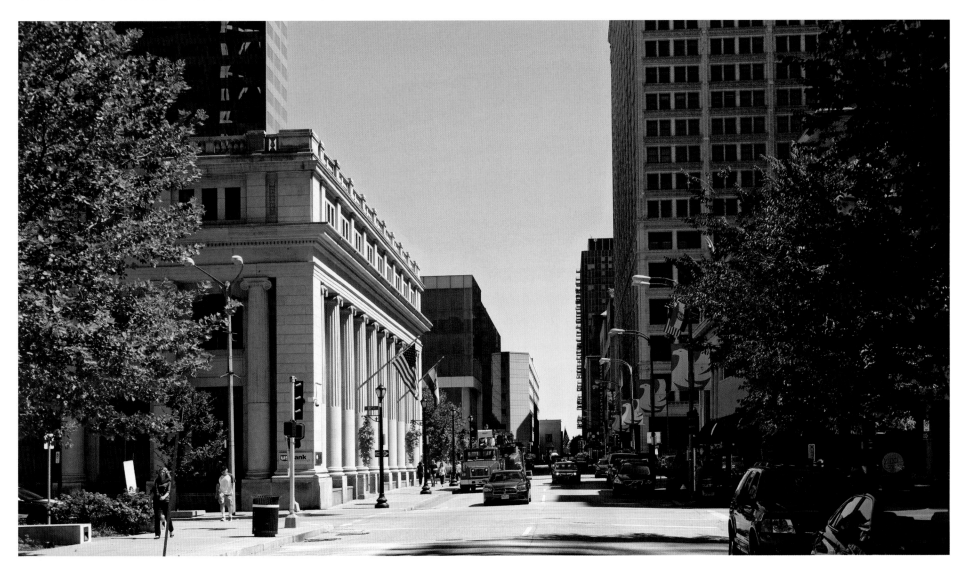

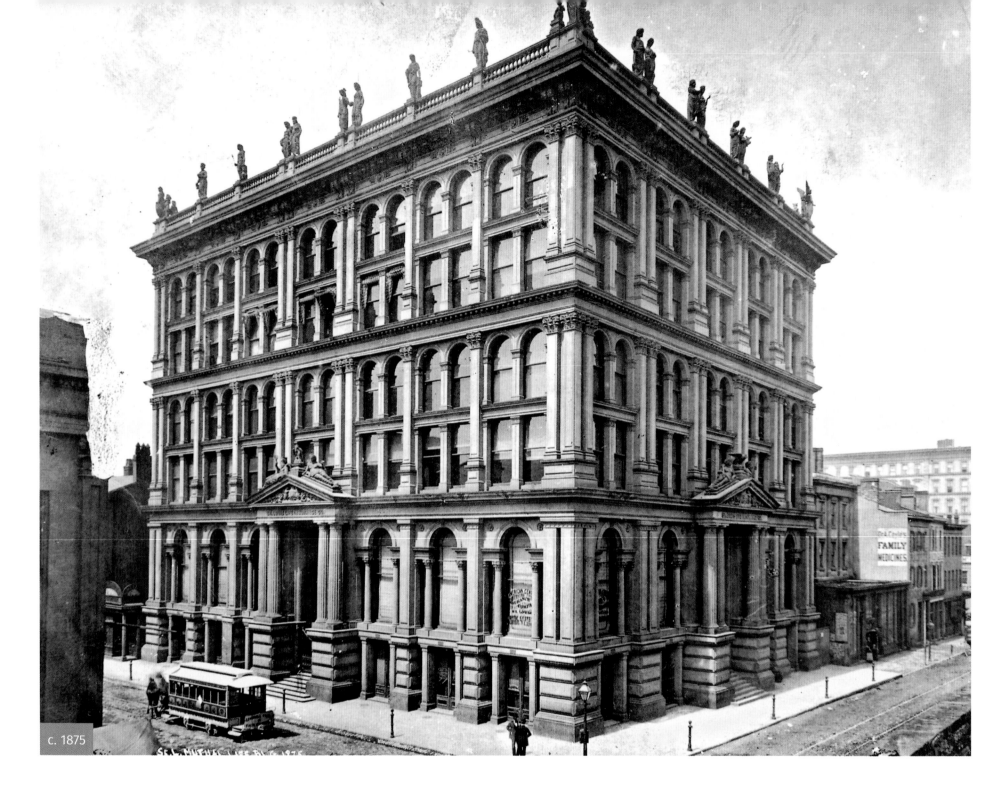

c. 1875

ST. LOUIS MUTUAL LIFE INSURANCE BUILDING
The rooftop statues didn't last long

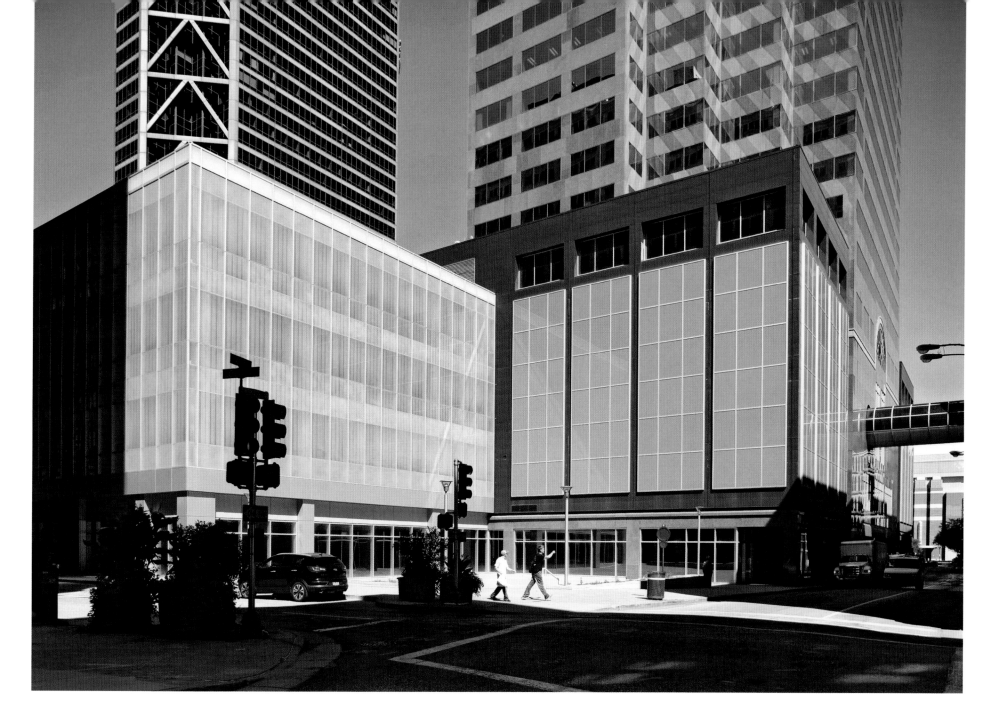

LEFT: Sixth and Locust streets, circa 1875. On this corner stands the St. Louis Mutual Life Insurance Building built in 1871. Designed by architect George Barnett it perfectly embodies the Classical style of which he was the St. Louis master. The building is graced by a series of neoclassical statues commissioned by James Eads, engineer of the Eads Bridge, who was also the organization's president. In typical Gilded Age style, he had originally planned to install them on the bridge itself, but thankfully was talked out of it, preserving the bridge's spare, elegant design. The statues were removed by 1886.

ABOVE: This corner is now home to the Mercantile Exchange (MX) Building. It went up in 1985 as St. Louis Centre, an office tower complex (One City Centre) attached to a four-story, 1,500,000-square-foot shopping mall. It linked two historic downtown department stores with a suburban-style mall featuring a three-story atrium with vaulted glass skylight, a light and airy style known as "steamboat surrealism." St. Louis Centre closed in 2006 but lives on as an anchor of the Mercantile Exchange District and as the new location of the historic Downtown YMCA, originally founded in 1875.

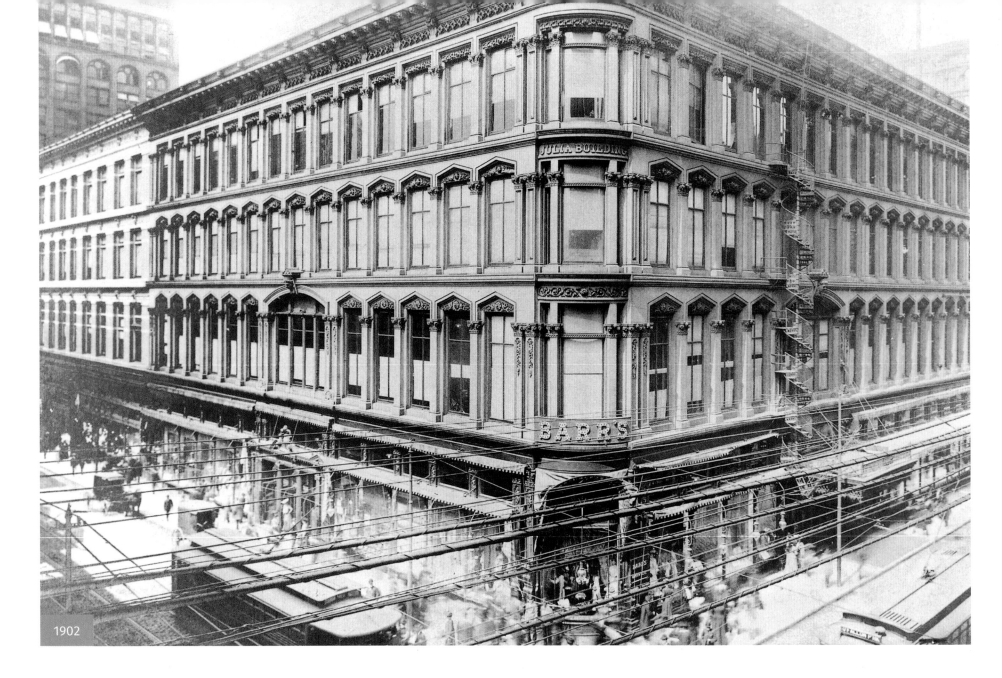

1902

WILLIAM BARR COMPANY / RAILWAY EXCHANGE BUILDING

In 1908, the Railway Exchange Building redefined the city's building limits

ABOVE: Northwest corner of Sixth and Olive streets, 1902. The William Barr Company was St. Louis' largest department store at the turn of the century, situated in a handsome four-story building with fashionable display windows at street level, just south of one of the nation's busiest garment districts. Founded in 1870 by retail dry goods representative William Barr, Barr's bought much of their stock directly from manufacturers, an unusual arrangement at the time, and conducted a thriving mail-order business with towns across the West. In 1900, wholesalers Hargadine and McKittrick purchased the Barr Company, and, flushed with success, would undertake construction of the city's tallest building, to be built on this same location. Electricity became available in St. Louis in 1884, making possible elevators to service tall buildings as well as the abundance of streetcars seen here.

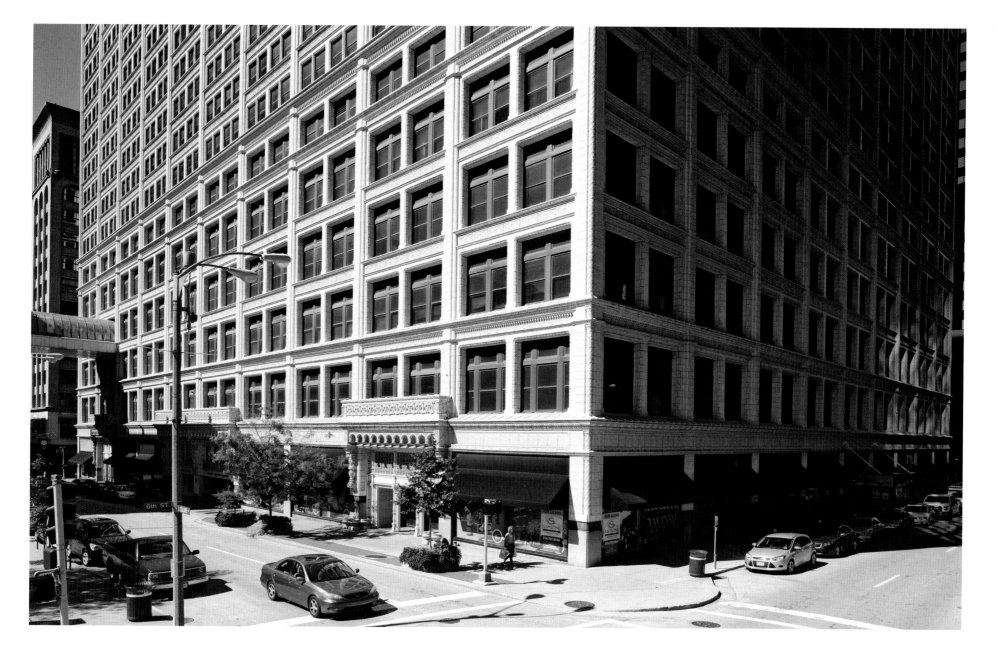

ABOVE: Seventy-five buildings of over five stories were built in St. Louis between 1887 and 1906, but the tallest peaked at twelve stories, the maximum allowed by city ordinance at that time, but also often the limit of smoke-obscured visibility. Then, in 1908, construction on the twenty-one story Railway Exchange Building designed in the Chicago-style by Mauran, Russell, and Crowell of St. Louis, began. Barr's was to occupy the first eight floors with the upper floors leased to the railroads for executive suites. But cost overruns and lack of railroad cooperation put the wholesalers in a squeeze. In 1911, they sold the Barr Company to its previous rival, the May Company, owners of the Famous Company and it became the Famous-Barr Department Store. Later known as Macy's, it closed in 2013.

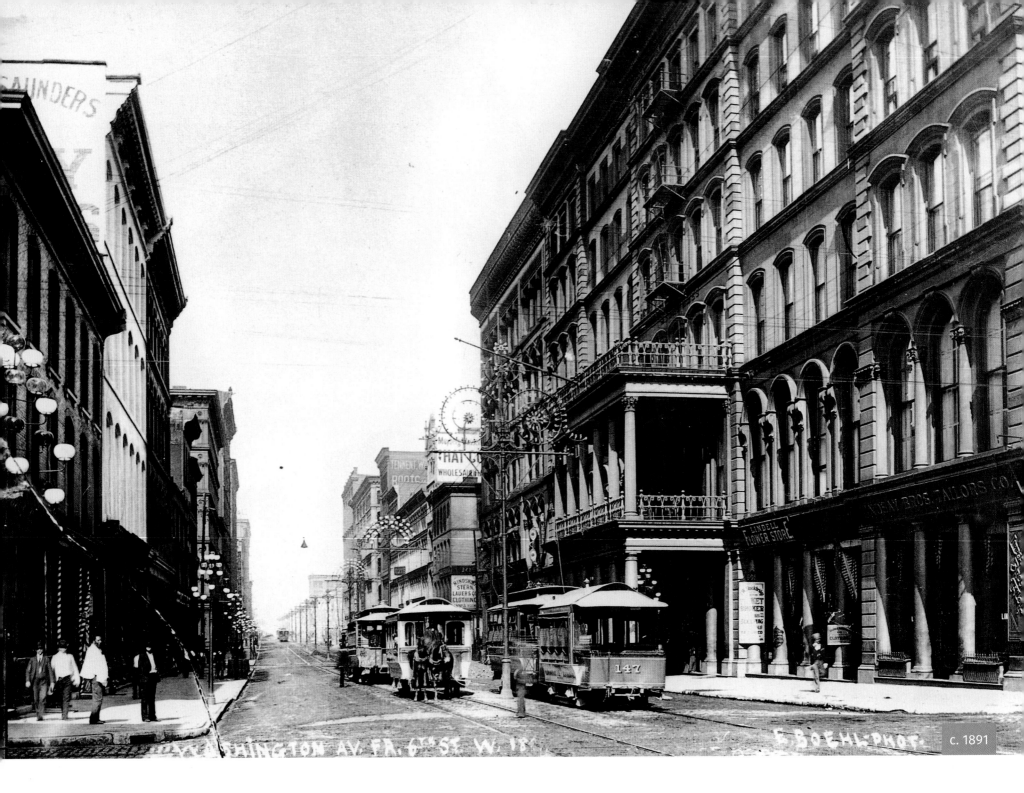

c. 1891

WASHINGTON AVENUE

For many years the view was blocked by the St. Louis Centre sky bridge

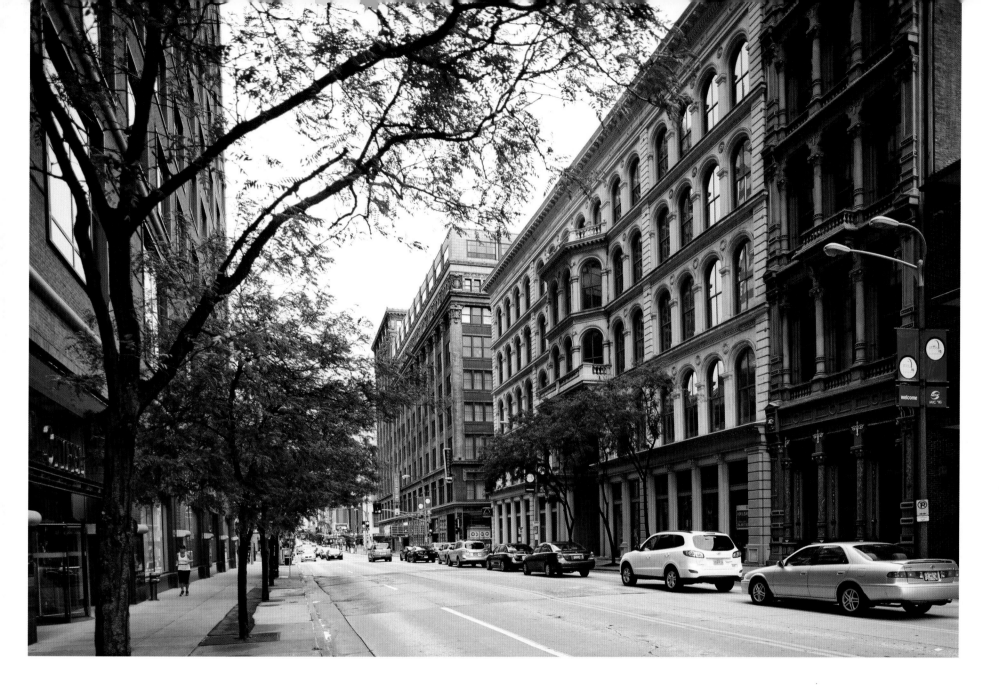

LEFT: West of Sixth Street, circa 1891. These blocks were partially developed in the heyday of Lucas Place in the 1860s as an elite residential enclave. But the opening of the Eads Bridge increased traffic in the 1870s and made the area eminently more valuable to business. By the 1890s, the city was electrified, and electric trolleys and streetlights were beginning to replace mule-drawn streetcars and gas lamps. The luxury Lindell Hotel, built in the 1860s, is decorated here for the Veiled Prophet Parade.

ABOVE: Washington Avenue, the first wide street in St. Louis, remains one of downtown's two major east-west thoroughfares. The view was blocked for almost twenty-five years by the St. Louis Centre sky bridge connecting to Dillard's Department Store, and a street party took place when the last of it came down in June 2010. Many great old buildings from the turn of the century remain, such as the original Bradford-Martin (1898) with the arched windows on the right (today the 555 Washington Building) facing off against late twentieth century high-rises like One Financial Plaza (1985). In 2016, the National Blues Museum opened at street level in the department store building (now hotel and apartments), seen just beyond 555 Washington Avenue.

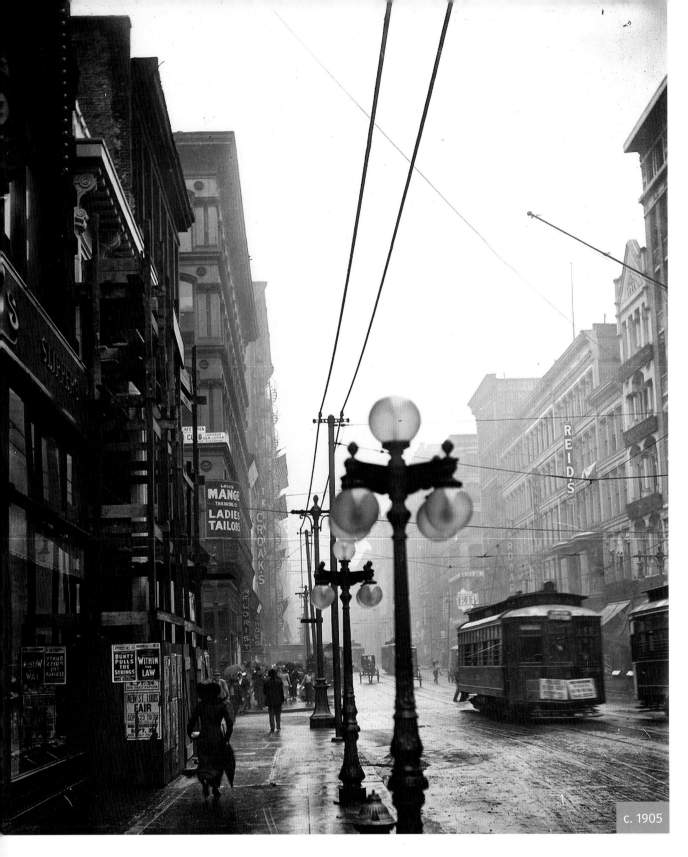

c. 1905

WASHINGTON AVENUE / AMERICA'S CENTER

Previously the center of St. Louis' wholesale business

LEFT: Washington Avenue looking west from Seventh Street in the early 1900s. By the turn of the century, Washington Avenue had become St. Louis' wholesale and manufacturing row. In 1897, the Businessmen's League of St. Louis claimed that "compared with the United States, St. Louis has the largest brewery, shoe factory, saddler market, streetcar factories, and hardwood lumber market."

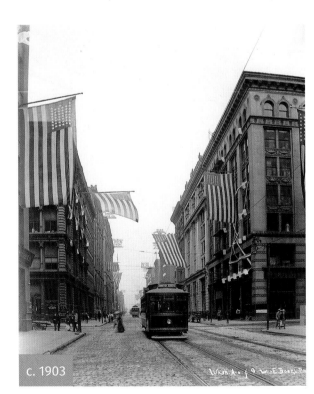

c. 1903

RIGHT: Today, this stretch of Washington between Seventh and Ninth is the southern face of the America's Center convention complex which covers 32 acres of the north side of downtown. Behind it lies the Dome at Convention Center, a massive contemporary stadium covering 14 acres and seating almost 65,000. Gyo Obata of Hellmuth, Obata, and Kassabaum broke the strict rectilinear lines of the canyon of Washington Avenue with a curved entrance to the convention center. Both facilities were completed in the 1990s following a resurgence in convention traffic. The beautiful Hotel Lennox (1929) with its twenty-five-story mural (1990s) can be seen rising to the west and is today part of the Marriott St. Louis Grand Hotel complex.

LEFT Washington Avenue west from Ninth Street, circa 1903, captured by Emil Boehl, who photographed hundreds of St. Louis streets, buildings and landmarks between 1870 and the early 1900s.

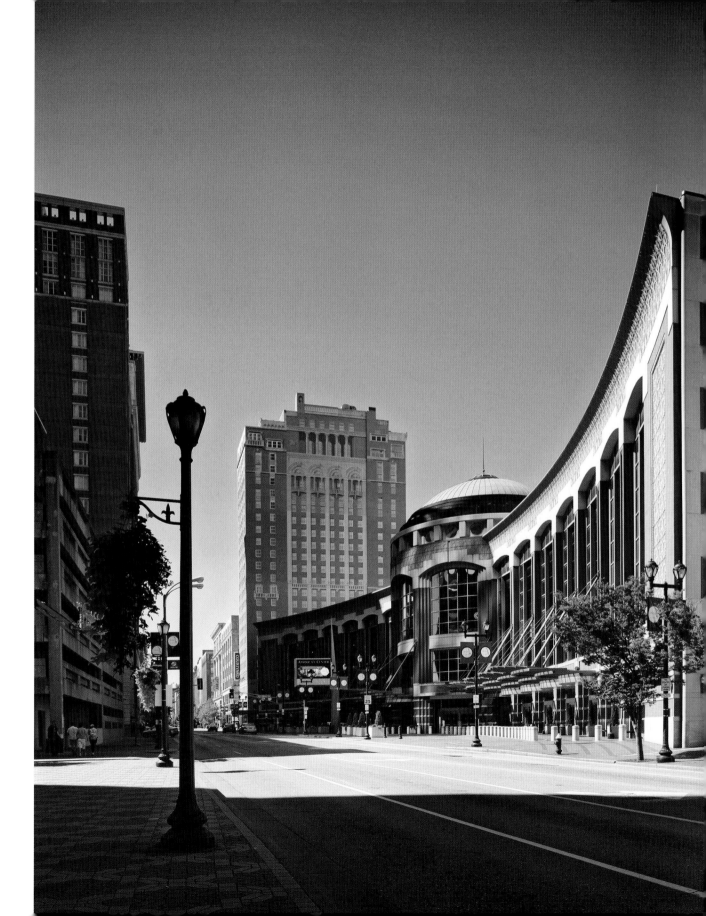

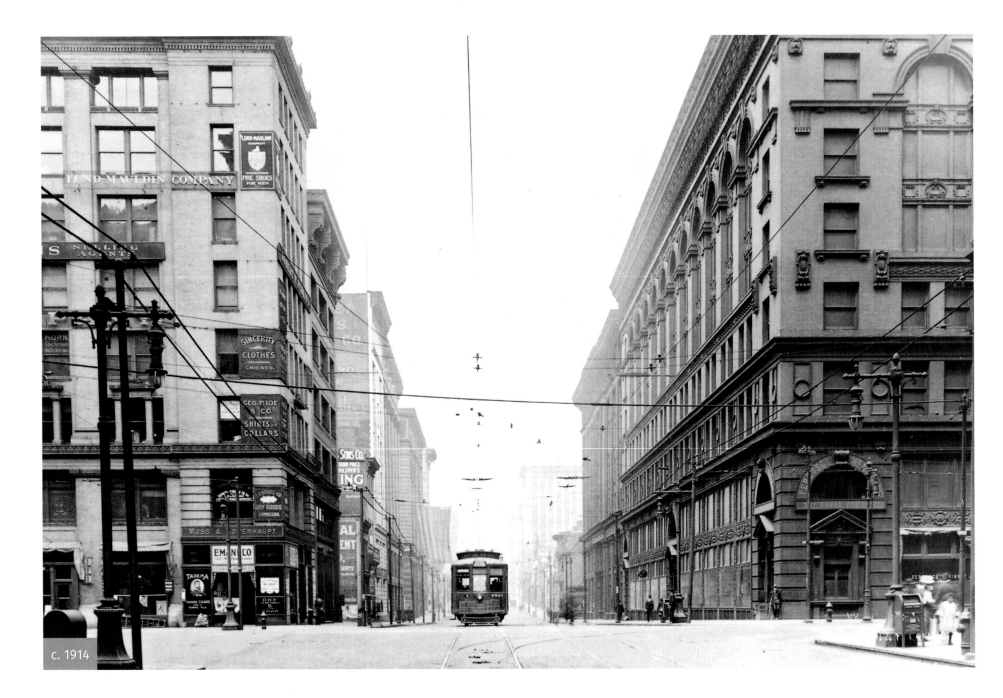

c. 1914

THE GARMENT DISTRICT
Now "loft central" in downtown St. Louis

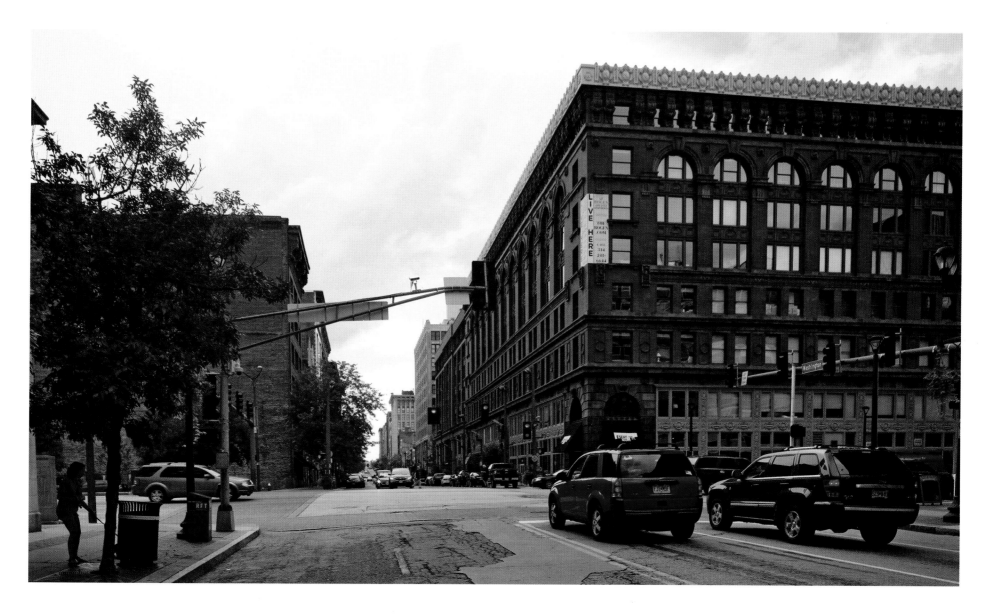

LEFT: Washington Avenue from Twelfth (Tucker), circa 1914. Known at this time as Wholesalers' Row, Washington from about Eighth westward, presented a unified face of robust, turn-of-the-century, eight- to twelve-story buildings, filled with wholesalers and manufacturers. A popular saying held that St. Louis was, "First in shoes, first in booze, and last in the American League" (this last a reference to the poorly performing St. Louis Browns baseball team). Washington featured most of the "shoes," and as the century progressed, ready-made clothing became a particular specialty of this district. The monumental structure on the right, constructed in 1903, was designed for the Lesser-Goldman Cotton Company by Eames and Young.

ABOVE: Thanks most likely to the longevity of the garment businesses, Washington Avenue is the best-preserved section of early twentieth-century St. Louis. Most of these solid old buildings have never ceased to be inhabited, or if so, for only a short span of time. Today, while some of the remnants of the old-timers remain (shoe, hat, and clothing stores), this neighborhood is undergoing a fast-moving renaissance. Old garment factories have been converted into artists' lofts and offices, fiber optic cables run beneath the street, and the storefronts are filled with nightclubs and restaurants in what has become "loft central" in downtown St. Louis.

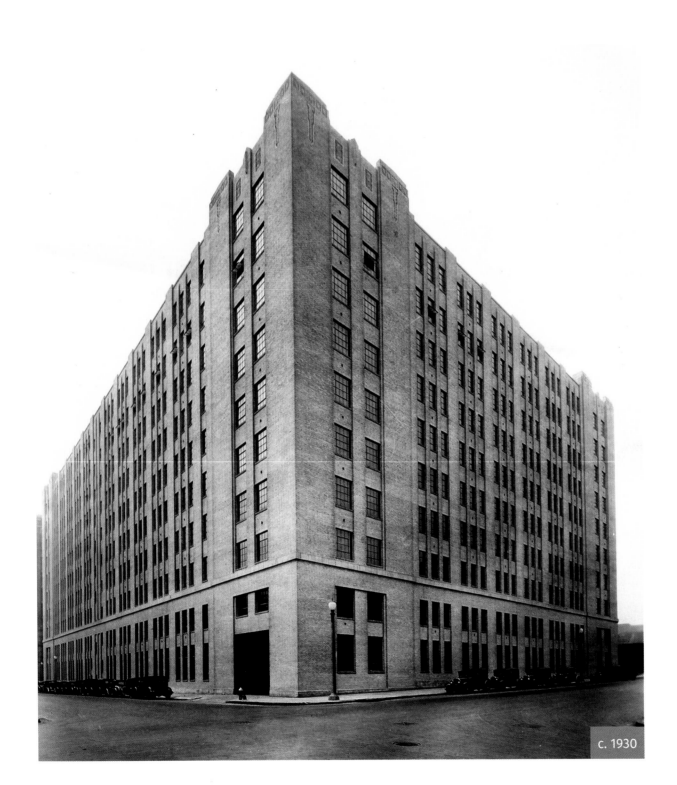

c. 1930

INTERNATIONAL SHOE / CITY MUSEUM

From a shoe building to a chute building

LEFT: On August 2, 1911, the *St. Louis Republic* reported that Roberts, Johnson, and Rand Shoe Company had merged with Peters Shoe Company to form International Shoe. With eighteen factories and 8,500 employees, it was the largest company of its kind in the world. During the first two decades of the twentieth century St. Louis evolved from distributing shoes produced in the East into the largest manufacturer of boots and shoes in the U.S. By the mid-1920s shoes had become the city's largest industry and International Shoe was the leader with overseas exports to Hawaii, Europe, Central and South America. Their production reached an all-time high in 1929 of fifty-four million pairs of shoes. In 1930, International Shoe Company constructed this 600,000-square-foot factory annex adjoining the national headquarters, which faced Washington Avenue, "Shoe Street" in St. Louis.

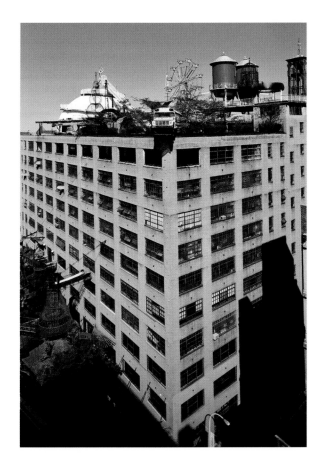

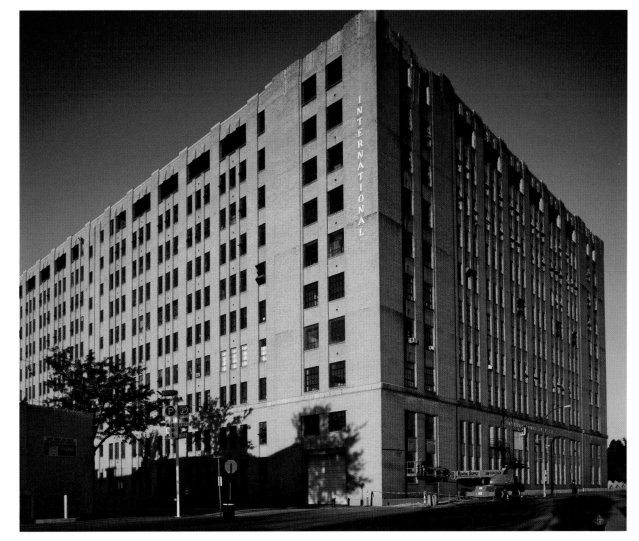

ABOVE AND LEFT: A young Tom Williams (before adopting the pen name Tennessee) went to work in this building in 1932, later naming the lead character in his Pulitzer Prize-winning play, *A Streetcar Named Desire*, for co-worker Stanley Kowalski. International Shoe celebrated the fiftieth anniversary of its founding in 1948 as the world's largest manufacturer of shoes with 32,000 employees in eight states. In 1960 it evolved into Interco and left behind an obsolete warehouse. Today, the International Building is St.

Louis' wildly imaginative City Museum, a sprawling, ten-story phantasm of indoor/outdoor play space, loft apartments, and one of the world's largest collections of found art. It's the concept of St. Louis sculptor Bob Cassilly and a devoted crew that shared his artistic vision. They began creating it with him in 1995, and have expanded upon it since his death in 2011. It is a warren of aboveground caves, subterranean crawl spaces, crazy outdoor climbing structures, and dizzying slides.

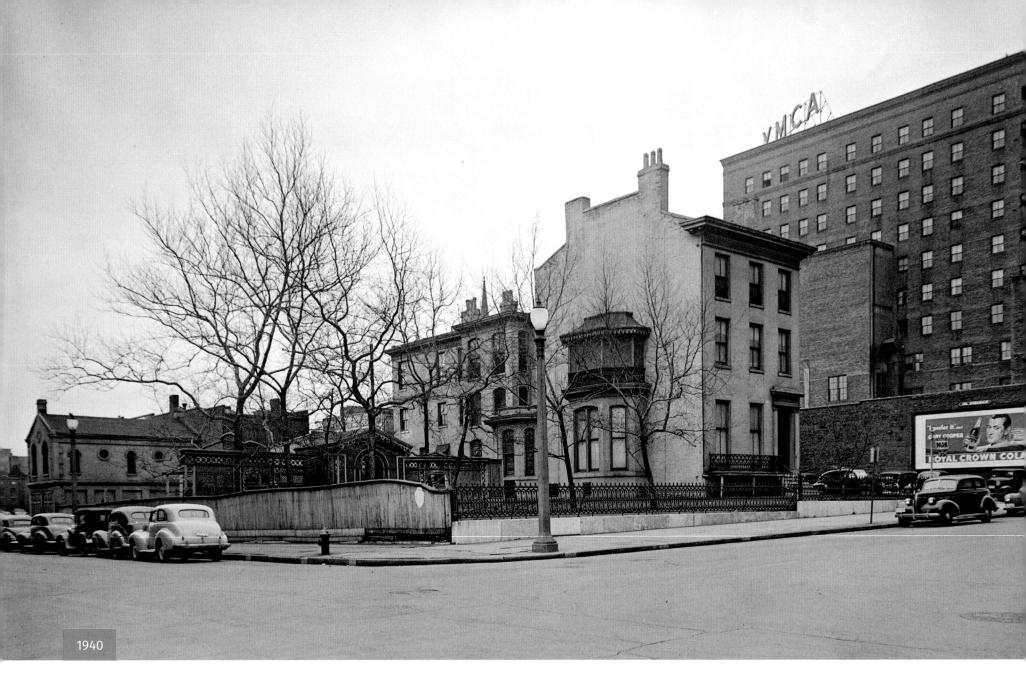

1940

CAMPBELL HOUSE
One of the most authentically furnished houses of its era

ABOVE A photograph of the Campbell House, past its heyday, in 1940. Built in 1851, the mansion stood on the newly formed Lucas Place, the most exclusive residential enclave at that time and the city's first private street. Irish-born Robert Campbell and his wife purchased the home in 1854. Campbell was a prosperous businessman—a partner with William Sublette in the Rocky Mountain Fur Company, as well as a merchant provisioner of wagon trains and a banker—and his wife Virginia was famous for her hospitality. Many notable people of the era visited their home, including President and Mrs. Ulysses S. Grant, General William Tecumseh Sherman, and James Buchanan Eads, engineer of the great St. Louis bridge. The downtown YMCA Building constructed in 1926 looms over the house to the west.

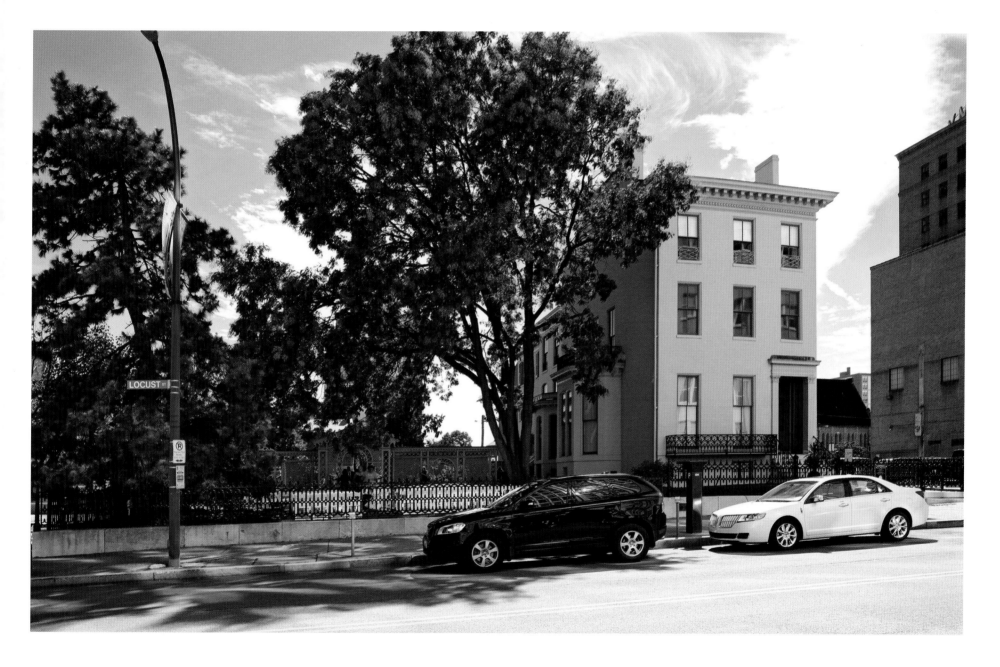

ABOVE: Today, on Locust Street, the Campbell House stands as the sole survivor of once-elegant Lucas Place. Now a museum beautifully restored to the way it looked in the 1880s the home is a marvel of preservation, thanks in part to the tragic family history. Robert and Virginia Campbell had thirteen children, but only three lived to adulthood. After the youngest brother died of pneumonia in his Paris apartment at age thirty, the two remaining sons became virtual recluses, living out their days well into the twentieth century in the family home, as commercial buildings sprouted around them. They altered hardly a thing, and the museum now contains most of the original furnishings—from chandeliers and carpets, to silverware and china, to the original horse carriages.

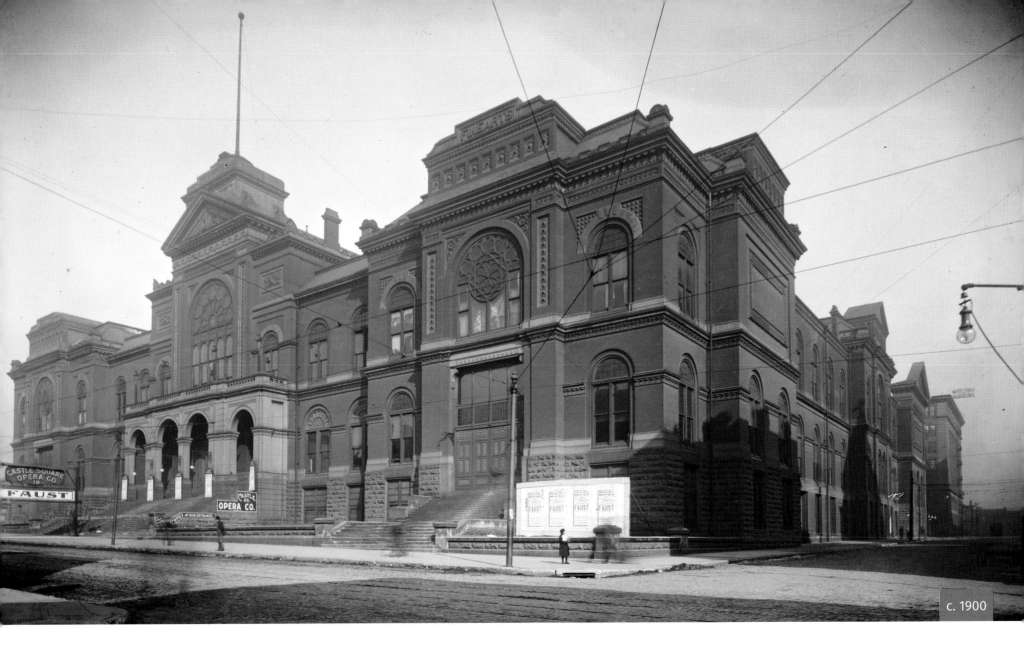

c. 1900

EXPOSITION HALL / ST. LOUIS PUBLIC LIBRARY

Before the World's Fair, the city held an annual exposition here

ABOVE: Missouri Park once divided exclusive Lucas Place from the city, but in the 1880s the heirs of Judge Jean-Baptiste Lucas allowed the city to use the parkland for an exhibition hall. Built in just over a year and opened in 1884, the Exposition and Music Hall served as the site of the new, annual St. Louis Exposition. The music hall hosted some of the biggest bills of the 1880s, including John Philip Sousa's band and the national Saengerfest (singer festival). The Exposition Hall was also the scene of the Democratic Presidential Convention, both in 1888 and 1904. The stage alone could seat 1,500 people and was for a time home to the St. Louis Symphony Orchestra.

c. 1915

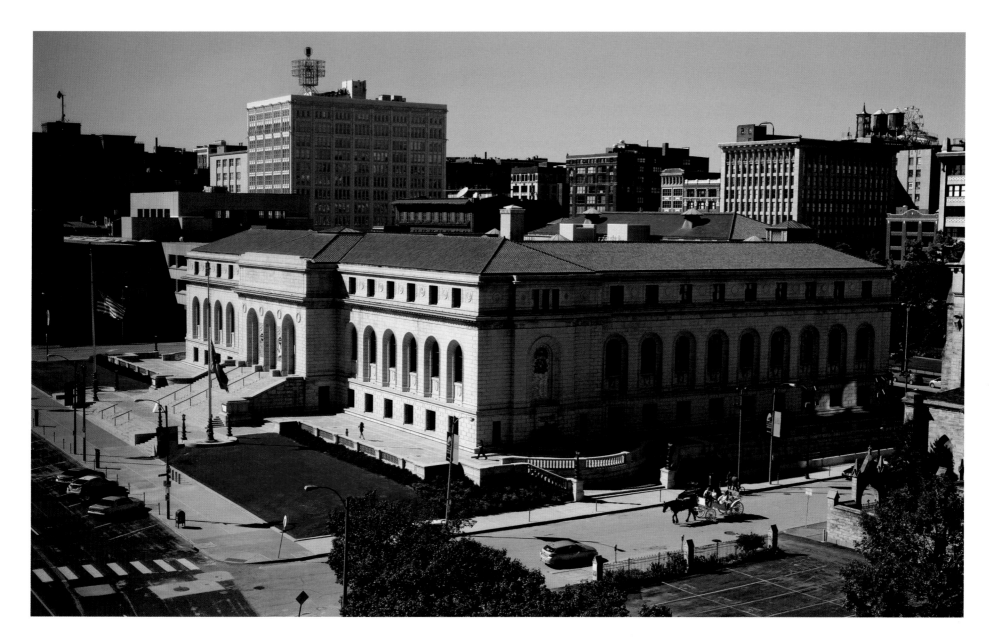

ABOVE: Today, in its place stands the Central Building of the St. Louis Public Library. By the turn of the twentieth century, the St. Louis Expositions were likely to be discontinued, despite their success. It appeared the hall would be razed, and the site would revert to parkland. In 1902, however, steel magnate Andrew Carnegie donated one million dollars for a St. Louis library system, provided the city would supply the land. The Exposition Hall site was now approved for library construction. Architect Cass Gilbert designed this lovely public building with its clean Italian Renaissance lines. It opened in 1912. From 2010-2012 the central library building underwent a restoration and renewal project under the direction of Cannon Design that brought Gilbert's magnificent 1912 structure fully into the twenty-first century and added 40,000 square feet of public space with a new north wing. City Museum's rooftop amusement park can be seen in the distance on the right.

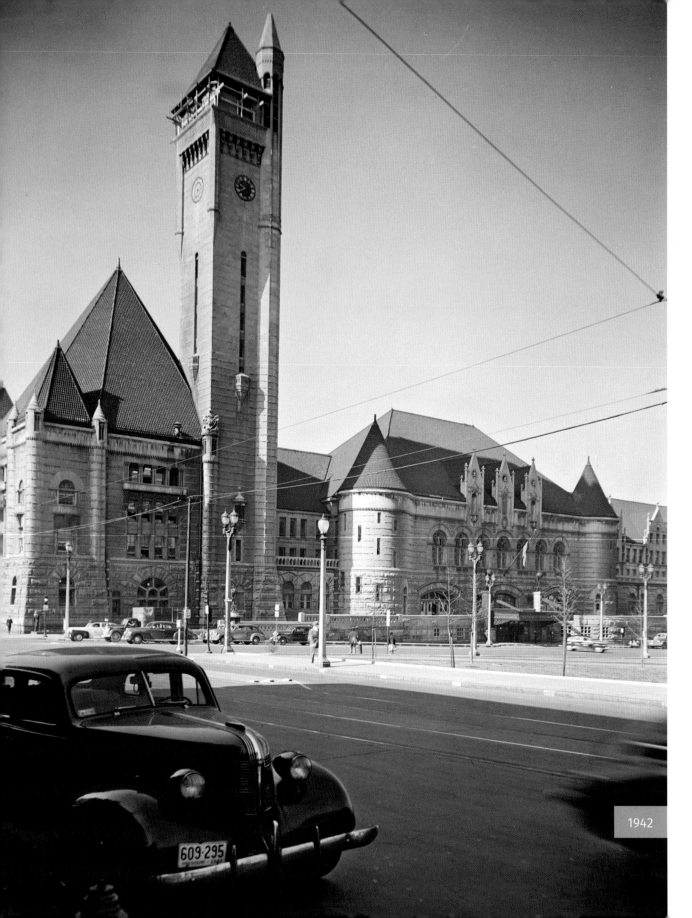

1942

UNION STATION
The last train left in 1979

LEFT: When completed in 1894, St. Louis Union Station was the nation's largest single-level passenger rail station. By the turn of the century, it was also one of the busiest. More railroads (twenty-two) converged at St. Louis than at any other point in the United States. Architect Theodore Link designed the main hall in a Richardsonian Romanesque style, with sturdy stonework and massive arches. Behind this Romantic exterior lay a thoroughly modern terminal that could accommodate 260 trains on forty-one tracks and 100,000 people a day. The yard was covered by George Pegram's elegant metallic train shed, which maximized natural light.

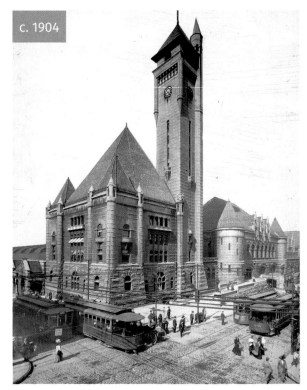

c. 1904

RIGHT: Along with the Eads Bridge, Union Station was a signature landmark of St. Louis until the construction of the Gateway Arch. It suffered the same fate as the railroads in the automobile age. The last train left the station in 1979 and the terminal lay dormant for seven years until the nearly $150 million restoration project was completed in 1985. Today, Union Station bustles once again, a tourist destination and a successful example of adaptive re-use as a "festival marketplace." The luxury station hotel was completely renovated, and the terminal converted into shops and eateries. In 2016, Lodging Hospitality and Management, the owners of Union Station, announced plans to construct a one million gallon aquarium and half-million gallon shark tank in the largest single-span train shed ever built.

LEFT: Though medieval in design, Theodore Link's handsome clock tower housed a modern air-conditioning system.

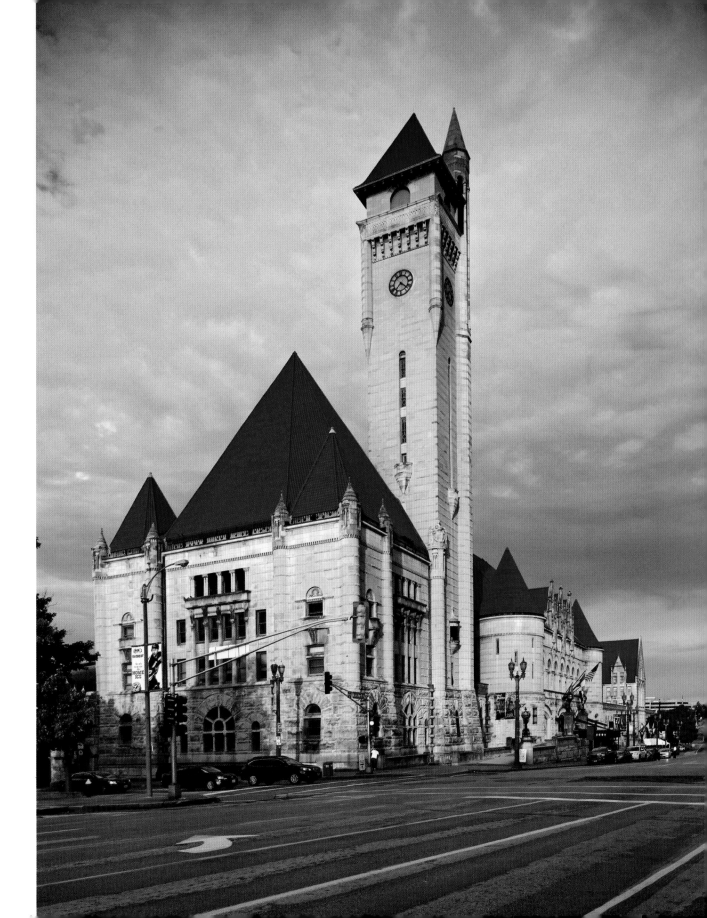

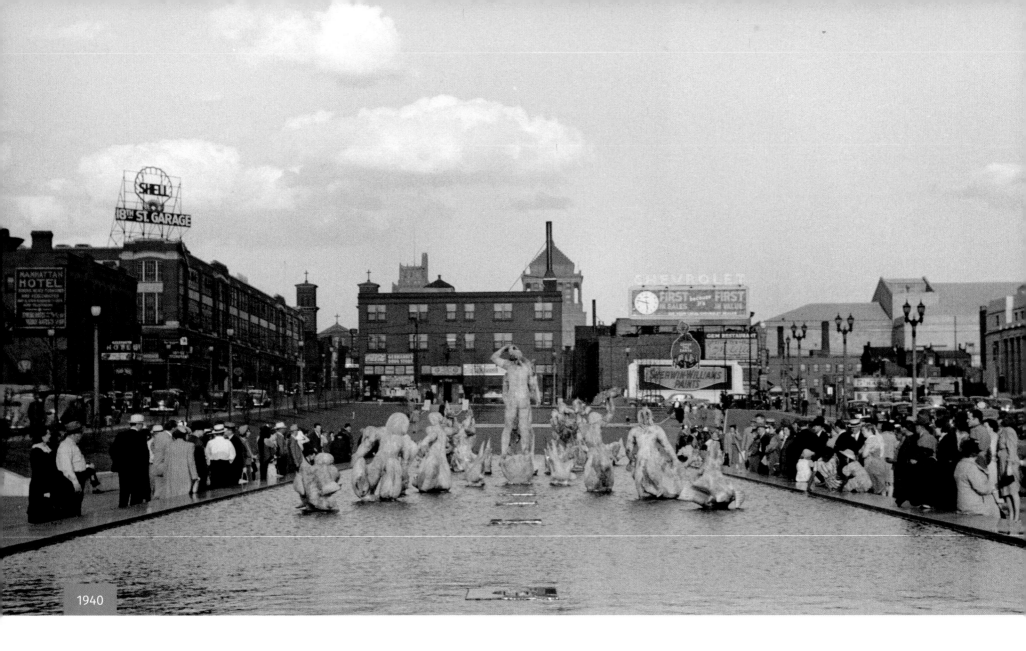

1940

MEETING OF THE WATERS FOUNTAIN

An epic fountain to celebrate two mighty rivers

ABOVE: The view is to the east from Aloe Plaza, between Eighteenth and Twentieth streets. People gather around the city's newest and most controversial fountain. Swedish-born sculptor, Carl Milles fashioned the bronze figures to commemorate the founding of St. Louis on the first elevated site below the confluence of the Mississippi and Missouri rivers. He sculpted the Mississippi, Father of Waters, as a powerful young male in the prime of life and the Missouri as a beautiful young woman, reminiscent of Botticelli's *Venus Rising*. Twelve fanciful creatures akin to the Naiads of Greek mythology represent the streams and tributaries of the two great rivers. It was unveiled in 1939. The pyramidal roof of the Civil Courts Building can barely be seen in the distance as the older buildings east of Aloe Plaza have yet to be cleared for the grassy mall.

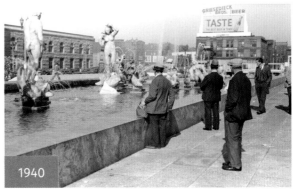

1940

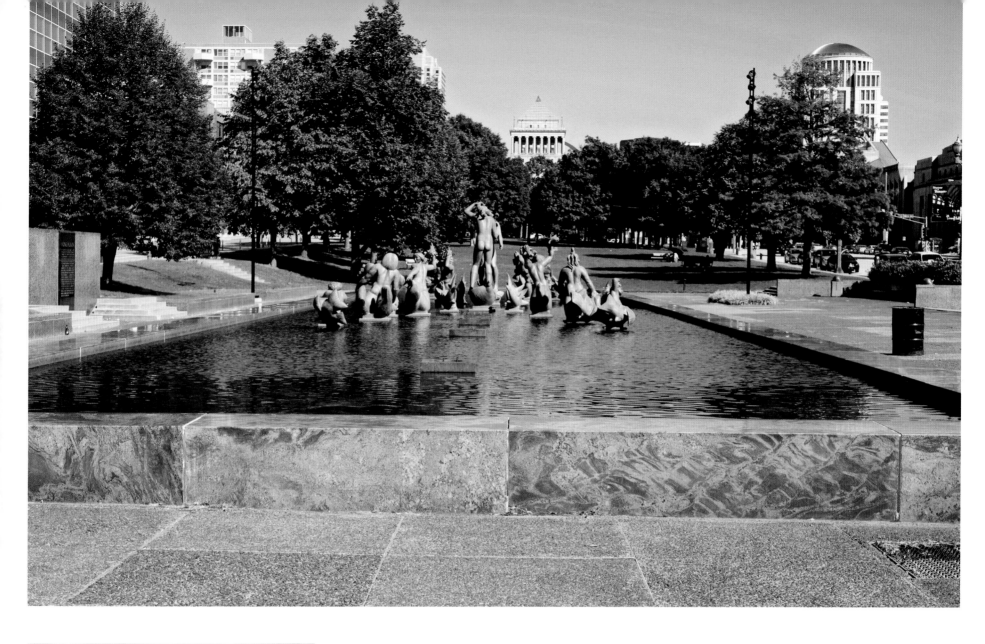

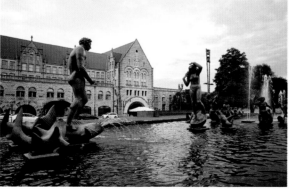

ABOVE: Although Milles' bronze nudes were considered scandalous by some when unveiled in 1940 they became one of the most endearing works of public art in St. Louis. The *Meeting of the Waters Fountain* is today a favorite backdrop for wedding photographs and social gatherings. Designed as a fountain, the figures are frequently viewed in bright sunlight with rainbows arcing over them. Commissioned specifically for the City of St. Louis the only copy is the artist's working model in the Milles Garden in Stockholm. The Gateway Mall has been evolving as a green space, a central park area of courthouses, monuments, and sculpture for decades. It is bordered by Market Street on the south, Chestnut Street on the north and stretches from the Mississippi riverfront in the east to Twentieth Street in the west. The elegant headhouse of Union Station across from Aloe Plaza can be seen in the photograph on the left.

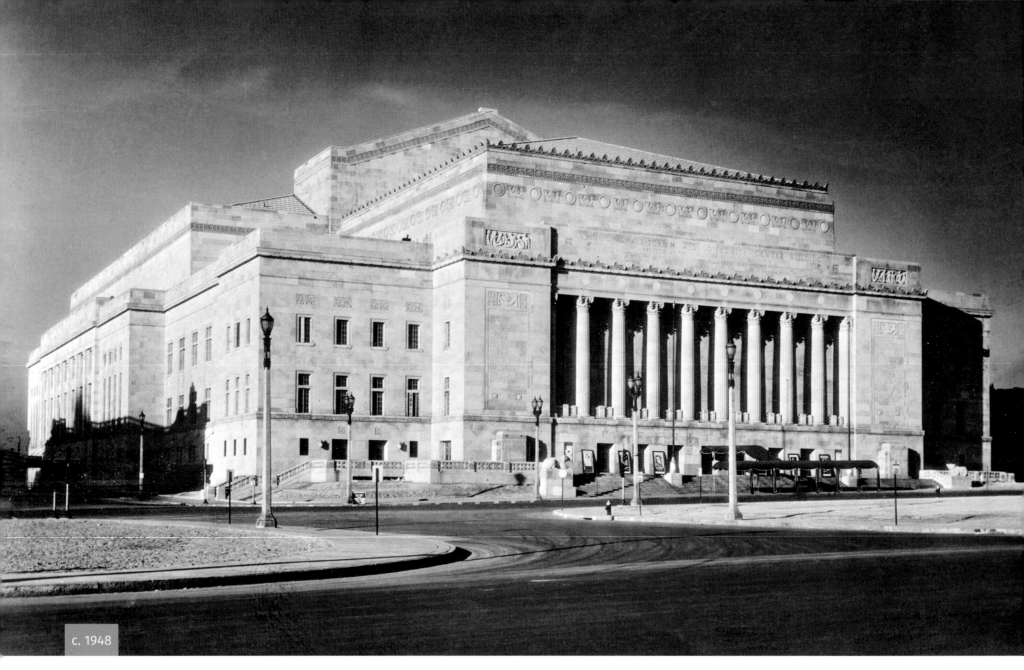

c. 1948

KIEL OPERA HOUSE / PEABODY OPERA HOUSE

A magnificent venue recently revived

ABOVE: On October 15, 1899, Frankie Baker shot and killed her eighteen-year-old lover, Allen Britt, during an argument about his two-timing her with a legendary beauty named Alice Pryor. Street balladeer Bill Dooley immortalized the incident with a song that became known worldwide as *Frankie and Johnny*.

This incident took place at 212 Targee Street, which ran right down the middle of what would become the Municipal Opera House/Kiel Opera House. The Municipal Opera House and Auditorium took the role of the older Coliseum building and represented St. Louis' participation in a national, City Beautiful movement

to revitalize decaying urban areas. It opened in 1934 with a production of *Aida* in the 3,600-seat Opera House just before construction began on the 11,500-seat Convention Hall next door. It was renamed Kiel Auditorium in 1943 to honor Henry Kiel, the first St. Louis mayor to serve three consecutive terms.

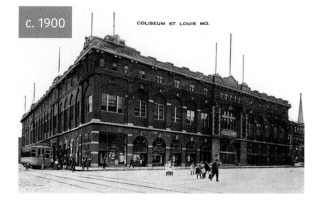

c. 1900

COLISEUM ST LOUIS. MO.

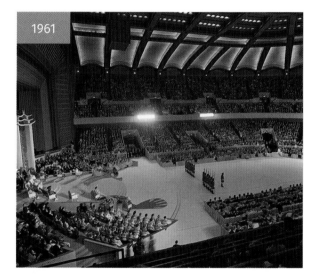

1961

TOP: The Municipal Opera House and Auditorium replaced in popularity an earlier, enormous venue known as the Coliseum. Constructed in 1908 over Uhrig's Cave at Jefferson and Washington avenues, the Coliseum could hold 20,000 people attending various concurrent events.

ABOVE: Interior of the Kiel Auditorium in 1961, staged for the Veiled Prophet Ball, an elite formal gala during which young debutantes had been introduced into St. Louis Society since 1878.

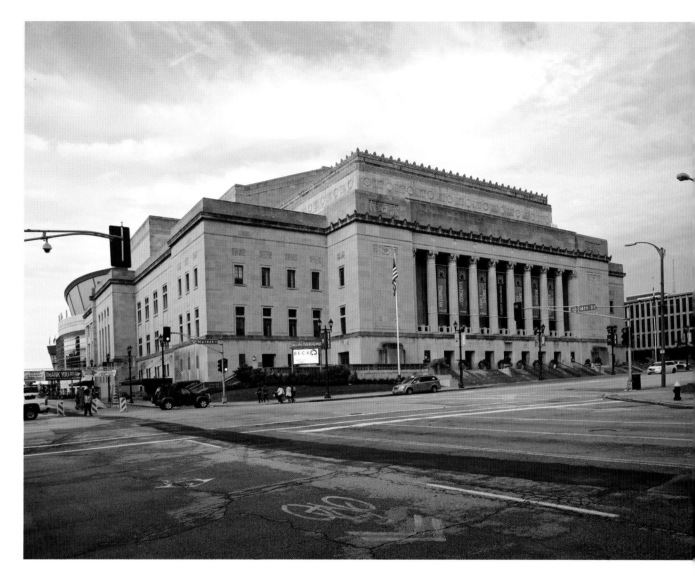

ABOVE: Today it is known as the Peabody Opera House, shown here with the Scottrade Center in the rear of the photograph adjoining it. Legendary performers from Frank Sinatra, Judy Garland, and Duke Ellington to Elvis Presley and the Rolling Stones have headlined at the venue. Before the auditorium went dark in 1991 it was home to the St. Louis Symphony Orchestra for over thirty years. In 1991 the enormous convention hall, where political rallies, sports tournaments, and the elite Veiled Prophet Ball had been held, was demolished. It was replaced in 1994 with a 19,150-seat arena, designed by Ellerbe Becket of Kansas City, which is home to the St. Louis Blues Hockey Team. The Opera House reopened in 2011 with financing from Peabody Energy.

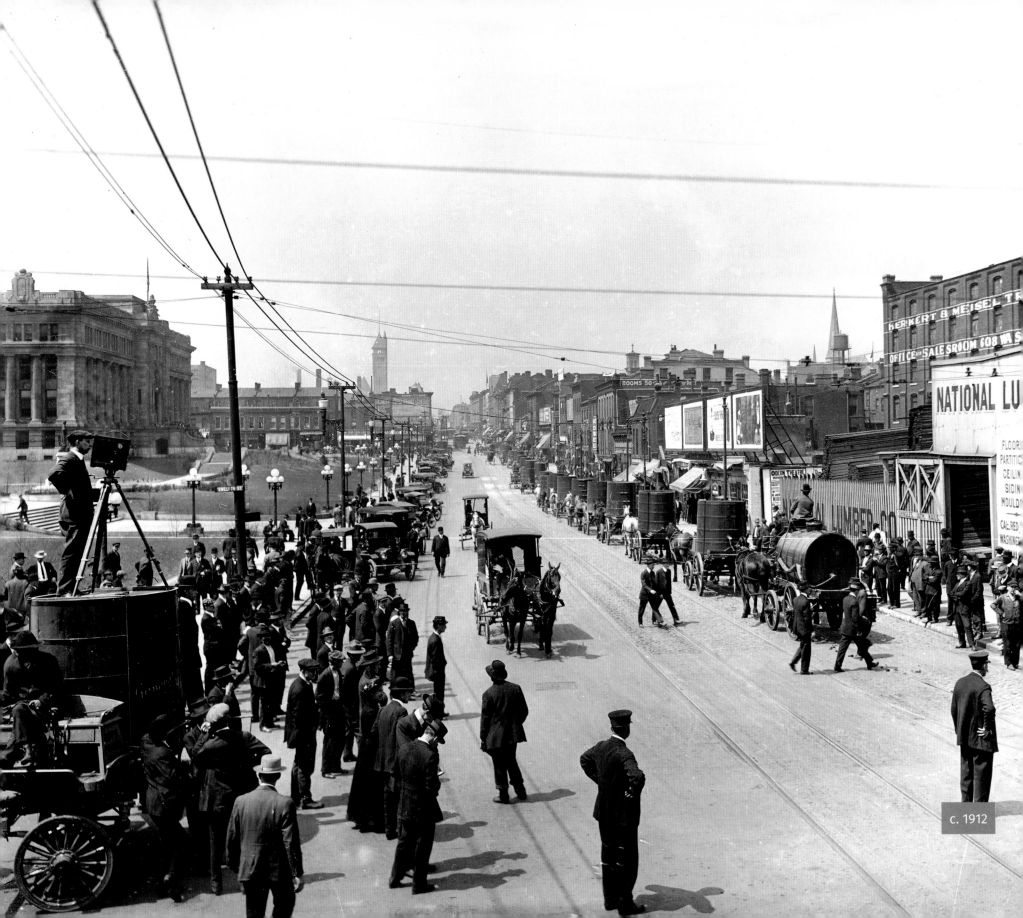

c. 1912

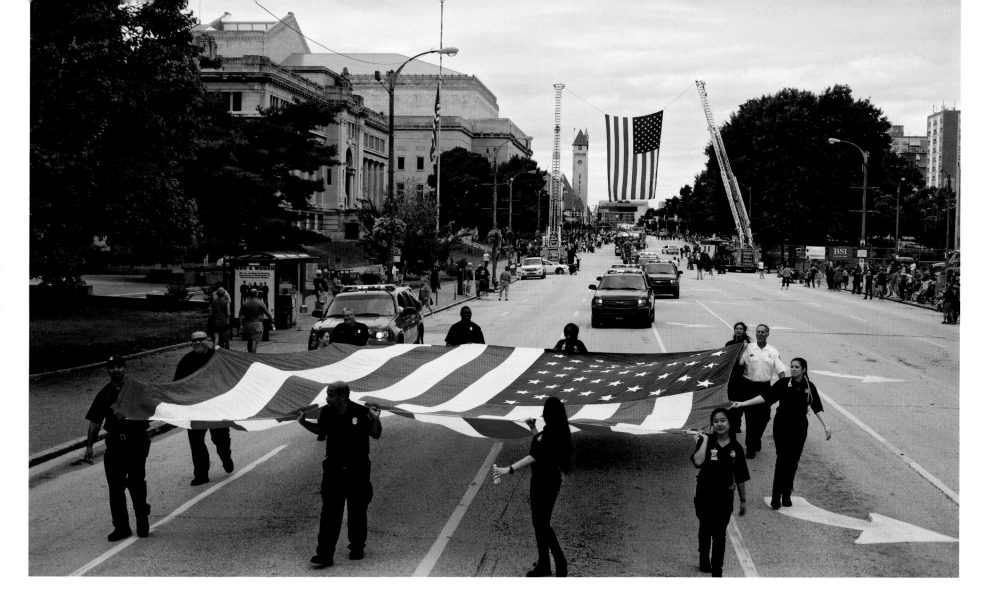

MARKET STREET
The oldest street in St. Louis

LEFT: Market Street was the first road in St Louis and for a time the most commercial. Originally called Rue de La Place it was the only road that led from the village down to the river until 1817. It bordered Place d'Armes, the grassy square on which the militia drilled, villagers exchanged crops, and held festivals. It also bordered the fur trading post of Maxent, Laclède & Company. In 1904, the world came to St. Louis. Travelers from thirty-five nations and across the United States exited an elegant Union Station into a hodgepodge market place that stretched endlessly west from the Mississippi. The handsome Beaux Arts-style Municipal Courts building on the left was competed in 1911, the clock tower of Union Station visible in the distance was built in 1894.

ABOVE: After St. Louis' Civic Center was completed in 1935, a widened Market Street became parade central. Except for construction of the Old Courthouse on a prominent hill overlooking the Mississippi, the city had evolved without a civic plaza. In 1923, having seen what could be possible with the World's Fair in Forest Park, St. Louisans passed, what was then, the largest bond issue in U.S. history for clearance and urban renewal. Over the next decade everything in the photograph on the left, on the north side of Market Street was leveled and replaced with parks and monuments. Federal buildings including the metropolitan area's largest post office and the Municipal Auditorium and Opera House opened on the south side. The Great Fire Engine Rally takes place during an annual weekend devoted to firefighters and their families.

ST. LOUIS CITY HALL
Modeled on the Hôtel de Ville in Paris

c. 1915

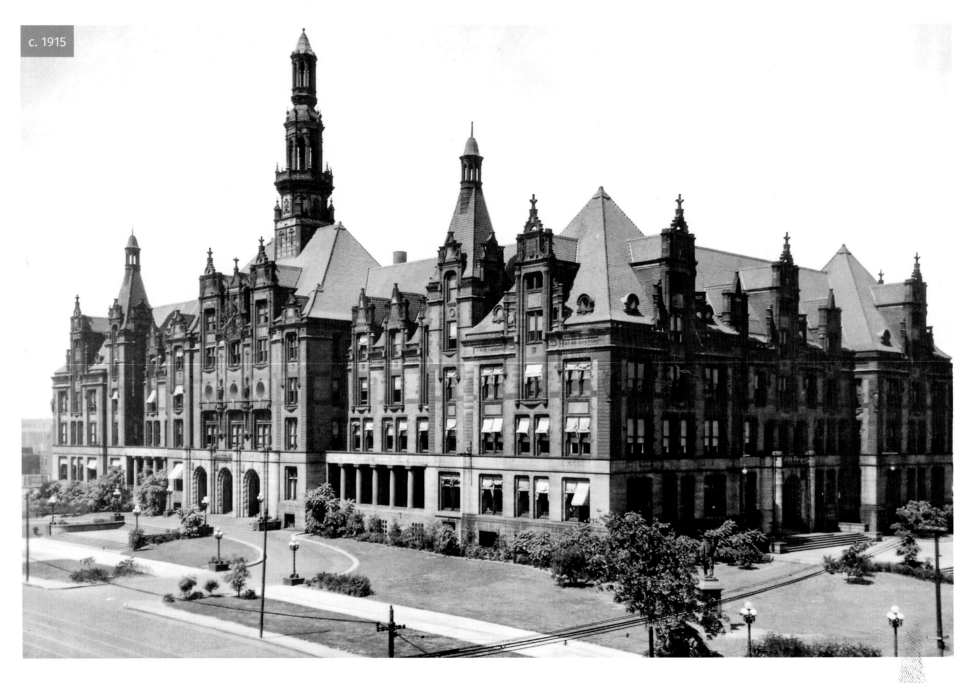

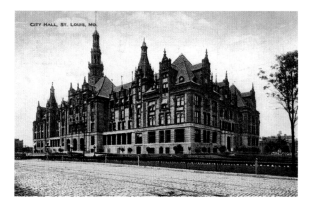

OPPOSITE: A national competition was held to design the St. Louis City Hall, and architect Harvey Ellis, then of Eckel & Mann in St. Joseph, Missouri, won with this French Renaissance creation. Modeled on the Hôtel de Ville, the Paris city hall, the building was completed in 1896 to great acclaim. The interior houses a four-story court, completed in 1904. A statue of long-time St. Louisan, Ulysses S. Grant by Robert Porter Bringhurst stands in the northeast corner of Washington Square Park adjacent to City Hall. After leading the Union to Civil War victory, Grant became the eighteenth U.S. president.

BELOW: Today, this block along the corner of Tucker (Twelfth) Boulevard and Market Street is subtly changed from a century ago. The grassy lawn has been minimized to make way for parking and a broader Market Street. The towers and finials on the roofline, integral parts of Ellis' design, were removed in 1936, victims of the changing fashion. Over a century after its completion, the building still functions as the City Hall, housing the offices of the mayor and city council. The first two stories are constructed of lovely rose granite, quarried in the state of Missouri. The interior four-story court is the site of an annual Mardi Gras Ball hosted by the mayor.

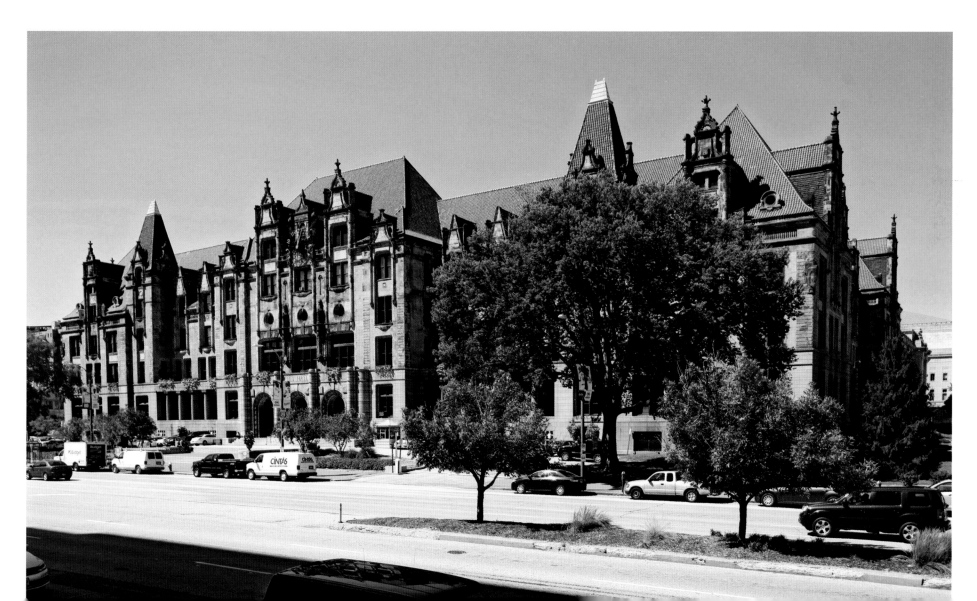

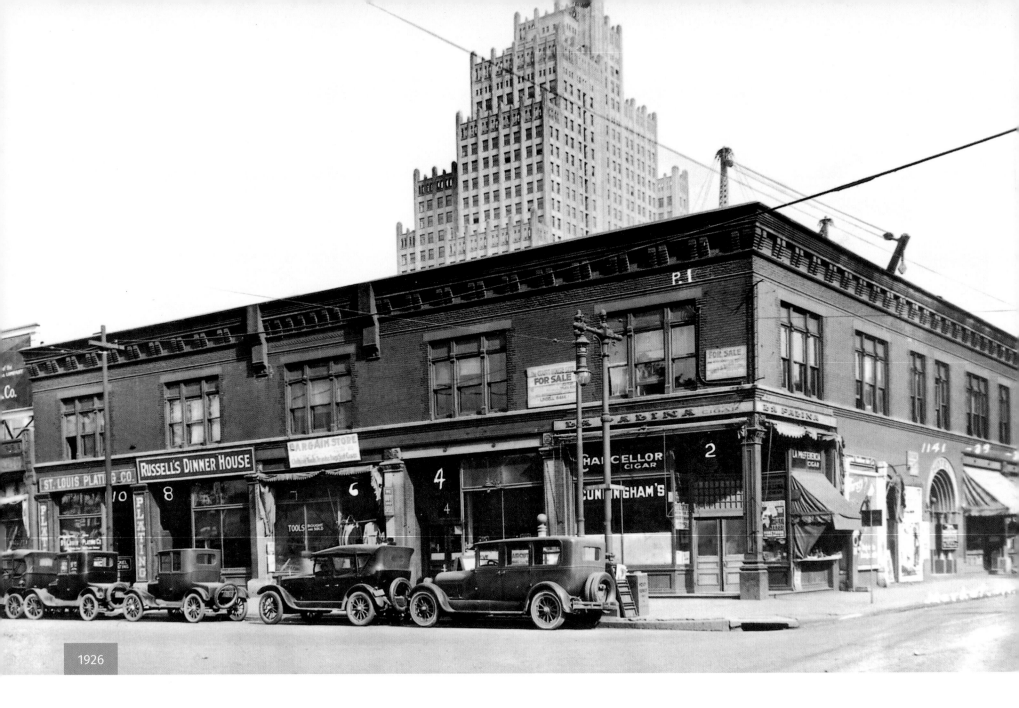

1926

TUCKER AND MARKET STREETS

Market was widened to create a grand avenue

ABOVE: When Pierre Laclède founded St. Louis, the limestone bluff along the river afforded one opening onto a sandy levee. That east-west gap became Market Street, a bustling commercial street throughout St. Louis' history. By the 1920s, merchants were clamoring for the widening of Market Street, and the city needed land for a

courthouse. Looming over the older row of storefronts, stands the modern Bell Building at 1010 Pine. Completed in 1926, with striking set-backs and a particular Art Deco style described as "skyscraper Gothic," the Bell Building was then the tallest building in the city.

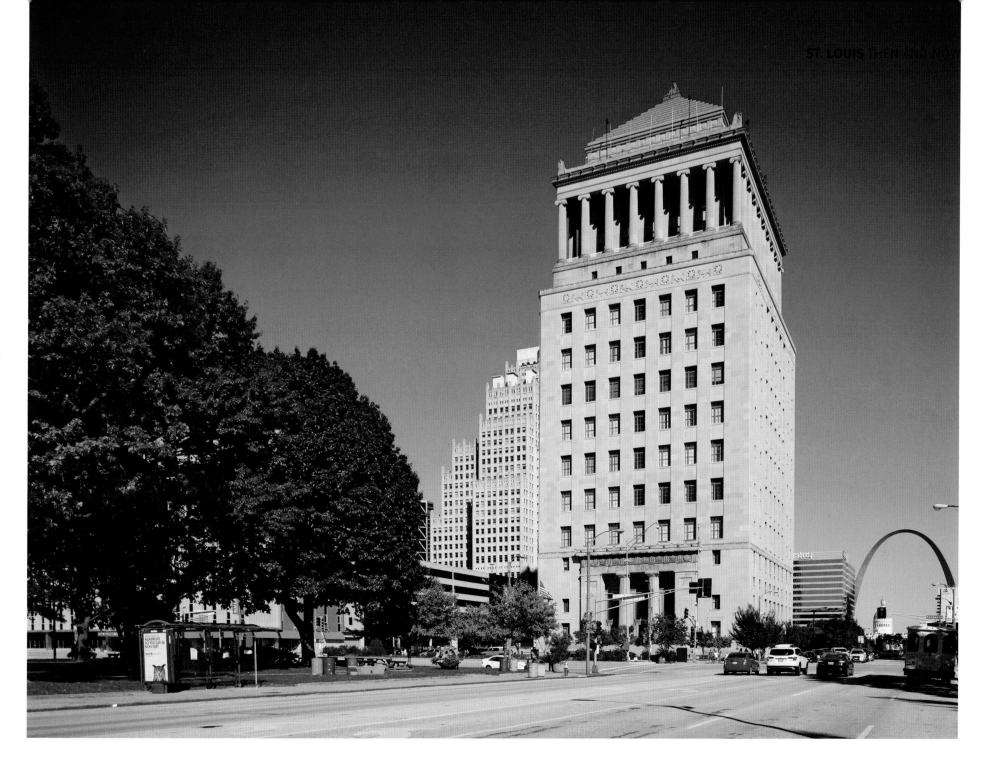

ABOVE: The block of mostly low-rise, nineteenth-century buildings between Chestnut and Market was torn down. Market was widened, making it St. Louis' natural route for parades and festivals. Indeed, the hand lettering on the vintage photo may well have been part of the eminent domain process for acquiring the buildings before they were razed. Blocking the view of the 1010 Pine Building, a new Civil Courts Building was erected in 1930. In style it is the architects' Klipstein & Rathmann's vision of what the tall tomb of King Mausolus of Caria looked like, complete with pyramid on top.

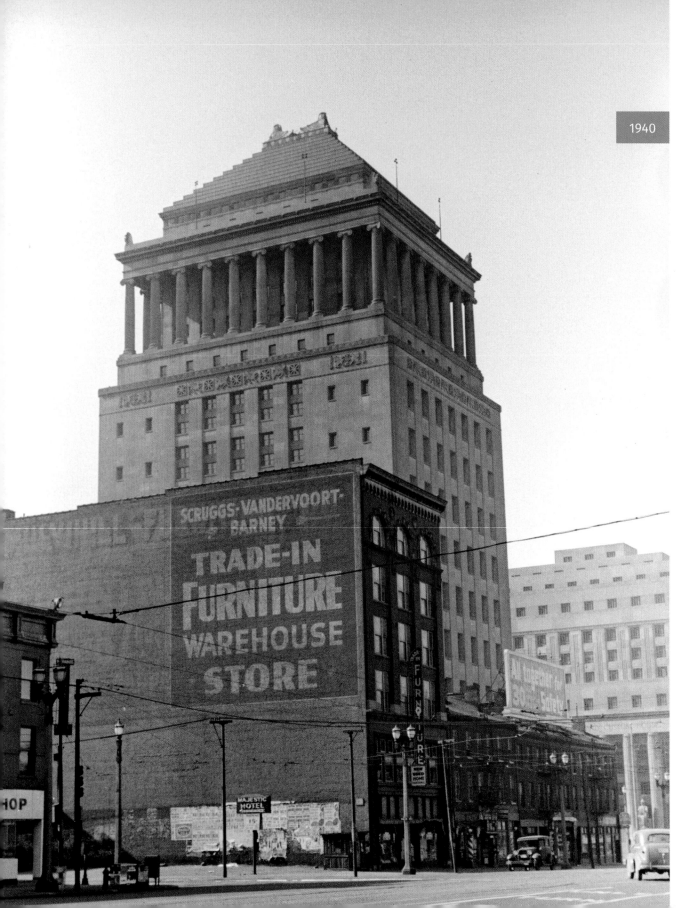

CIVIL COURTS BUILDING

At the heart of St. Louis' "legal campus"

LEFT: The southern end of a row of stores that faced N. Twelfth Street at Market Street were replaced by the Civil Courts Building, which went up in 1930. In this photo the northern end remains intact providing a sharp distinction between it and the older commercial buildings that lined and bordered Market Street for decades. It was designed by Klipstein & Rathmann of St. Louis to resemble the Mausoleum at Halicarnassus. Unlike the chariot drawn by four horses, which crowned the pyramid on top of Mausolus' tomb, the cast-aluminum step pyramid atop the Civil Courts Building has griffin sphinxes just visible in the photograph— one facing east and one facing west. Sculptor Steven Rebeck crafted them with human faces. The columns of a new U.S. Court House and Custom House can be seen in the distance across Market Street.

RIGHT: Today, the view southeast from Tucker Boulevard (formerly Twelfth Street) and Pine Street is all about legal justice in downtown St. Louis with three fully functional courthouses—civil, circuit, and federal —and a law school filling the photograph. Everything commercial has disappeared from view. The newest and tallest of these (the building with the dome) is the Thomas F. Eagleton U.S. Courthouse, although the topography gives the illusion of the Civil Courts topping it. It's the largest single courthouse in the nation. In 2013, St. Louis University moved its School of Law from the Frost Campus in Midtown to the building across the street from the Civil Courts. Established in 1842, the oldest law school west of the Mississippi is once again central to government with City Hall one block west of the photograph and the Missouri Court of Appeals in the Old Post Office building five blocks to the north.

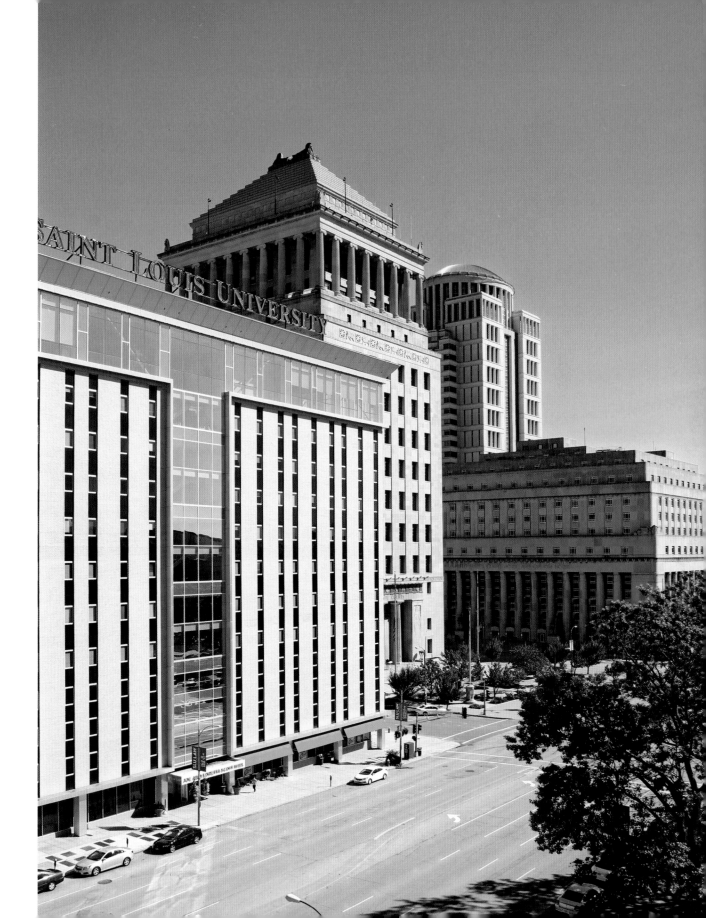

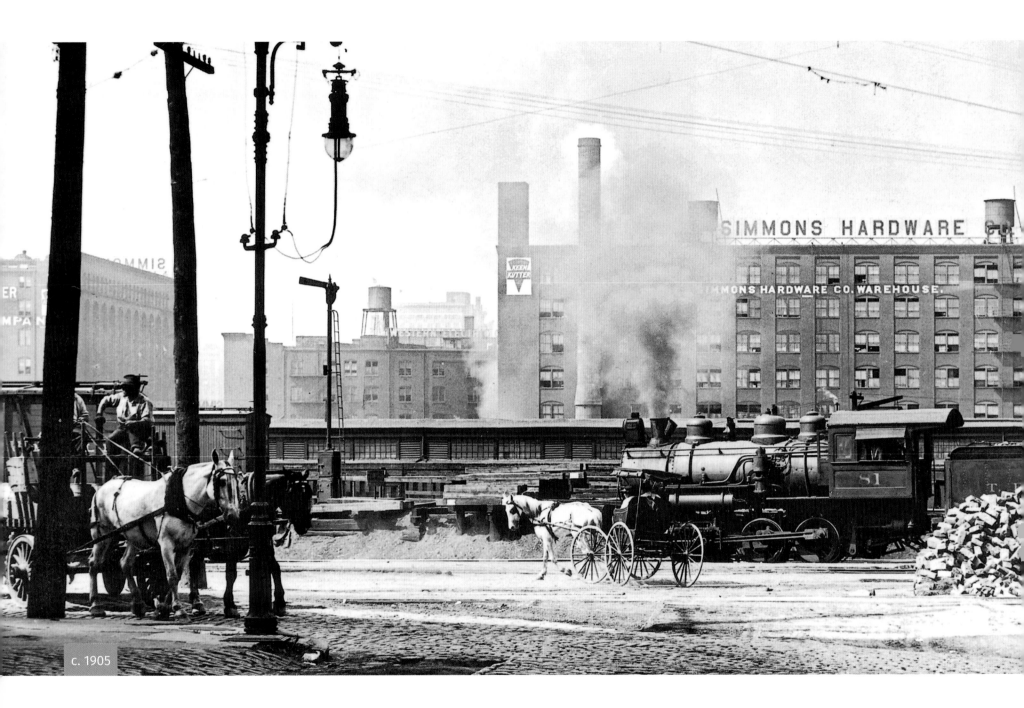

c. 1905

CUPPLES STATION

Slated for demolition, preservationists helped save the historic warehouses

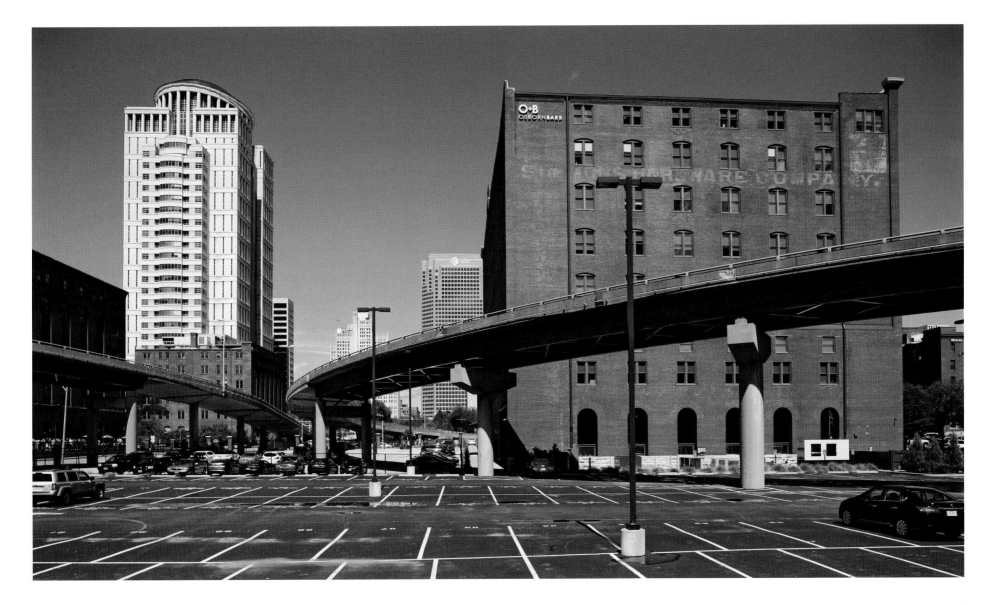

LEFT: Looking north from Eighth and Poplar, circa 1905. Turn-of-the-century St. Louis was an industrial powerhouse. In this photograph we see the horse-drawn street traffic beside the Terminal Railroad Association yards, with Cupples Station warehouses beyond. In 1892, Eames & Young designed eighteen such warehouses, comprising a freight-storage, handling, and transfer complex situated along a double-track tunnel leading from Eads Bridge to the Mill Creek Valley industrial zone. At the turn of the century, most of the city's wholesale trade (more than $200 million annually) was handled here.

ABOVE: Today, cars and highways have replaced trains and rail. Cupples Station was donated to Washington University in 1900. Several of the warehouses were torn down in the 1960s to make way for Busch Stadium and its attendant parking garages, just behind the building at right. In the 1980s, several more were slated for parking garage space, but finally the historic worth of the building group was recognized, and the remaining block of warehouses at left were renovated by Westin Hotel. The modified building at right, more than a hundred years since the photo at left was taken, bears the faint ghost sign of Simmons Hardware.

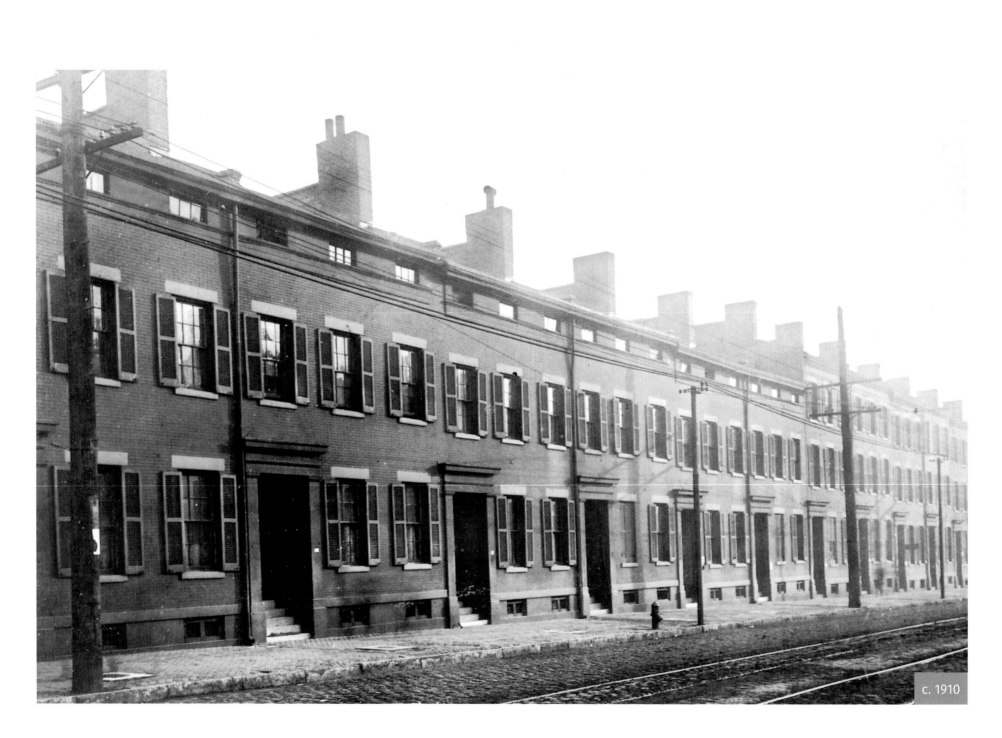

c. 1910

EUGENE FIELD HOUSE

The last survivor of a twelve-unit row house

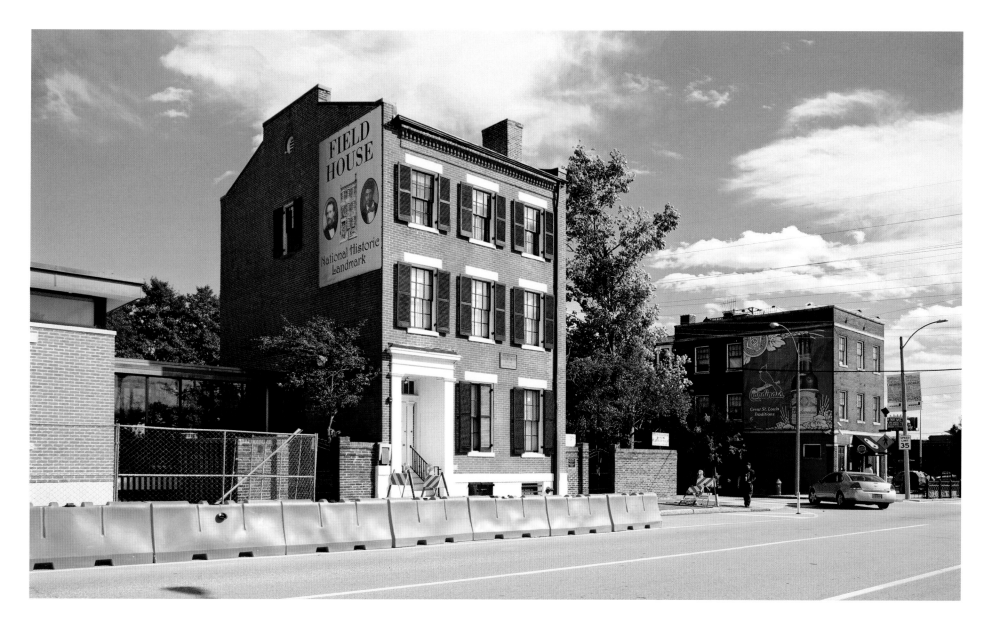

LEFT: South Broadway, circa 1910. Auguste Chouteau, one of the founders of St. Louis, originally owned the land where these row houses stand. Upon his death in 1829, the land was deeded to the city of St. Louis for the support of public schools. Almost twenty years later, the city still had not grown far enough away from the riverbank to utilize the land and it was leased to prominent merchant capitalist Edward Walsh. He built the twelve-unit row house seen here, known as Walsh's row. Attorney Roswell Field and his wife Frances moved into the second unit from the end of the original row.

ABOVE: Today, only one row house remains, the Eugene Field House and the St. Louis Toy Museum. Field was a journalist and poet best known for his children's verses *Little Boy Blue* and *Wynken, Blynken and Nod*. Mark Twain dedicated a plaque on the house in Field's honor in 1902. Field's father, Roswell, a prominent local attorney, represented Dred Scott in his suit for freedom. The rest of the row, long since derelict, was demolished in the 1930s. In 2015, the museum foundation broke ground on a 4,000-square-foot north wing extension.

THE GREAT CYCLONE OF 1896

The tornado in 1896 permanently altered the landscape of St. Louis

BELOW Lafayette (then known as Soulard) and Broadway, May 27, 1896. Perhaps the worst tornado in recorded St. Louis history, the Great Cyclone of 1896, ripped through the city damaging the Eads Bridge and flattening much of the near south side. The cyclone killed 137 people in St. Louis and another 118 in East St. Louis when the tornado crossed the Mississippi, bringing the death toll in the area to 255. Over 1,000 were severely injured, many of them struggling immigrants living in homes between Lafayette Square and the river. More than 8,000 buildings were destroyed and damage estimates surpassed $10 million dollars (the equivalent of $2.9 billion today).

RIGHT: The Lafayette Square and Soulard neighborhoods were hit the hardest with twenty-three people killed at the intersection of Seventh & Rutgers streets alone as buildings on both sides of the street collapsed. The cyclone cut a ten-mile swath of destruction in just twenty minutes.

FAR RIGHT: Jefferson and Lafayette Avenues looking east. The Union Club on the far right had its roof torn off and the city's most elegantly landscaped park left a wasteland.

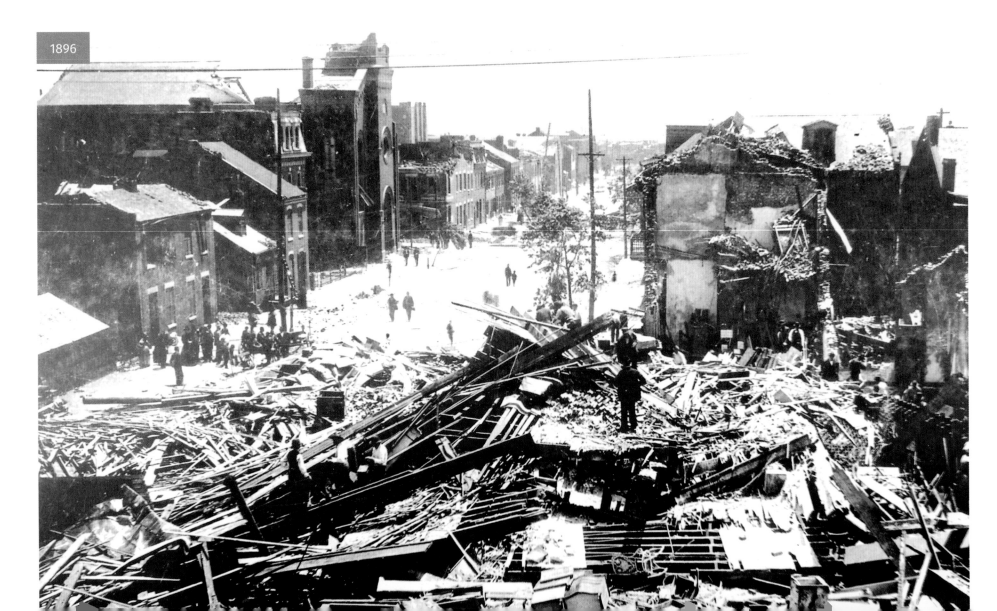

1896

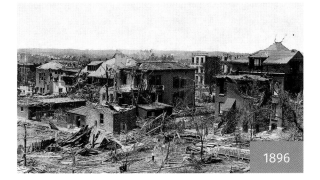

1896

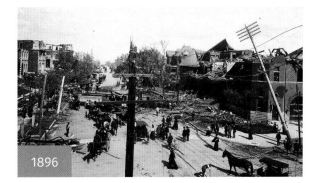

1896

BELOW: The tornado was a natural disaster, but the city's handling of the aftermath was a manmade disaster. The victims, many of them German immigrants, appealed to the city for disaster relief and loans, but were met with admonitions to be brave and self-reliant. Despite the city's lack of relief planning, the close-knit community pulled together and did manage to rebuild much of the neighborhood. However, certain areas never fully revived and eventually lapsed into the sort of nondescript semi-industrial location seen here.

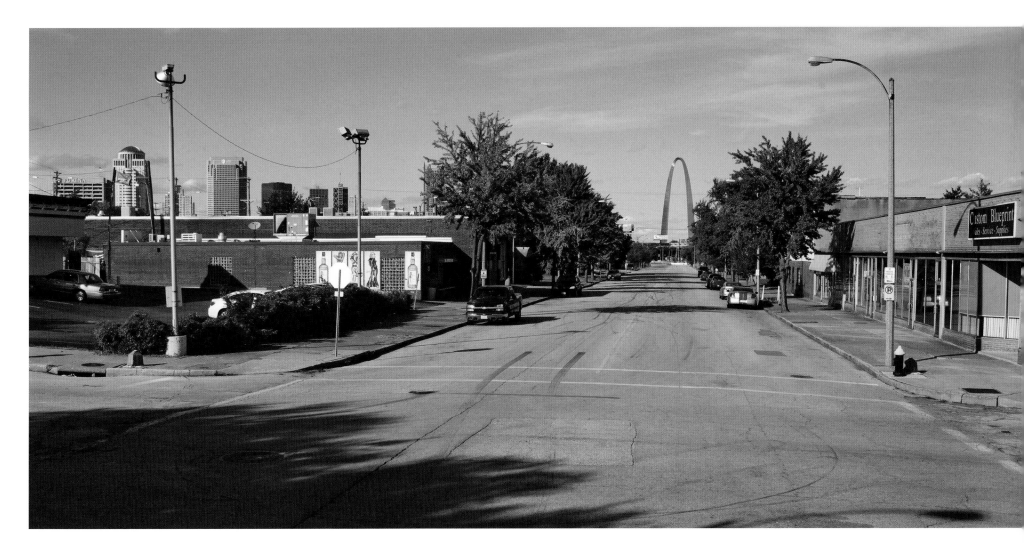

c. 1900

LAFAYETTE PARK AND BENTON PLACE

St. Louis has its own "painted ladies"

LEFT: One of the many elegant private streets in the genteel Lafayette Square neighborhood on the north side of Kennett Place. Lafayette Park, the city's first and the nation's first urban public park west of the Mississippi, was created in 1836 on the high point of the old St. Louis Common, that had been set aside for grazing livestock. It was named for the Marquis de Lafayette, who served under George Washington in the Continental Army. The area remained relatively undeveloped until the 1850s when the surrounding streets became a fashionable suburban enclave for the city's wealthiest families, and a flurry of construction began. Benton Place, the city's second private place, was platted around a central green. It opened in 1867 and was named for Senator Thomas Hart Benton.

BELOW: This fourteen-room mansion constructed on Benton Place in 1891, with double parlors and matching marble fireplaces, was a fortunate survivor of the 1896 Cyclone.

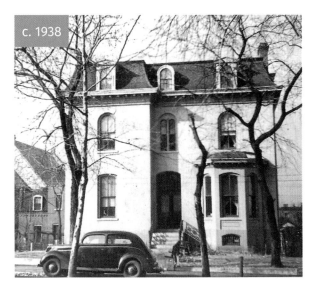

c. 1938

RIGHT: Both the park and the Lafayette Square neighborhood were badly damaged by the tornado of 1896. Thanks to the personal wealth of the inhabitants, many of these beautiful homes were quickly rebuilt, and others were replaced with huge Romanesque mansions. However, the sprawl of the city was encroaching on this exclusive area, and residents began moving west. Architect, historian and urban pioneer, John Bury Ashton moved to Benton Place in 1949 and began an initiative to preserve the neighborhood even as the city of St. Louis was planning to demolish it for new development. His efforts succeeded and inspired succeeding generations to dig in. Today, Lafayette Square, with its Victorian Painted Ladies (three-story Victorian townhouses) many of them lining the park, is one of the city's most desirable and most visited neighborhoods, both for its spring and winter house tours and its annual Tour de Lafayette bike race.

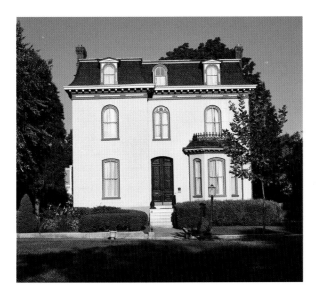

c. 1910

SOUTH EIGHTH STREET, SOULARD

Cherishing its connection to New Orleans, Soulard has its own Mardi Gras

LEFT: Eighth Street, near Soulard Market, around 1910. In the middle of the nineteenth century the Soulard neighborhood, with its plentiful work opportunities in factories and breweries, became the point of entry for many recent immigrants. Around the central farmers' market, there grew up communities of Croatians, Czechs, Hungarians, Italians, and most of all, the "Southside Dutch" (Germans). In these insular "support communities," people spoke their own languages, published community newspapers, and built ethnic churches. When the Great Cyclone of 1896 partially destroyed the area, these close-knit ethnic communities rebuilt Soulard. The City of St. Louis named this neighborhood just south of downtown for Antoine Soulard, who owned much of it in colonial times. Soulard was Surveyor-General of the Upper Louisiana Territory and the King of Spain paid him for his services in land.

RIGHT: Today, Soulard is on the National Register of Historic Places. It is an eclectic hodgepodge of nineteenth century styles loosely described as "vernacular" that range in size and style from stone cottages to brick mansions. Eighth Street displays Soulard's characteristic red-brick row houses. Buildings date mostly to the first half of the nineteenth century, and there are examples of a type of flat thought to be unique to St. Louis, in which the second floor is accessed via a street-level tunnel through the first floor leading to the back-porch stairs. With its intricate wrought-iron balconies, Mansard-roofed townhouses, and secret patio gardens, Soulard is the city's French quarter and a reminder of St. Louis' Creole ancestry and close connection to the city of New Orleans. The Soulard area remains a true walking neighborhood with farmers' market, sidewalk cafes, and shops nestled among the homes. In spring it hosts the second-largest Mardi Gras celebration in the U.S.

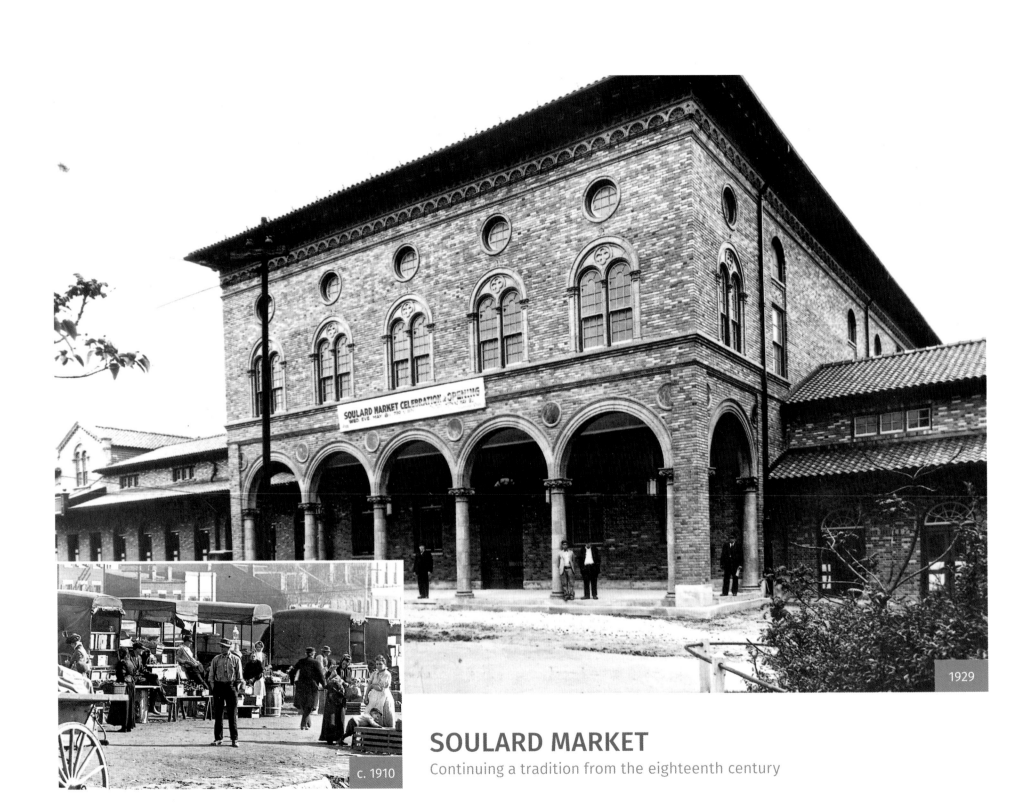

1929

c. 1910

SOULARD MARKET

Continuing a tradition from the eighteenth century

LEFT: This photo shows the new Soulard Market building at Lafayette Avenue between Seventh and Ninth. It was taken on April 23, 1929, just two weeks before the grand opening. Buyers and sellers had been meeting on the site since 1779. In 1838, Julia Cerré Soulard, widow of Antoine, donated the two blocks to the city of St. Louis, stipulating that the land continue to be used as a public marketplace, and shortly thereafter the first permanent building was erected.

LEFT: The destruction of the early market house in 1896 didn't stop farmers from gathering where they had for generations, now using their wagons for stalls.

ABOVE: The elegant 1929 building, modeled on Brunelleschi's Foundling Hospital in Florence, still stands on the exact location of the 1840s market that was destroyed in the tornado of 1896. Not surprisingly Soulard Market is St. Louis' oldest public market. The market has grown somewhat since 1929, but several of the same family produce businesses are still represented today. People from all over the St. Louis area come to shop on Saturdays at Soulard Market for fresh flowers, fruit, and vegetables, dairy, meat, fish, spices, baked goods, and household items.

ANHEUSER-BUSCH BREWERY

A working brewery that tourists can visit, and sample the products

LEFT: Having surpassed the one million barrel mark in 1901, Anheuser-Busch was well on the way to becoming the largest brewery in the world. Eberhard Anheuser founded the company in 1860 when he bought the Bavarian Beer Co. He was joined in business by his astute son-in-law, Adolphus Busch, in 1864. It was Busch who developed Budweiser, the first national brand, in 1876. Three years later, the company was renamed Anheuser-Busch Brewing Association. The brewery complex was essentially self-contained, with such facilities as a blacksmith, wagonmaking, cooperage, even cork manufacture. Later, glassworks and refrigerated rail cars were added. It also contained the family home of Adolphus and Elise "Lilly" Anheuser Busch and their thirteen children at One Busch Place before they moved to their country estate.

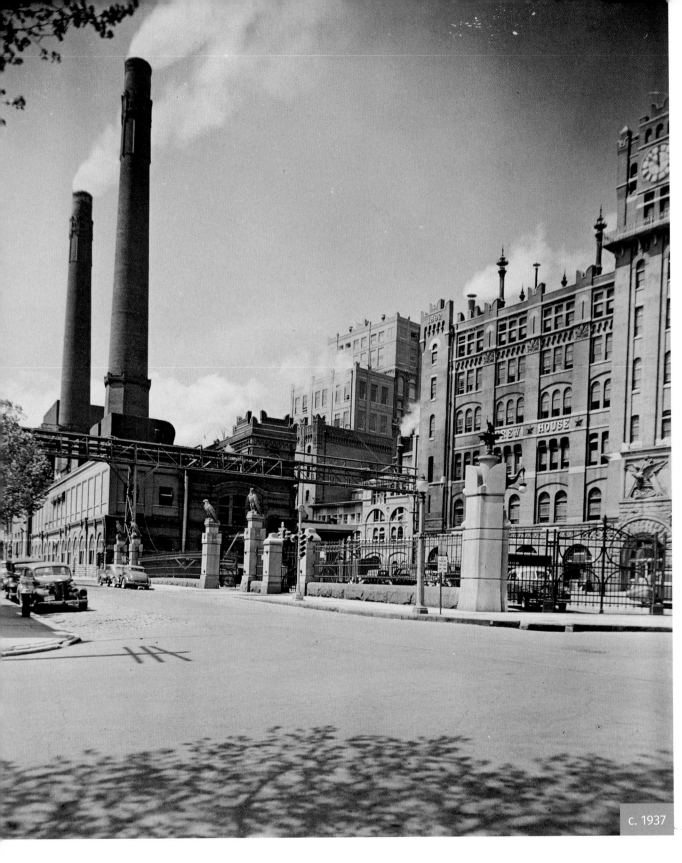

c. 1937

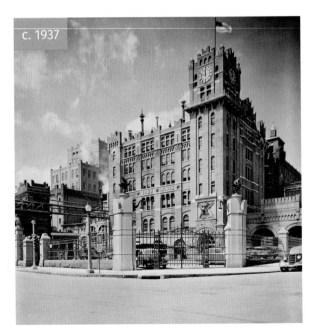

c. 1937

ABOVE: By 1902 the brewery covered twelve city blocks and employed 6,000 workers. Today, The 142-acre Anheuser-Busch brewing complex holds three National Historic Landmarks: the 1885 Clydesdale Stables, the Old Lyon Schoolhouse, and the Brew House seen here. Built in 1891-2, the Brew House, with its distinctive eight-story clock tower, is Victorian Gothic in style, but presides over a wide range of architecture on the campus. Today, the company offers a wide variety of tours to view the hundred-plus years of brewing history. These include a complimentary tour, a "Day Fresh" tour, a History Tour and a Beermaster Tour which offers a sample directly from the Finishing Tank (for those over 21 years of age).

c. 1946

CHATILLON-DEMENIL HOUSE

A rare example of antebellum architecture, complete with antebellum security

LEFT: In 1848, well-to-do widow Odile Delor Lux purchased this lot from the city; it was formerly part of the Commons. Her second husband Henri Chatillon, guide and hunter with Francis Parkman on the Oregon Trail, built the original structure soon after. When wealthy French physician Nicolas DeMenil purchased the house in 1856, it was still considered a farmhouse, and DeMenil and his wife (St. Louis aristocrat Emilie Chouteau) used it as their summer retreat. In 1861, they commissioned English architect Henry Pitcher to transform the building into a Greek Revival mansion, a style already then considered old-fashioned, but one which Emilie associated with Southern charm.

ABOVE: After a long slide into disrepair, and a stint as a tourist attraction based on the caves that lie beneath the area, the mansion was slated for demolition in the 1960s to make room for Interstate 55. Preservationists fought to save it as one of the few remaining examples of Greek Revival architecture in St. Louis. In 1964, the Landmarks Association was able to purchase and restore the house. It is now a museum governed by the Chatillon-DeMenil House Foundation. The elegant iron railings are original, and surprisingly so are the first-floor window bars. Known Southern sympathizers during the Civil War, the DeMenils had them installed to protect the house from pro-Union vandals.

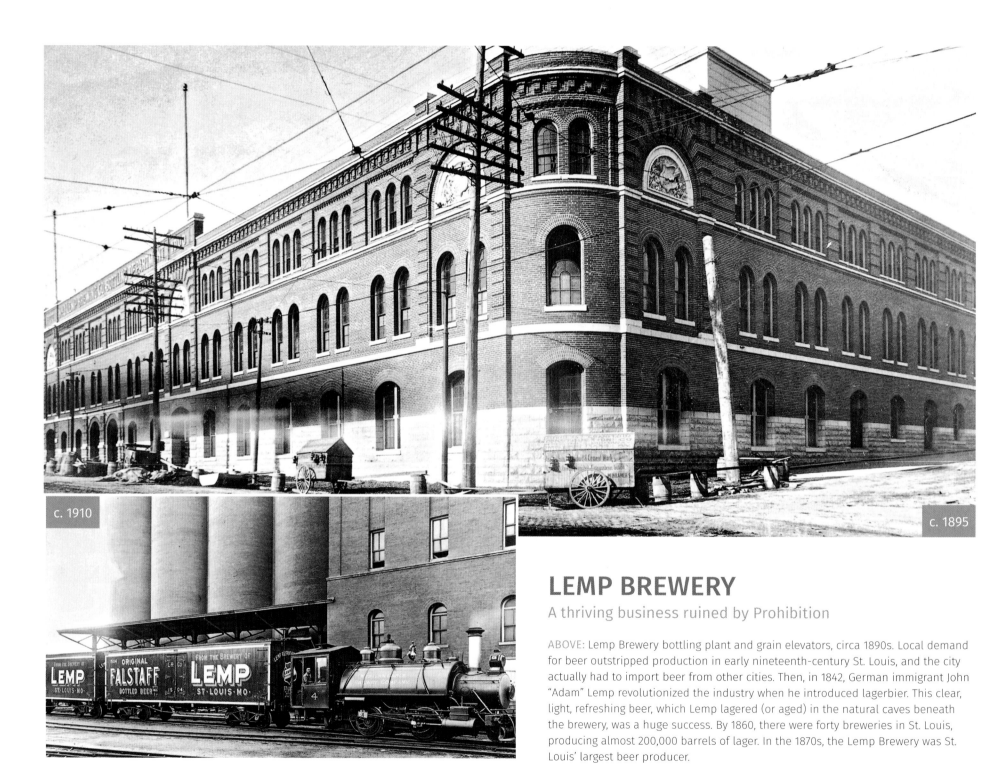

c. 1910

c. 1895

LEMP BREWERY

A thriving business ruined by Prohibition

ABOVE: Lemp Brewery bottling plant and grain elevators, circa 1890s. Local demand for beer outstripped production in early nineteenth-century St. Louis, and the city actually had to import beer from other cities. Then, in 1842, German immigrant John "Adam" Lemp revolutionized the industry when he introduced lagerbier. This clear, light, refreshing beer, which Lemp lagered (or aged) in the natural caves beneath the brewery, was a huge success. By 1860, there were forty breweries in St. Louis, producing almost 200,000 barrels of lager. In the 1870s, the Lemp Brewery was St. Louis' largest beer producer.

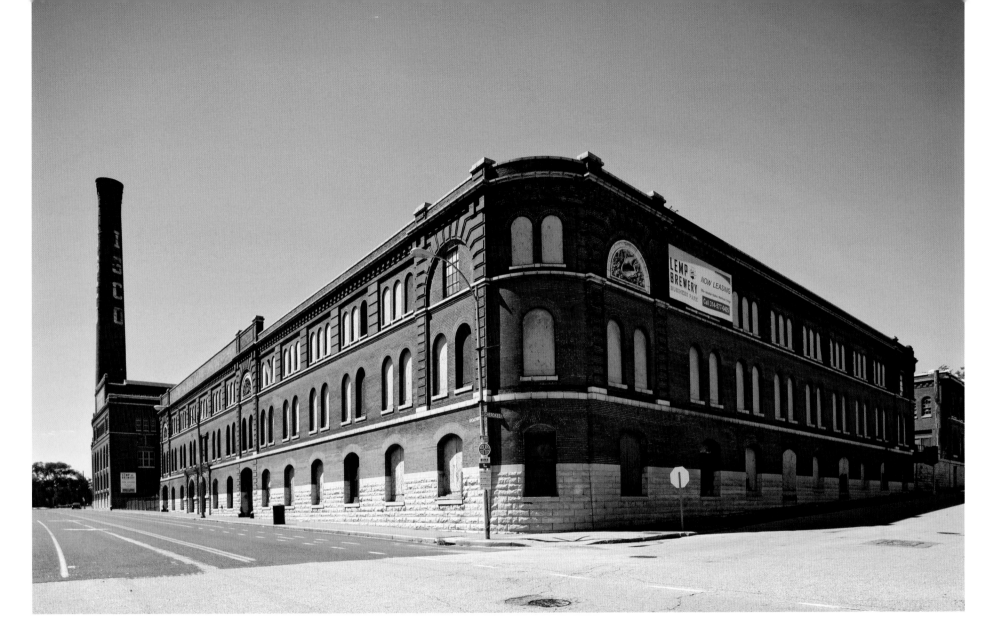

ABOVE: By the turn of the century, only nineteen of the forty city breweries survived. Lemp Brewery and Anheuser-Busch had become the city's leading beer producers; they succeeded by economies of scale and innovation in brewing technology. Busch introduced pasteurized beer in 1873, and both companies invested in refrigerated rail cars. A-B survived Prohibition by selling commercial yeast, hops as animal feed, and a variety of soft drinks and near-beers, but Lemp was ruined. The Italian Renaissance-style complex still stands, but is now used only for storage.

LEFT AND RIGHT: Lemp was the first brewery in the U.S. to ship its beer from coast to coast in refrigerated cars, developing their own Western Cable Railway Company to do so. By the late 1890s they were exporting beer to South America and the Far East. These enormous brick granary stacks were constructed in 1905.

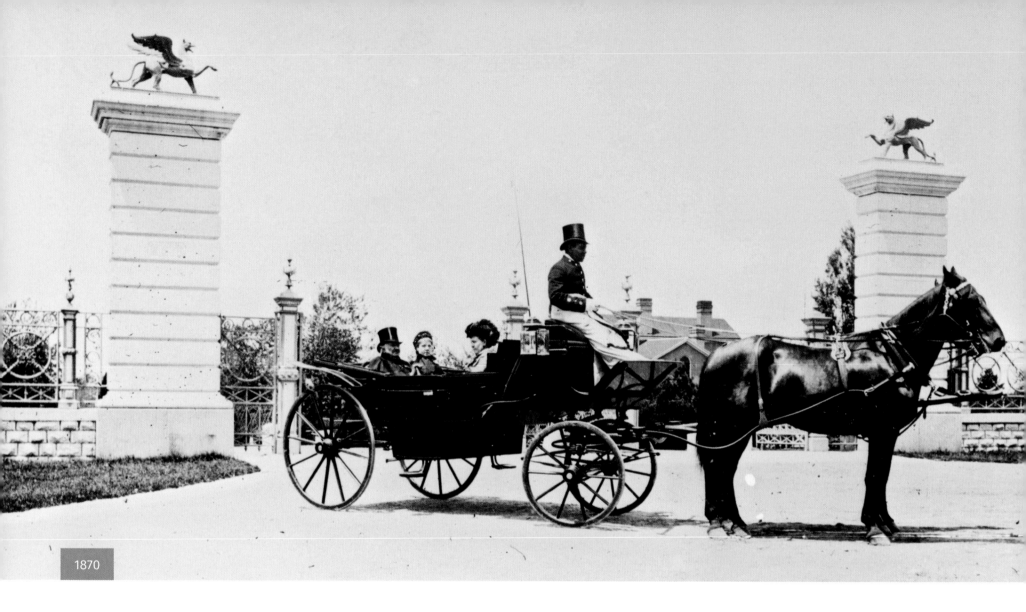

1870

EAST GATE, TOWER GROVE PARK
A philanthropist outside his gift to St. Louis

ABOVE: East Gate of Tower Grove Park, 1870. In this photo taken by Emil Boehl, philanthropist Henry Shaw is seen in the company of his sisters leaving the Victorian carriage park which he donated to the City of St. Louis in 1868 for the enjoyment of its citizens. Shaw fell in love with this part of the prairie shortly after immigrating to St. Louis and purchased it as soon as he could. It would make up the southern portion of his country estate. There were fortunes to be made in St. Louis during the 1820s and 1830s. Shaw made his as a merchant selling hardware and cutlery produced in his native Sheffield. He was eighty years old when this photograph was taken and would live another nine years. The griffins and lions atop the lovely east gate giving access to Grand Boulevard were imported from Berlin.

c. 1870

ABOVE: Henry Shaw's Tower Grove Park has fully matured into one of the loveliest public parks in the nation. Although wind and storms have taken their toll, the tornado of 1896 especially, nature continually renews itself here. Many of the mature trees can be dated to the mid-nineteenth century when Shaw had them planted. There are pavilions designed by local architects inspired by those Shaw viewed during his world travels, statuary that he commissioned for special locations and a great Victorian Band Stand. Generations of St. Louisans have found it an idyllic setting for picnics and formal weddings. In recent years tennis courts and a great playground were constructed along Center Cross Drive. Tower Grove Park is also the setting for the city's International Festival, a celebration of the many nationalities that have enriched St. Louis from its founding to the present.

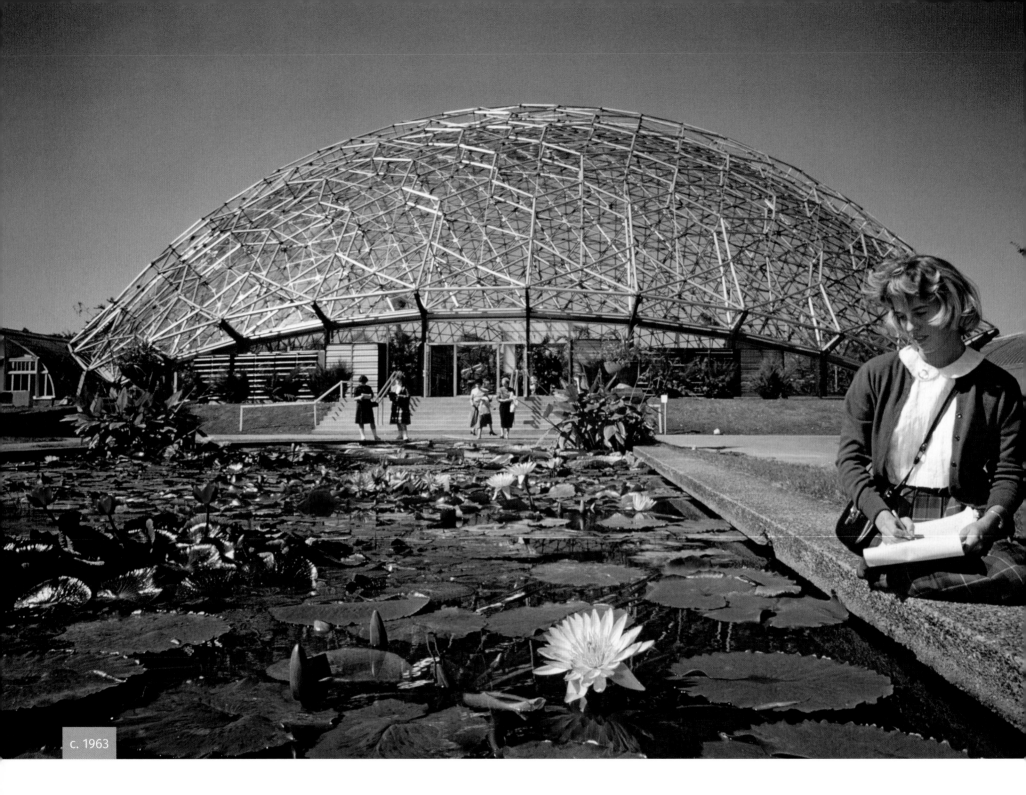

c. 1963

MISSOURI BOTANICAL GARDEN
Inspired by Kew Gardens, Henry Shaw's legacy is also world-renowned

c. 1900

c. 1900

ABOVE: The early conservatory seen above and the Victorian Folly shown below it were characteristic of the buildings constructed soon after Shaw's Garden opened to the public in 1859.

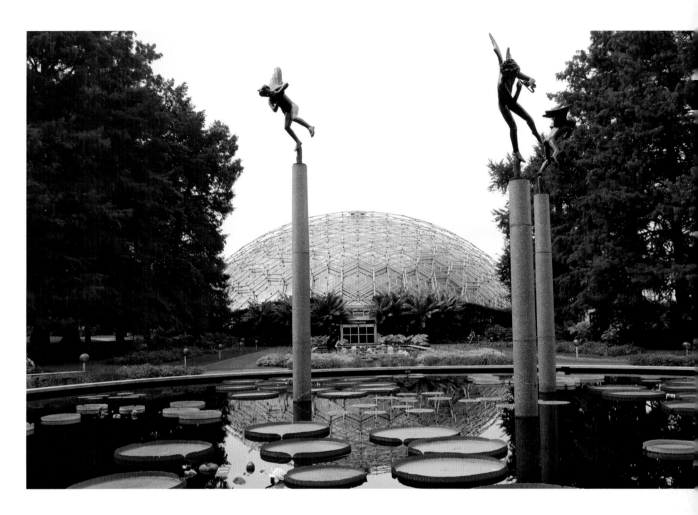

LEFT: A native of Sheffield, England, Henry Shaw was just nineteen when he came to St. Louis in 1819 and made a fortune in hardware. As a child he had admired Kew Gardens, and he planned for years to found a public garden for St. Louis. He commissioned George Engelmann, physician and famed botanist, to build the collection. In 1859, Shaw donated to the city his scrupulously groomed, 79-acre country estate. He would later donate an additional 277 acres (Tower Grove Park) and lease the land surrounding it. Upon his death in 1889, Shaw left his fortune and the lease revenues for the support of the garden. The garden quickly became a major attraction, drawing almost 50,000 visitors in 1868. In 1904, the great Frederick Law Olmsted,

designer of New York's Central Park, was commissioned to design a master plan for future development. The garden evolved with the city, and today only one nineteenth-century greenhouse remains. Seen here is the Climatron, a geodesic dome built in 1960 to house tropical vegetation.

ABOVE: The Garden continues to be an active research institution with a world-renowned herbarium of over 4.5 million specimens and an excellent horticultural library. Other highlights include formal rose gardens and a popular Japanese garden.

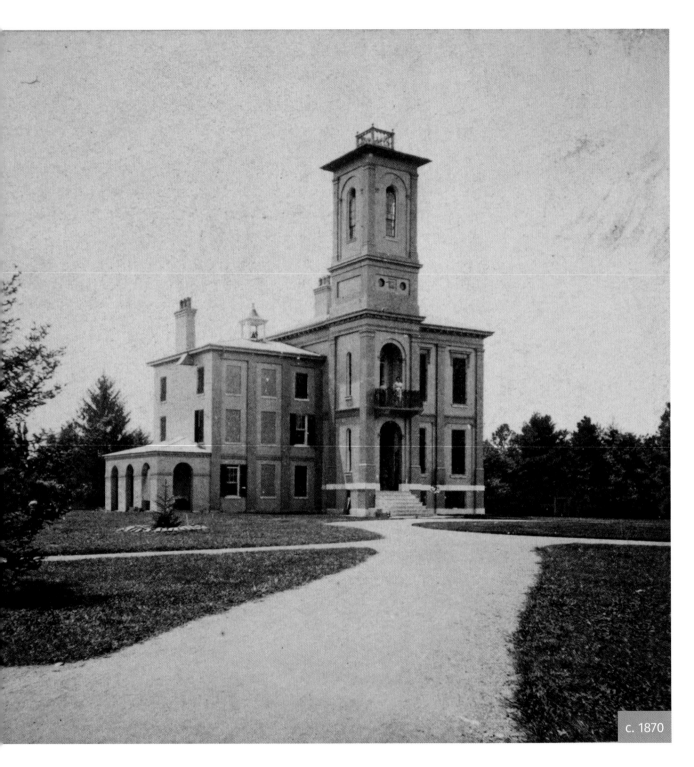

c. 1870

TOWER GROVE HOUSE
Designed by the architect of the Missouri Governor's mansion

LEFT AND BELOW: Like most of his wealthy peers, hardware magnate Henry Shaw maintained both a country villa and a town house. In 1849, he hired architect George Barnett to design a home on property that was, at that time, fields of tall prairie grass and wildflowers far from the city. The Italian Renaissance palazzo style was very fashionable in the period, and the name was derived from the tower on the house and a nearby lone grove of sassafras trees. English-born architect, George Ingram Barnett, was a favorite of Henry Shaw's. He had previously designed Shaw's handsome townhouse and Shaw would commission him to design the rose granite mausoleum where he would be buried on his country estate.

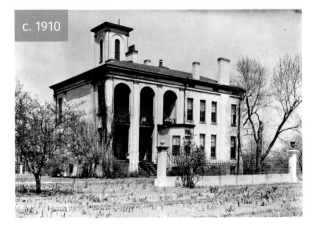

c. 1910

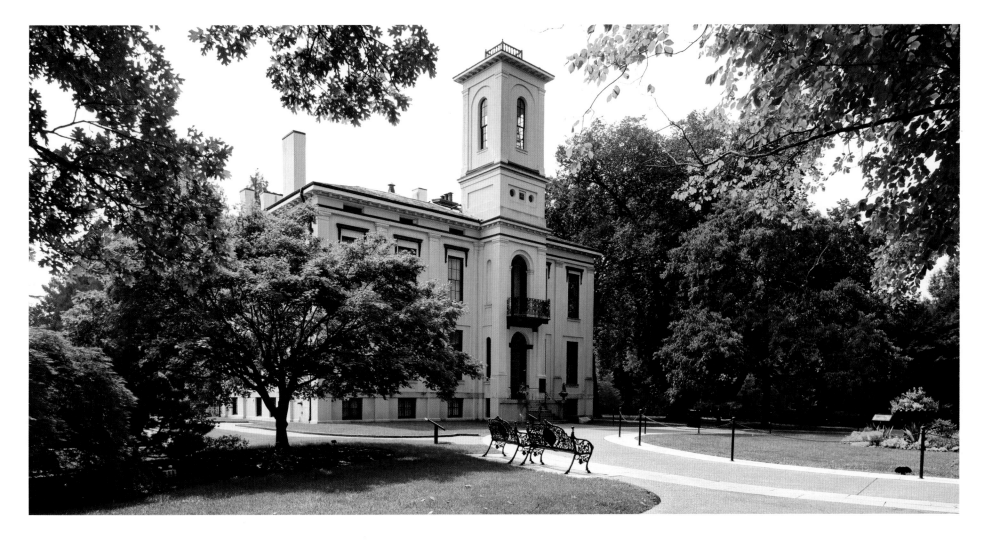

ABOVE: Shaw retired to Tower Grove House, and lived there in the midst of his newly created public garden until his death in 1889. The interior of the house has been restored as a Victorian showpiece and is today open to the public. After Shaw's death, his town house, located at Seventh and Locust streets downtown, was dissembled and moved to the public garden as well. Today, the attractive Renaissance palazzo-style house provides administrative offices for the Garden. The endowments Shaw left to fund it proved the basis for what has become internationally renowned as the Missouri Botanical Garden. Henry Shaw also endowed the School of Botany at Washington University in St. Louis. The photo at right shows the Victorian Garden, with its geometric design, popular during that era; a colorful and elaborate formal garden that resembles a tapestry.

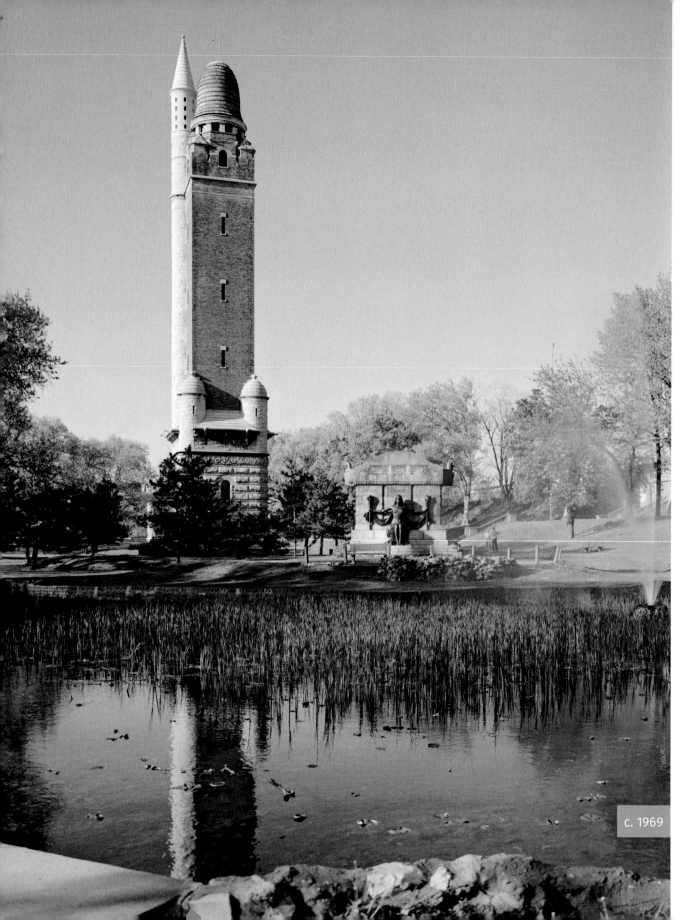

c. 1969

COMPTON HILL
WATER TOWER

Joined by a once-controversial statue

LEFT: Built in 1898 as the last of three water towers to control water pressure as part of the city's waterworks system, it was the most whimsical. The Compton Hill Water Tower was a fairy tale-like confection in Reservoir Park designed by Harvey Ellis for architect George R. Mann. It was the third phase in a major undertaking begun by the St. Louis Water Department in 1867 under the supervision of Thomas J. Whitman (the poet Walt Whitman's brother). But its function to manage surges and maintain even water pressure for the enormous reservoir had become obsolete by 1929. Construction of Interstate 44 in this area necessitated moving *The Naked Truth* sculpture from the northern end of Reservoir Park, which the highway cut off, to this location.

RIGHT: Today, Reservoir Park has changed little. *The Naked Truth* sculpture of 1914, once considered risqué, is no longer considered scandalous. Adolphus Busch's suggestion that it be sculpted in bronze rather than white marble somewhat softened the shock when it was originally installed. Tennis courts remain on the east side of the park but the elevated courts that once stretched out over the cover of the reservoir have disappeared. In 1998, restoration began on the basin and the tower, which was showing tremendous wear to the brickwork, shingled dome, and stonework. Happily, the climbs to the top on the circular stairway that ended in the 1970s have been resumed. The Compton Hill Water Tower with its 360-degree panoramic views of the city is open to the public on the first Saturday of the month and for special events like "Full Moon Viewing."

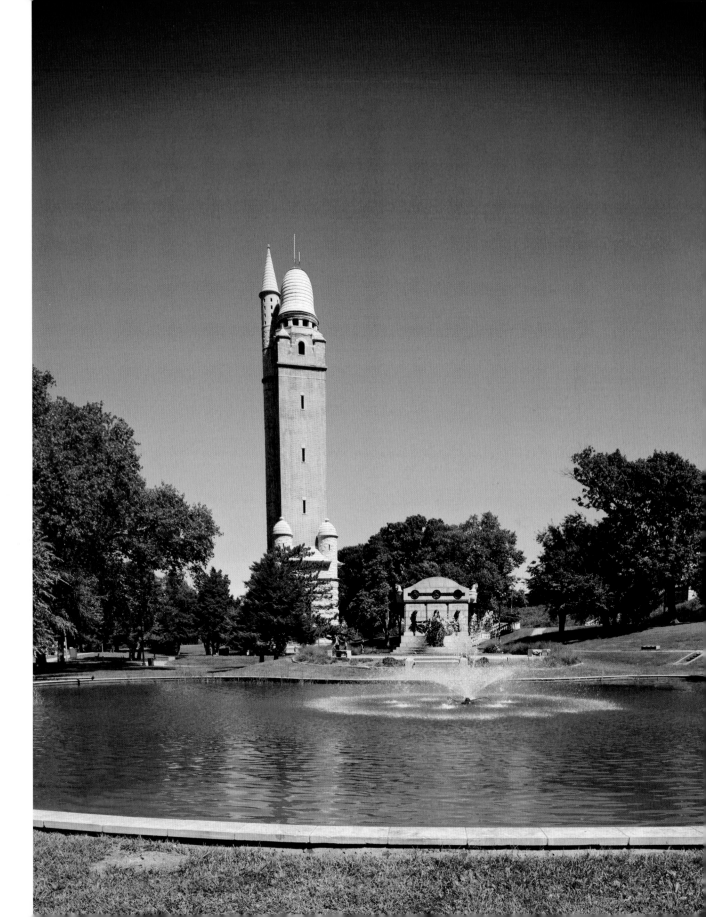

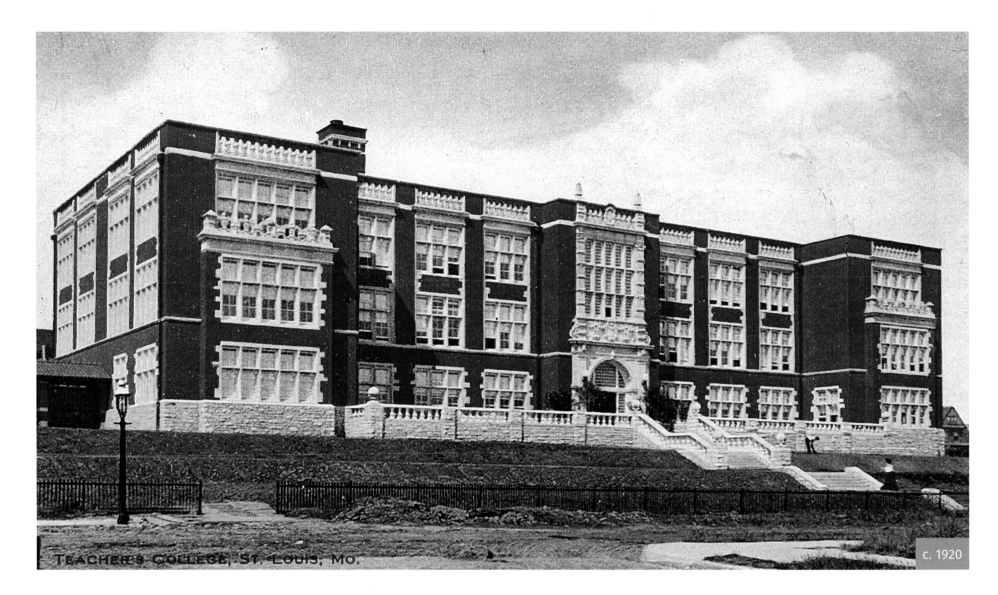

TEACHERS COLLEGE, ST. LOUIS, MO.

c. 1920

HARRIS TEACHERS COLLEGE

Buildings supervisor William B. Ittner was a pioneer in designing school buildings

ABOVE: Designed as the city's first public college for teachers and named for educator, William Torrey Harris, the college embodied the vision of architect William B. Ittner. He believed that public schools should be civic monuments and places to inspire learning unlike the St. Louis public schools he'd known as a boy—utilitarian boxes subdivided into classrooms without heating, indoor plumbing, or healthy ventilation. In 1897 he began introducing novel open plans. They were E-, U-, and H-shaped floorplans with spaces for specific learning needs—auditoriums and hallways bordered with banks of windows providing abundant natural light. Handsome exteriors with decorative brickwork, ornamental terra-cotta, and grand entrances were Ittner's signature touches.

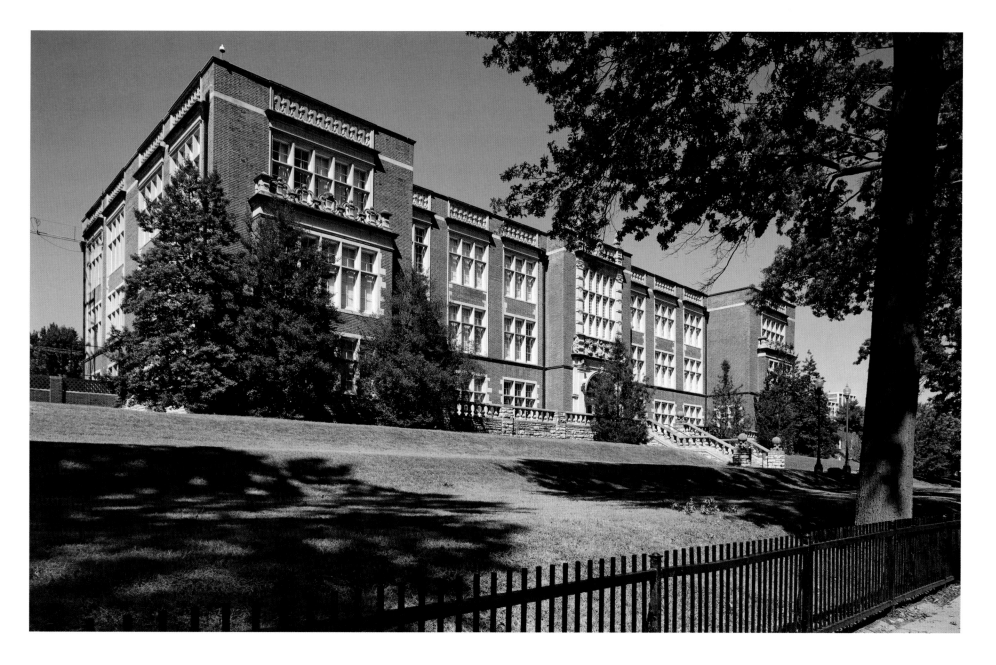

ABOVE: Today, forty-eight of the fifty public schools that William Ittner designed in the city of St. Louis are still standing and several of them are listed on the Register of National Historic Places, including the school on Theresa Avenue. In 1950 Harris Teachers College moved to its present campus in Midtown St. Louis and the building became an elementary school and finally the Board of Education Curriculum Service Center before being sold and nearly leveled for a shopping mall. Fortunately this distinguished building was preserved and has new life as Theresa Park Lofts. Classrooms were renovated into thirty-five loft apartments with high ceilings and hardwood floors, the original classroom doors restored. William Ittner also designed schools in St. Louis County and more than 400 schools in twenty-five other states.

NEAR NORTH LEVEE

Roy's old mill defined the city's boundary

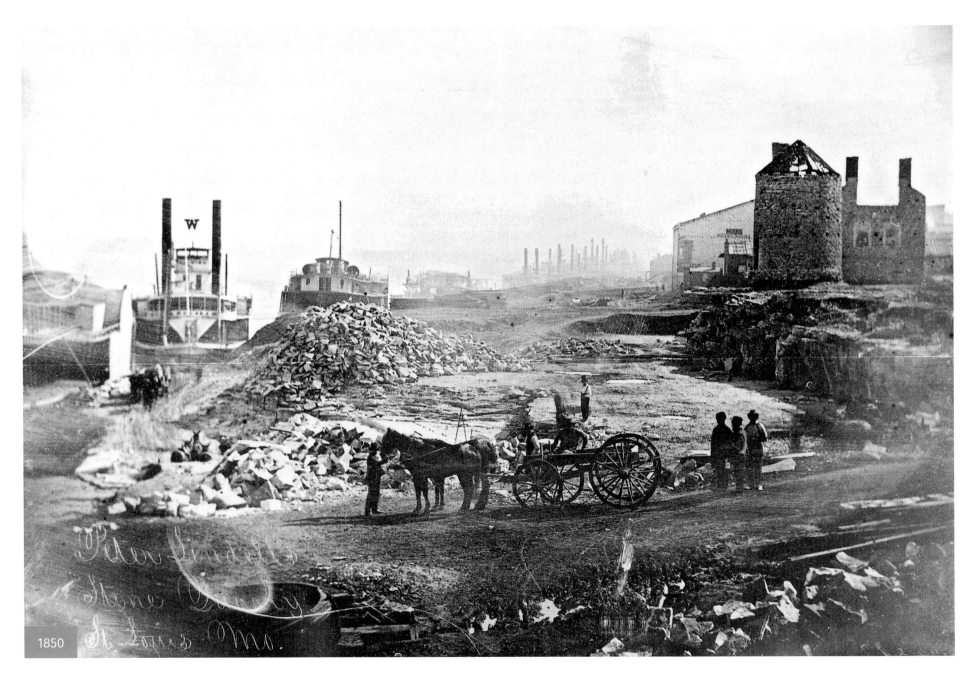

1850

LEFT: Looking south from Mullanphy Street, 1850. This daguerreotype by Thomas Easterley shows Peter Lindell's stone quarry at the junction of the river and Bates Street. The bluff that originally bordered the river here had been all but leveled by the quarrying of stone. At right, the decrepit round structure was the old windmill of original French settler Antoine Roy. In 1811, the northern boundary of the city was defined by Roy's mill.

BELOW: The same scene today is changed, but just as industrial. Milling of grain into flour was a St. Louis specialty until the later half of the nineteenth century. As the city grew and Roy's mill fell into ruin, the tower became known as Spanish tower. It was thought to have been part of Spanish eighteenth-century fortifications from the forty-year period when Spain held the Louisiana Territory. (Note the city floodwall on the far right with the gates open because the Mississippi is within its banks.)

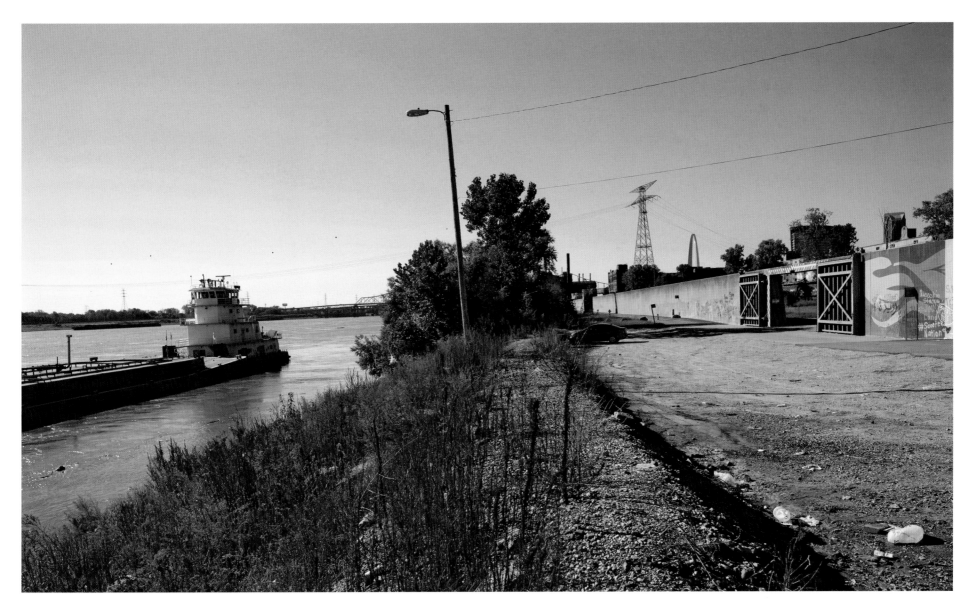

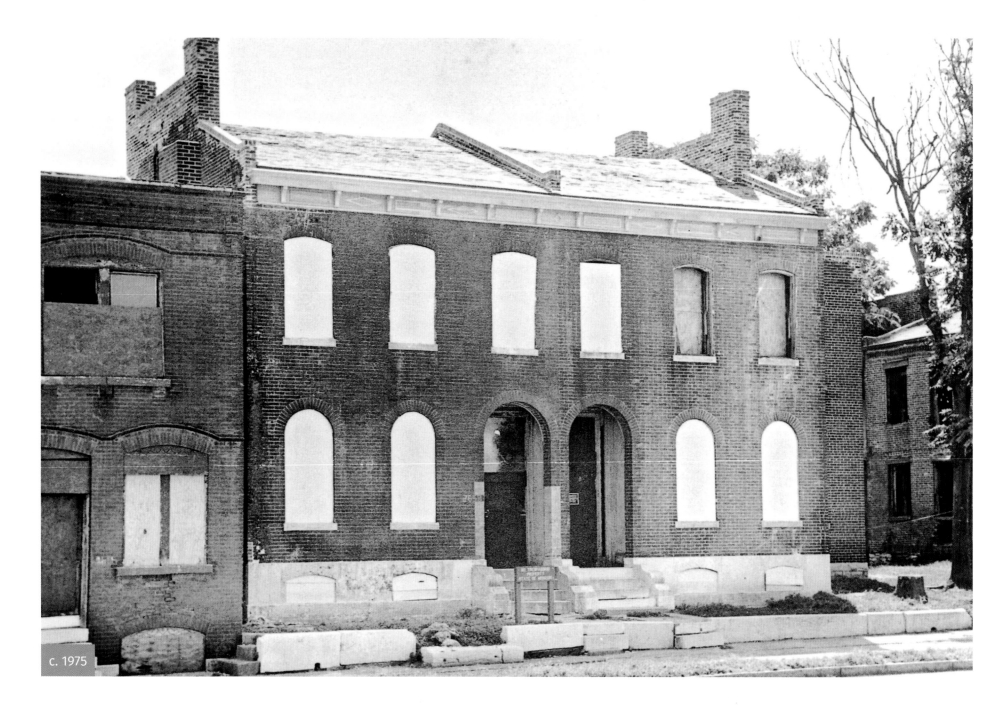

c. 1975

SCOTT JOPLIN HOUSE

The former home of the "King of Ragtime"

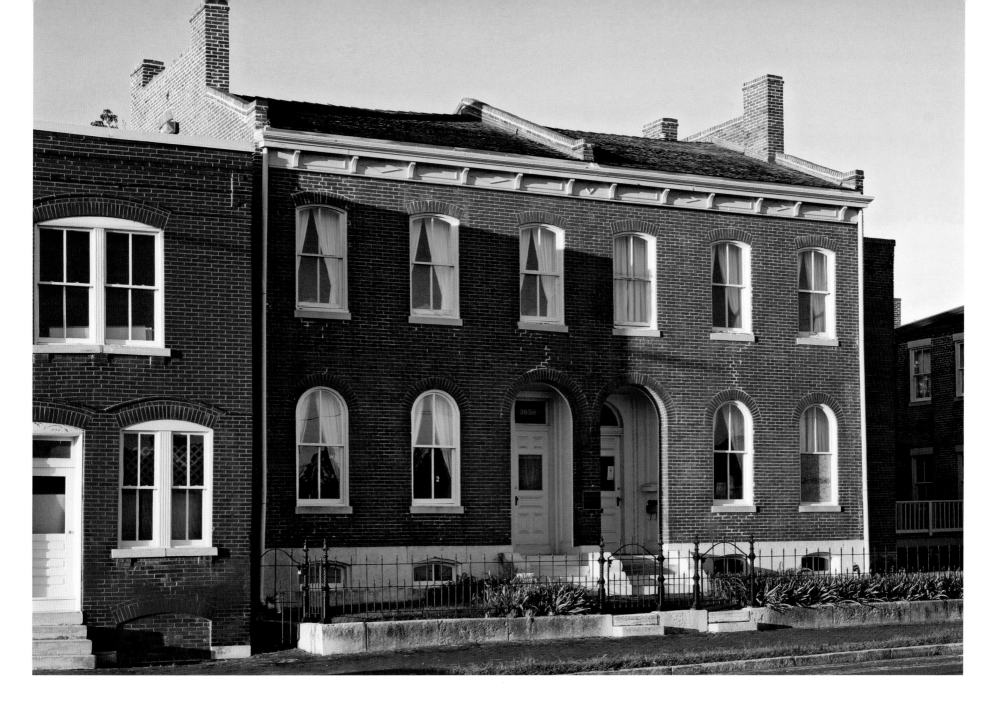

LEFT: Delmar Boulevard shortly before renovation by the state of Missouri in the 1980s. At the turn of the century, Morgan Street, as Delmar was then called, was a busy, densely populated blue-collar district of African-Americans and German immigrants. The nearby "Chestnut Valley" was the location of notorious dive bars and honky-tonks in which Joplin performed. He and his wife Belle moved from Sedalia, Missouri, into this modest walk-up flat in 1902 and lived in St. Louis for nine years before moving to New York.

ABOVE: Fallen into gross disrepair by the latter half of the twentieth century, this block of buildings was slated for demolition. Thankfully, its historical context was discovered, and it was declared a National Historic Landmark and State Historic site. Joplin composed one of his most famous works here, *The Entertainer*, among others. Today, the house is a museum dedicated to the "King of Ragtime" and the building at the corner has been renovated to commemorate musician and composer Tom Turpin's legendary Rosebud Bar and Cafe, where Joplin often played.

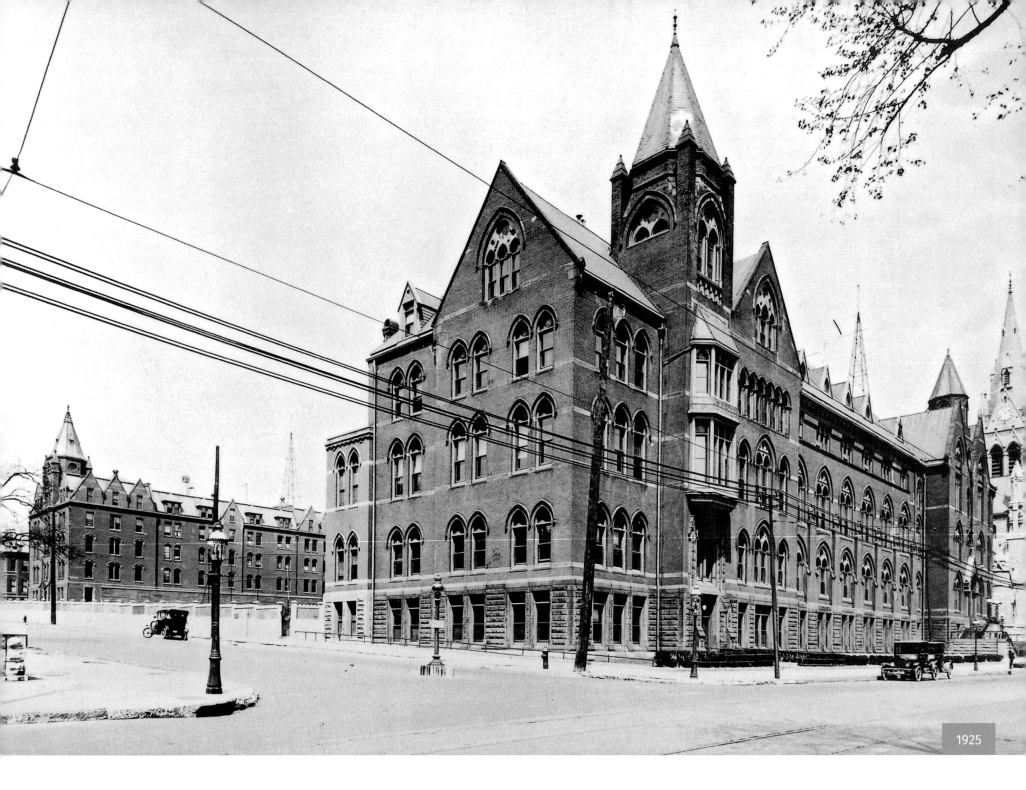

1925

ST. LOUIS UNIVERSITY
The Gothic-style hall is named for Bishop Louis DuBourg

118

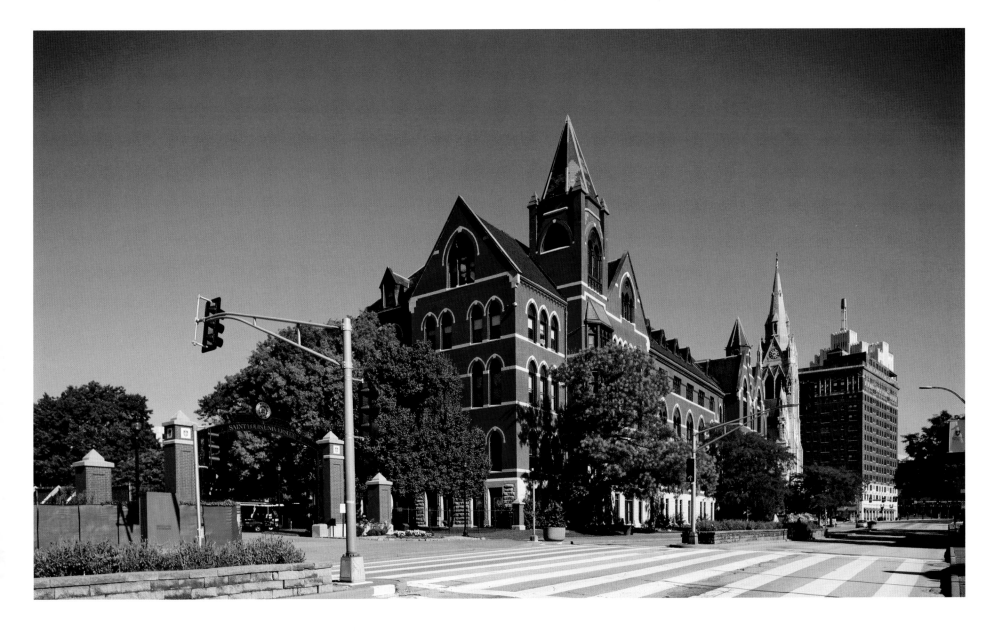

LEFT: Designed by Thomas Waryng Walsh, the English Gothic-style hall of St. Louis University contained the entire institution when it opened in 1888. Bishop Louis DuBourg founded an academy downtown in 1818, near the Old Cathedral and later situated at Ninth and Lucas. In the 1820s, he invited the Jesuits to take over, and in 1832, St. Louis University became the second Jesuit institution in America (after Georgetown) and the first university west of the Mississippi. St. Francis Xavier Church, constructed in 1898, stands beyond the hall.

ABOVE: Today, the building is known as DuBourg Hall, and the university has grown dramatically. In 1962, SLU purchased 22 acres of the cleared Mill Creek Valley area for expansion. Several classroom buildings, lecture halls, and an athletic field were constructed on the site. Today, SLU is a leading Catholic institution with nearly 13,500 students, who come from all fifty states and almost eighty foreign countries. Greater St. Louis is also home to Washington University and a campus of the University of Missouri.

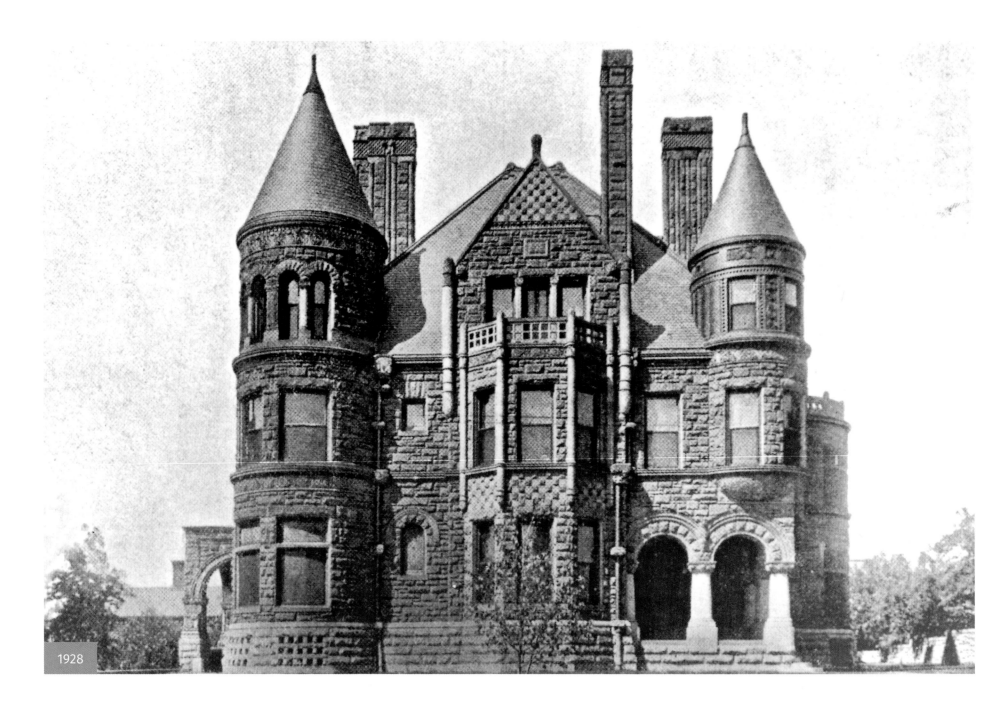

1928

SAMUEL CUPPLES HOUSE
A unique mansion of the Gilded Age

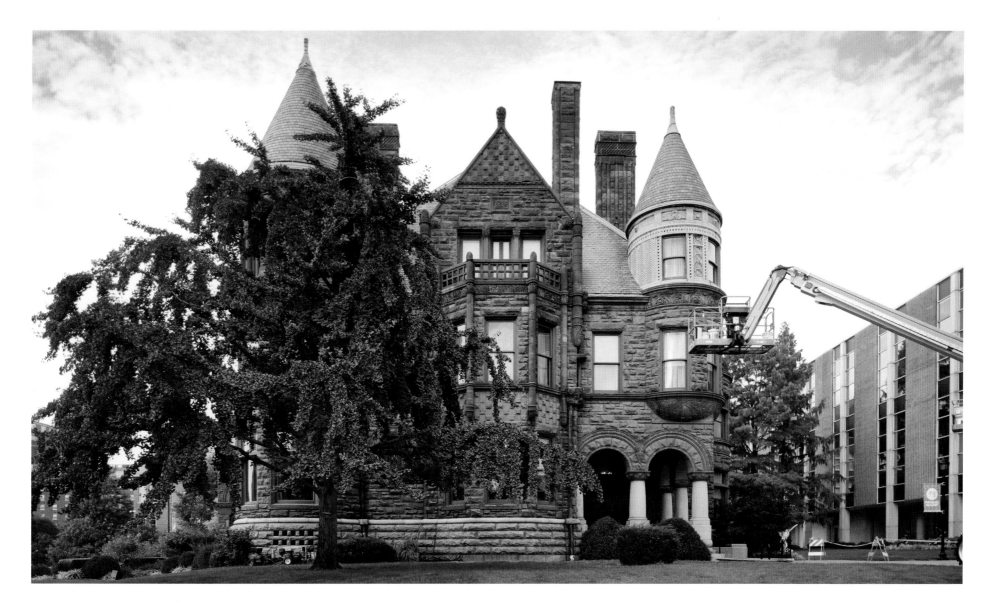

LEFT: In 1888, woodenware importer Samuel Cupples commissioned Thomas Annan to design this mansion in the Romanesque Revival style that came to be known as Richardsonian Romanesque (after the Boston architect Henry Hobson Richardson). The home included forty-two rooms, with twenty-two fireplaces, and a richness of interior woodwork never before seen in St. Louis, at a total cost of $500,000 (the equivalent of $15 million in today's currency). In its day, it was one of a row of great opulent Gilded Age mansions built by wealthy St. Louis industrial magnates.

ABOVE: Once appropriately sited in a row of luxurious mansions, the Samuel Cupples House now sits alone on a block vacated to suit the St. Louis University quadrangle. One of the few Richardsonian Romanesque buildings in St. Louis, the house is even more unusual for its construction in "purple" Colorado sandstone, complete with towers and gargoyles. In addition to the rich woodwork, the interior also boasts several, clear-leaded-glass installations by Tiffany. Acquired by the University in 1942, the elegantly preserved home serves as an art center and museum. The SLU library is partially visible at right.

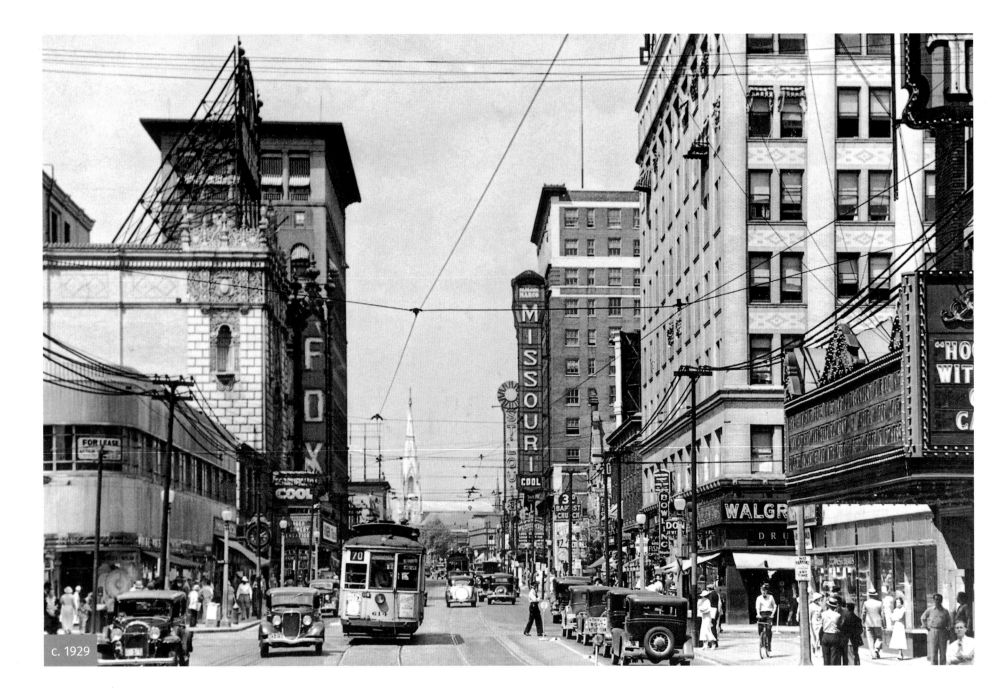

c. 1929

THEATER DISTRICT
The decline of the Midtown district was reversed in the late twentieth century

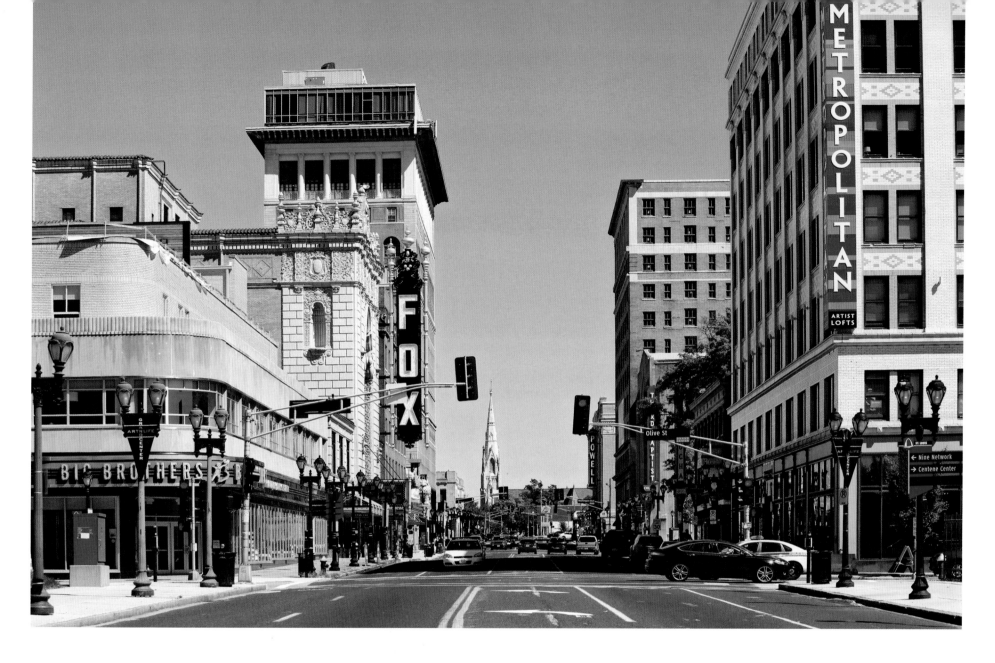

LEFT: Grand and Olive, circa 1929. From St. Louis University stretching north up Grand Avenue is an area known as Midtown. It was a thriving entertainment district with theaters, movie palaces, restaurants, bowling alleys, bars, and nightclubs to rival downtown. In 1867, the Grand Avenue Railway Company ran a line on Grand from N. Twentieth Street south to Meramec, and after the line was electrified in the 1890s, the intersection of Grand and Olive was deemed "fifteen minutes from anywhere." The Schubert Theater (near right), originally called The Princess, opened in 1912 as the area's first vaudeville house. The steeple of St. Alphonsus Liguori is visible in the background.

ABOVE: Ironically, the very success of Midtown proved its near undoing. With the advent of the car, businesses could afford to move "off-line" away from the hustle and high rents of the streetcar tracks. When the Mill Valley area south of the theater district was razed in the early 1960s, even streetcar service ceased, and the area began to decline. Today, Midtown is undergoing a renaissance thanks to the efforts of the non-profit organization Grand Center and a few long-timers. The Fall of 1992 saw the opening of St. Louis' first new theater in twenty years, the Grandel Square Theatre. The marquis for Powell Hall, home to the St. Louis Symphony, can be seen in the far right distance.

1929

FOX THEATRE
When it was opened, it was the second largest movie house in the country

1929

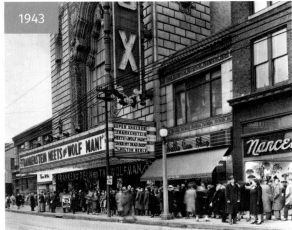

1943

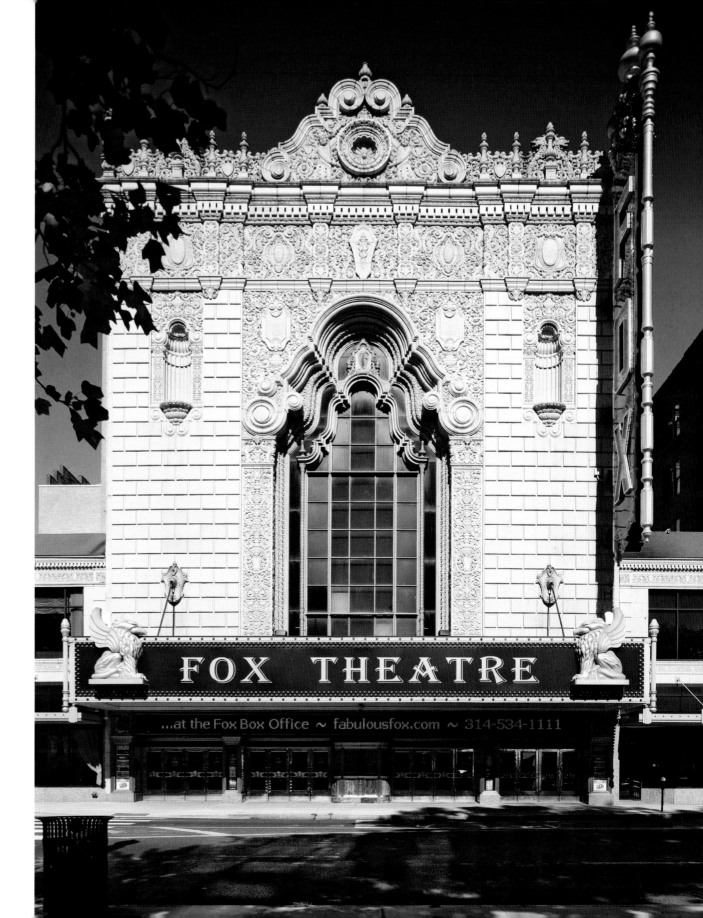

LEFT: The Fox Theatre opened on the eve of the Depression in 1929. With 5,042 seats, it was then the second largest theater in the country and truly lavish—it sported its own symphony orchestra, a barbershop for the ushers, and a second organ to serenade people lined up in the lobby. The building was designed by C. Howard Crane, but the wife of William Fox is often credited with the eclectic interior, sometimes referred to as "Siamese-Byzantine." She decorated the interior with exotic furnishings, paintings, and sculptures she had bought on overseas trips. The design features elephants, lions, and scimitar-wielding rajahs, among other fanciful creations. William Fox described it as "Eve Leo style."

RIGHT: Privately purchased in 1981, the Fox Theatre has been renovated to its former glory, only now with state-of-the-art sound, lighting, and stage equipment. Today, the Fox presents major touring theatrical productions and concerts. The St. Louis Symphony Orchestra, the second oldest in the nation, led the way for redevelopment of the neighborhood in 1967 with the purchase of the St. Louis Theatre up the street. They transformed it from a vaudeville/motion picture house into Powell Symphony Hall, where they perform to this day.

LEFT TOP: The Fox Theatre is draped with bunting for its grand opening on January 29, 1929, and the Silver Jubilee of the studio's founding by William Fox, who would lose his movie empire with the crash of the Stock Market.

LEFT: Crowds queue up outside the Fox box office to see Bela Lugosi and Lon Chaney, Jr. in *Frankenstein Meets the Wolfman*. Lined with great mansions in the late nineteenth century, by 1930 Grand Boulevard had become St. Louis' "Great White Way" lit up with the electric signs of nine theaters in a five-block area.

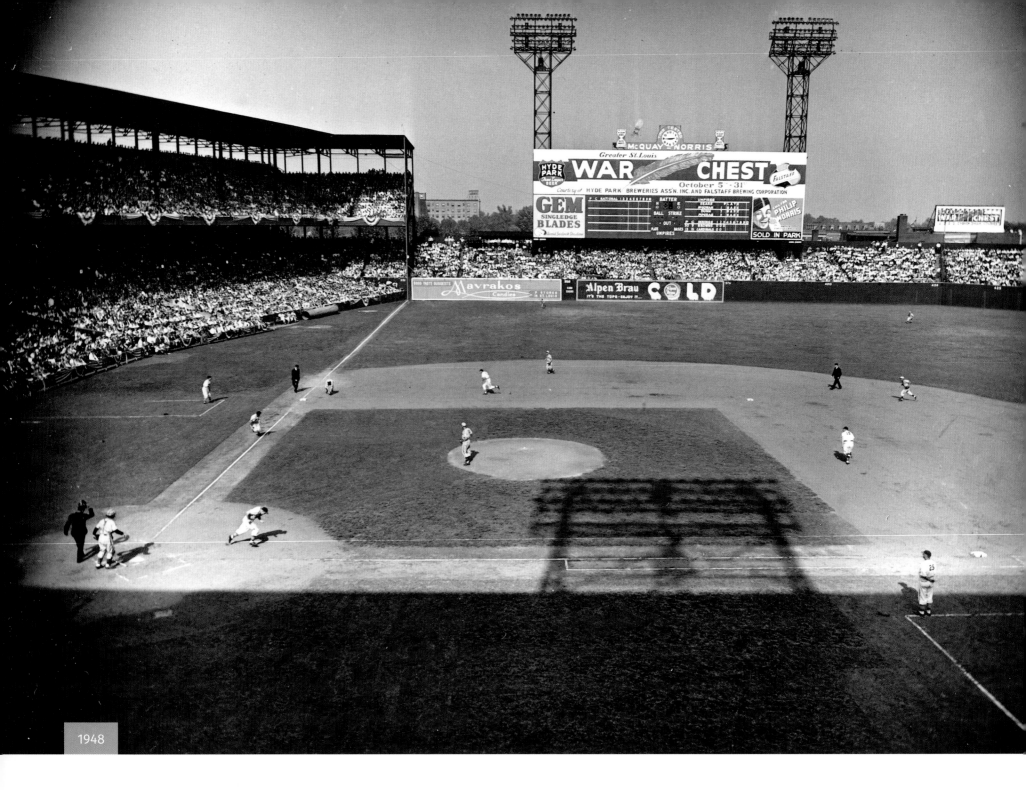

1948

SPORTSMAN'S PARK

Home of the Cardinals and the great Stan Musial

LEFT: The 1948 All-Star Game at Sportsman's Park. Established in 1866 in Midtown, the Grand Avenue Grounds were a private enterprise designed to entertain customers of local saloons with baseball games. It was renamed Sportsman's Park in 1876, when it became home to the St. Louis Browns. The Cardinals joined the Browns in 1920, and in 1934 the "Gashouse Gang" won the National League pennant. Ten years later, the unusual "Streetcar Series" would pit the Cards against the Browns, and the Cards emerged triumphant. The 1940s, 1950s, and 1960s saw the likes of Cardinals' Stan Musial and Enos Slaughter, and seven World Series wins. August "Gussie" Busch Jr., grandson of brewing magnate Adolphus Busch, bought the Cards and Sportsman's Park in 1953 and renamed it Busch Stadium. .

ABOVE AND RIGHT: The last game was played here on May 8, 1966. When the last out was called, a helicopter swooped onto the field, home plate was dug up and whisked away to be installed in a new downtown stadium. Busch Memorial Stadium was a "cookie-cutter" stadium designed to accommodate baseball and football, with a crown of ninety-six arches and seating for 50,000. It was demolished in 2006, replaced by a baseball-only stadium next door which would also bear the name Busch Stadium (pictured right). A sign on the wall of the Herbert Hoover Boys and Girls Club at N. Grand Boulevard and Dodier Street tells the story of the former site of Sportsman's Park.

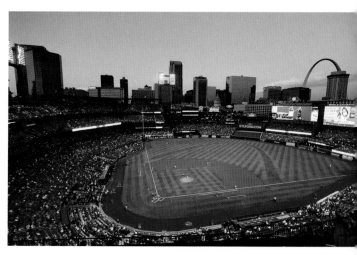

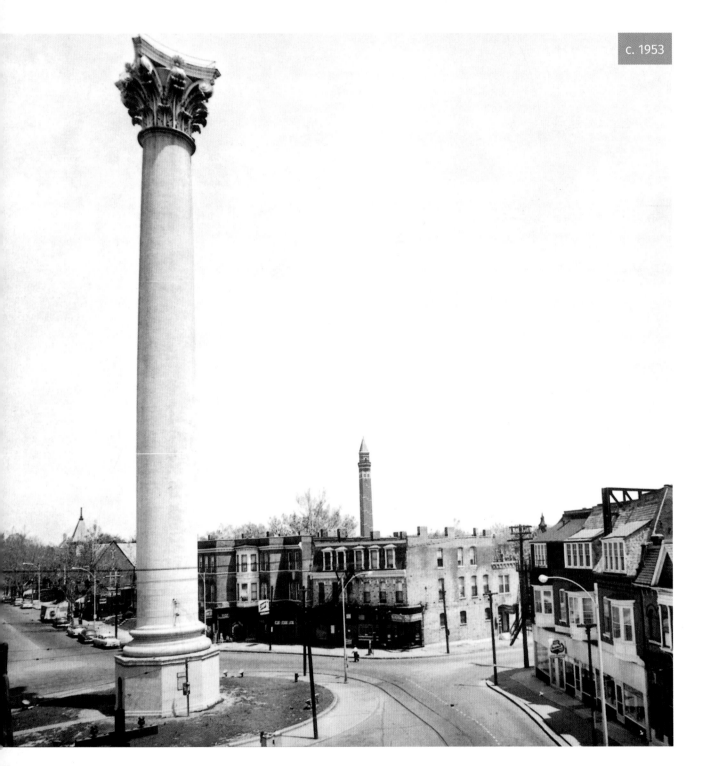

c. 1953

WATER TOWERS
St. Louis has three listed water towers

LEFT: North Grand Boulevard and Twentieth Street in the 1950s. The Grand Avenue Water Tower with its cast-iron Corinthian capital, was designed by George Barnett in 1871 to help regulate the mains water supply from the city's first waterworks on Bissell's Point. Perspective is deceiving because the distant red-brick tower, added fifteen years later at Bissell Street and Blair Avenue, was actually the tallest in the city at almost 200 feet. The Bissell Street Water Tower was the work of William S. Eames and features decorative brickwork with limestone and terra-cotta detailing. The surrounding area, originally known as Bremen (later Hyde Park), was a close-knit German community. In the nineteenth century, Germans were the largest immigrant group to impact St. Louis..

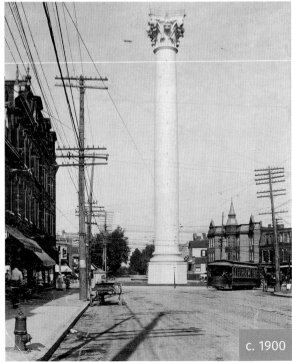

c. 1900

RIGHT: Today, the Hyde Park neighborhood faces the challenges of many urban areas that once prospered but have become fragmented. Though both towers were put out of service around 1912, they remain, as one architect put it, monumental punctuation in the middle of the street. Both landmarks are listed on the National Register of Historic Places. Of only seven historic water towers left in the United States, three are in St. Louis. The third is the Compton Hill water tower, which is still in service. In the 1990s the Gateway Foundation undertook a project to light all three towers to mark their landmark status and establish them as beacons for their neighborhoods. Sadly the Grand Avenue Water Tower is now in a state of disrepair as is much of the surrounding area of north St. Louis.

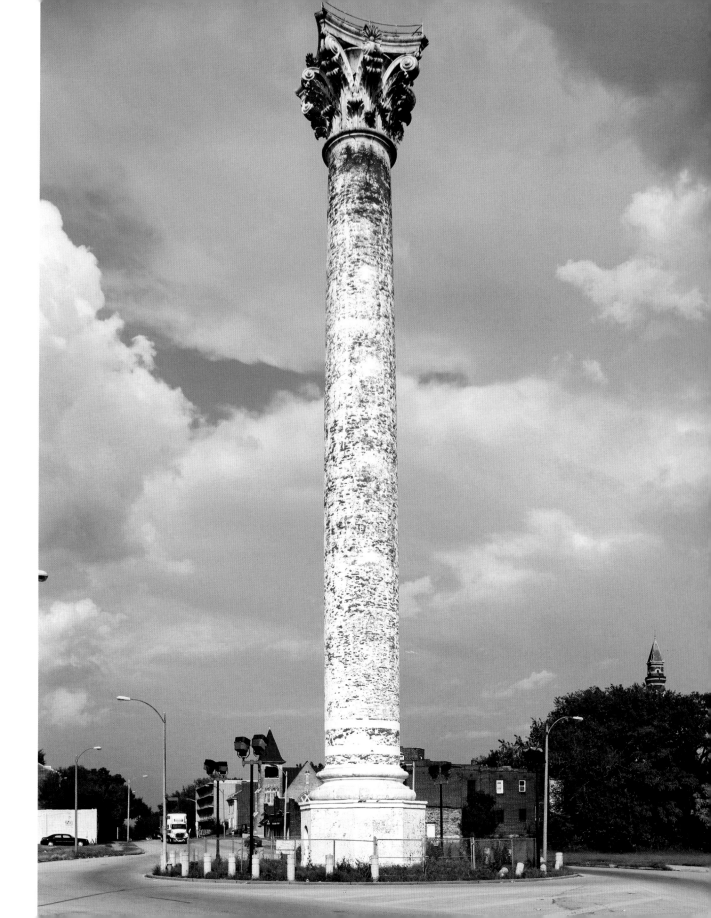

LEFT: The Grand Avenue Water Tower is also known as the White Water Tower for the stucco covering its red bricks. Set on an octagonal base it's the oldest of the city's three water towers

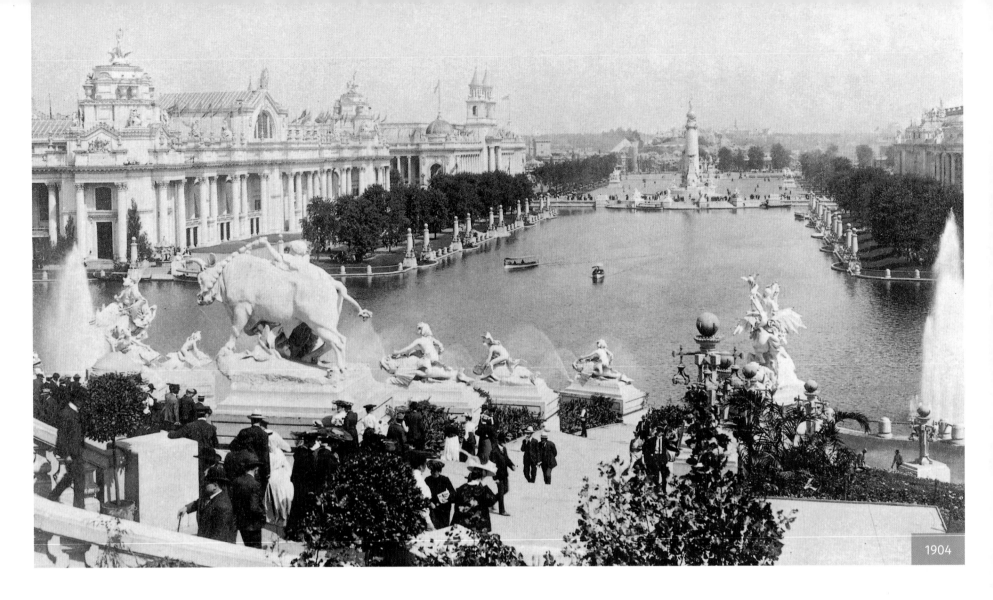

1904

1904 WORLD'S FAIR
Also known as the Louisiana Purchase Exposition

ABOVE: Grand Basin looking north with the Peace Monument in the distance, 1904. The 1904 Louisiana Purchase Exposition was the biggest World's Fair ever staged, before or since. St. Louis' Forest Park, one of the nation's largest at 1,293 acres, was deemed a suitable location. After much public debate, fair organizers were allowed to clear only the western end of old trees and construct there a Beaux-Arts fantasy of vast exhibition "palaces" and statuary set among the manmade cascades, canals, and fountains. Visitors could tour the entire grounds by gondola, and naval battles at three-quarter scale were staged on the lagoon.

RIGHT: The Palace of Electricity and Machinery covered eight acres and featured scientific advances in the decade leading up to the fair. It contained the world's largest pipe organ and a wireless telegraph tower.

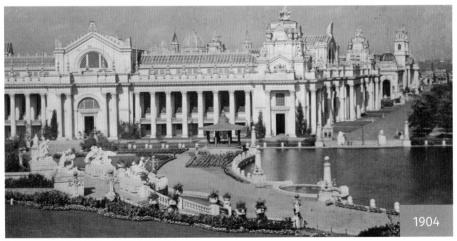

1904

ABOVE: With the sole exception of the Palace of Fine Arts, all Expo buildings were intended to be short-lived and were constructed in "staff," a reinforced plaster. The malleability of the medium led to great flights of fancy in design, admired by the visitors, but existing now only in photos. Organizers promised to restore the park to its pre-fair woodland; they planted thousands of trees. Forest Park today does feature fine tracts of wood, but Art Hill, as it's now known, is bare but beloved for its superb winter sledding (once the lagoon freezes, of course). In recent years Art Hill has become the site of open-air movies and free concerts by the St. Louis Symphony Orchestra. It is seen here covered with 7,021 Flags of Valor, commemorating the fifteenth anniversary of the September 11, 2001 terrorist attacks on the United States and the service men and women lost in the prevention of further attacks.

1904

PALACE OF FINE ARTS / ST. LOUIS ART MUSEUM
The one permanent building erected for the 1904 World's Fair

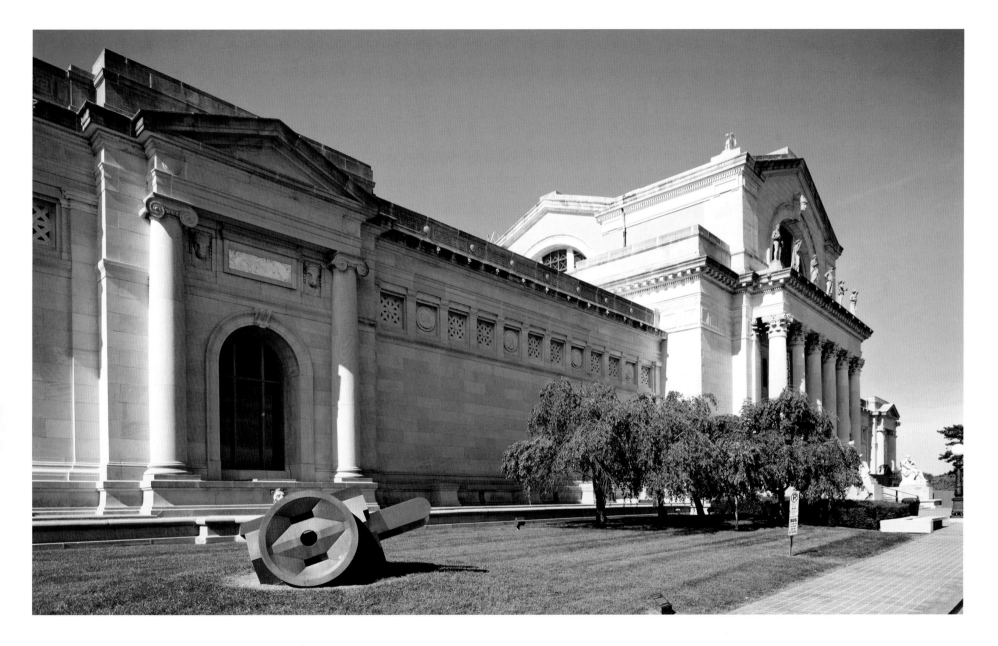

LEFT: St. Louis, then the fourth largest city in the nation, hosted the 1904 World's Fair celebrating the 100th anniversary of Jefferson's purchase of the Louisiana Territory. Of the twelve grand exhibition halls, only one was built to be permanent—the Palace of Fine Arts. Designed by New York architect Cass Gilbert in Roman Revival style, it was modeled on the Baths of Caracalla in Rome and clad in limestone. The words "DEDICATED TO ART AND FREE TO ALL" were inscribed over the entrance

ABOVE: After the fair, the Palace of Fine Arts housed Washington University's Museum of Fine Arts for a time. The attraction proved so popular that the city made it a permanent art museum. Today the St. Louis Art Museum holds over 30,000 works of art by masters like Rembrandt, Monet, van Gogh, and Picasso. Admission is free. In 2013, a 211,000-foot east wing (not shown) designed by British architect David Chipperfield opened, providing a brilliant setting for the museum's extensive modern art collection.

133

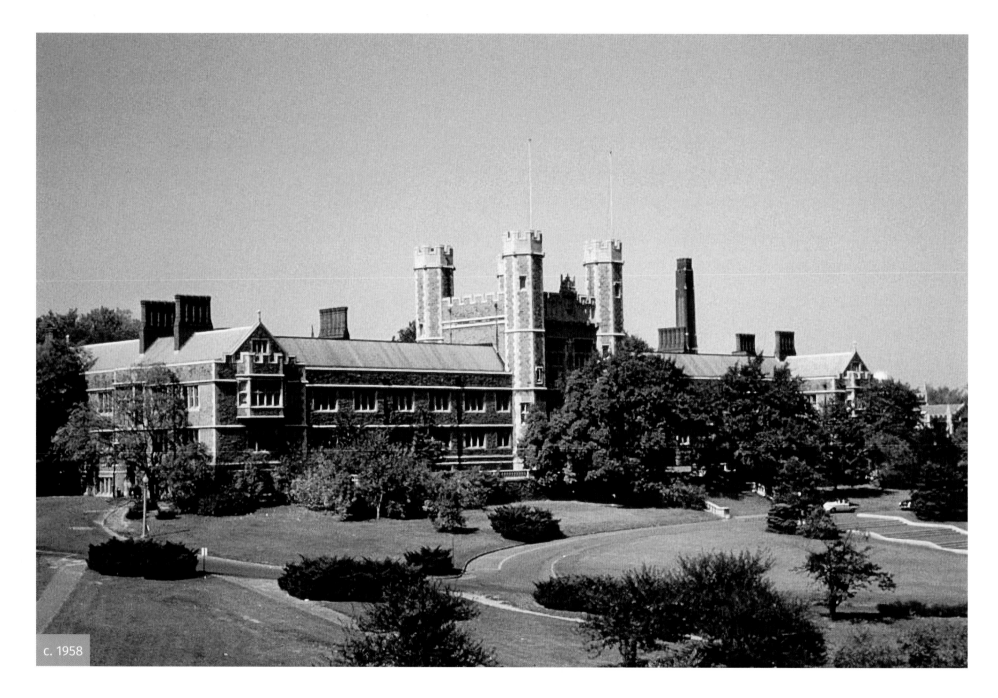

c. 1958

WASHINGTON UNIVERSITY
Co-founded by the grandfather of poet T. S. Eliot

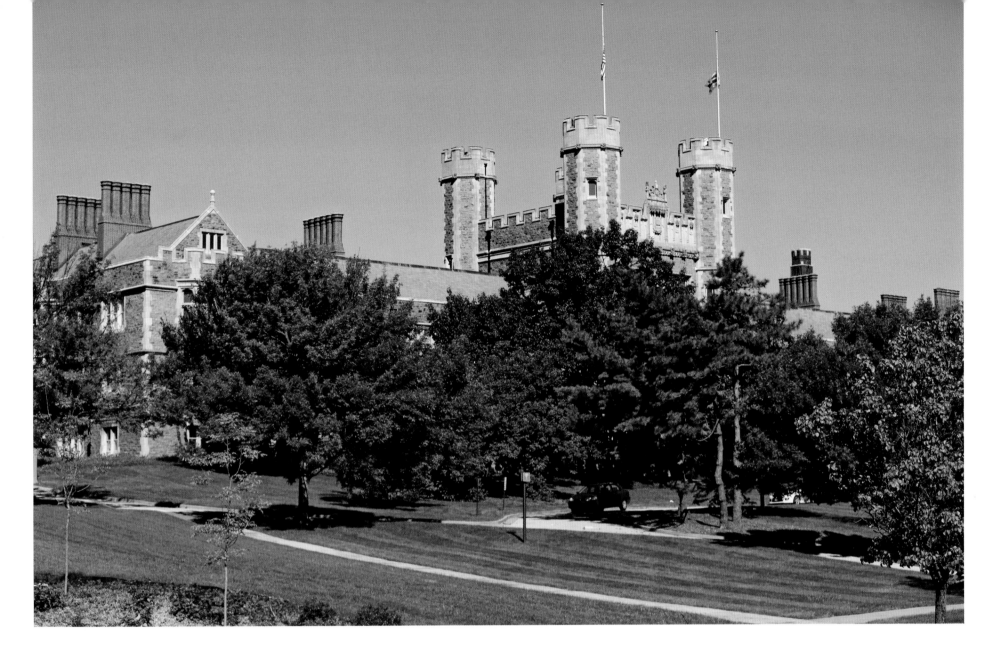

LEFT: Brookings Hall was constructed in 1902 as the east and main entrance to Washington University. Co-founded in downtown St. Louis in 1853 by state Senator Wayman Crow and Unitarian minister William Greenleaf Eliot, Jr. as a non-sectarian institute of learning, Washington University began its move to this site in 1899 as the city of St. Louis was planning to host the World's Fair of 1904. But classes didn't open until 1905, well after the fair closed because the Louisiana Purchase Exposition Company was leasing University Hall, for their administration building. Constructed of limestone and pink Missouri granite, University Hall was designed in the Collegiate Gothic style by Walter Cope and John Stewardson of Philadelphia, the architects of Princeton University. The large hill overlooking Forest Park, just west of the city limits, proved to be an ideal setting.

ABOVE: Today, Washington University is ranked as one of the top research universities in the U.S. Since the first cornerstone was laid in 1900 for Anheuser-Busch Hall, funded by brewing magnate Adolphus Busch, the Hilltop Campus, renamed the Danforth Campus in 2006, has grown to include a village of halls and residences enclosing a series of quadrangles. The campus now extends beyond Forest Park to include a medical complex covering more than seventeen city blocks on the east side of the park where the School of Medicine, Barnes-Jewish and the St. Louis Childrens hospitals are located. Washington University has been home to twenty-five Nobel laureates and hosted U.S. Presidential and Vice-Presidential debates. In 1953, Nobel laureate and poet, T. S. Eliot returned home to St. Louis to deliver a lecture on "American Literature and the American Language" at the university his grandfather had helped to establish.

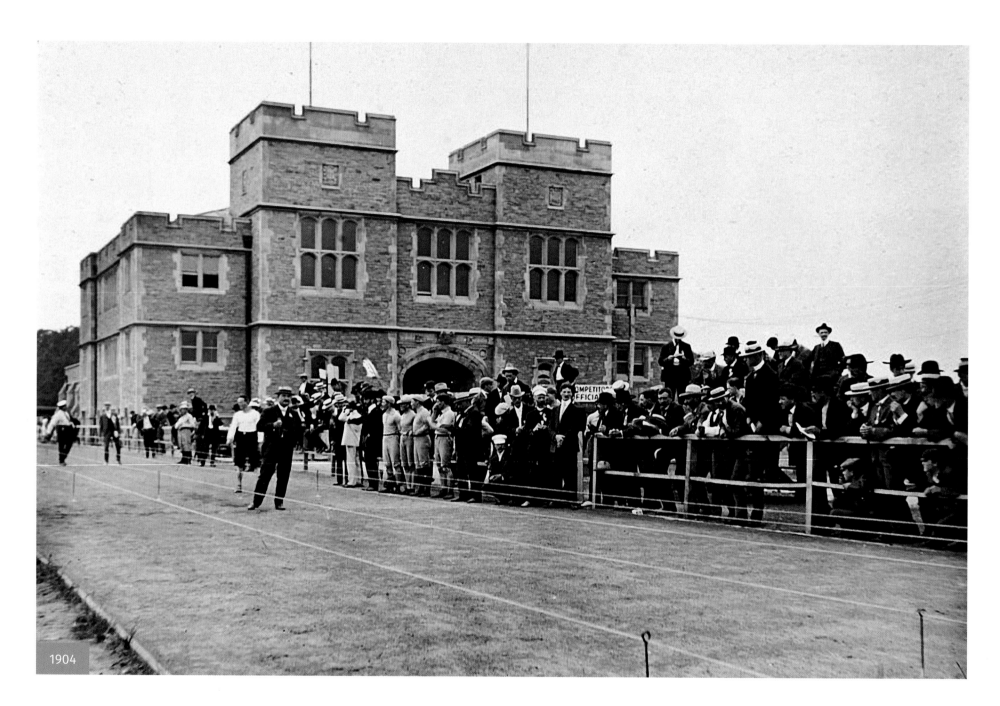

1904

1904 OLYMPICS

Along with a World's Fair, St Louis won itself an Olympiad

LEFT: Francis Field House and track near Forsyth and Big Bend boulevards, 1904. Like Paris four years earlier, St. Louis won a competition to host an Olympiad in conjunction with an international exposition. Forest Park was being landscaped in monumental fashion for the World's Fair but an appropriate place to host many of the athletic competitions was lacking. David R. Francis, President of the Fair proposed building an outdoor stadium and gymnasium at the west end of the campus of Washington University, across from the fairgrounds. Twelve nations including the U.S. participated in the Games of the III Olympiad in St. Louis, the first games in the Western Hemisphere. Of the 651 athletes only six were women. George Poage, representing the Milwaukee Athletic Club, was the first African-American to take part in a modern Olympics, winning two bronze medals in the 400-metre hurdles.

ABOVE: Today, David R. Francis Field is the heart of a modern athletic complex on the Danforth Campus of Washington University. Following the Summer Olympics of 1904 the stadium and gymnasium were given to the university and tall, ornamental gates erected at the east end of the field to commemorate the historic event. Elsewhere in St. Louis, Olympic memories faded until 1962 when Kiener Plaza was dedicated downtown to an amateur sportsman and St. Louis Olympian named Harry Kiener, who had been a member of the U.S. track team. "The Runner Fountain" by William Zorach, installed in a circular pool in the section of the Gateway Mall bordering Broadway just west of the Old Courthouse soon became a favorite rendezvous point for St. Louisans. Plans to remove it for a redesign of Kiener Plaza in 2014 drew such public outrage that the runner statue was recently reinstalled saluting a legacy that began at Francis Field.

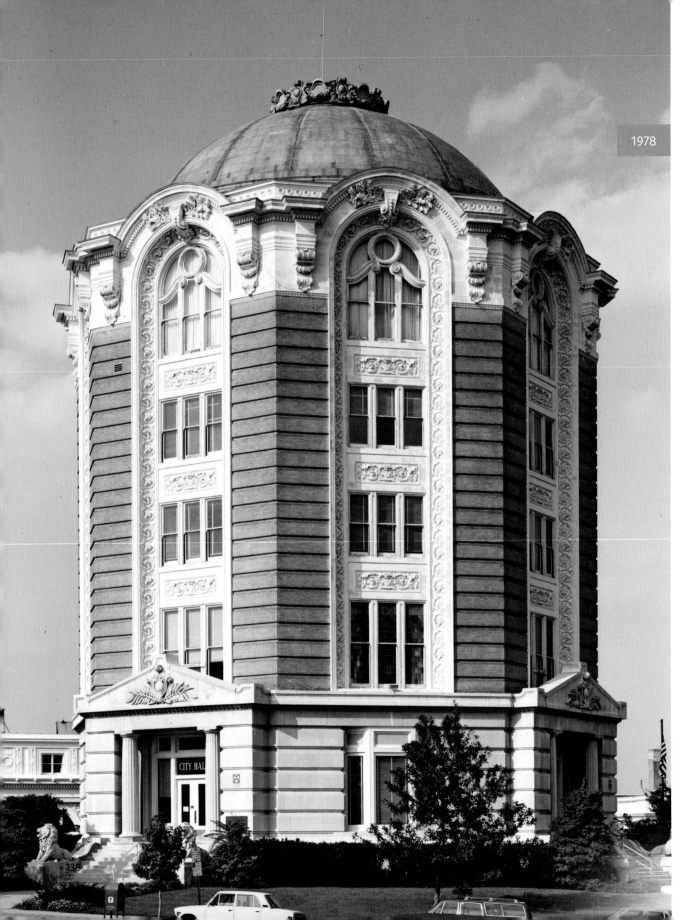

1978

MAGAZINE BUILDING

E. G. Lewis was a remarkable publisher

LEFT AND BELOW: The tinted postcard below captures the beauty of the Lewis Magazine Building shortly after completion in 1903 as the headquarters of publisher, Edward Gardner Lewis. In 1899, Lewis purchased a popular St. Louis magazine, *Winner*, which he changed to *Woman's Magazine*, reduced the price along with advertising rates, and made a fortune as its subscribers grew to well over a million. The Magazine Building became the center of Lewis's utopian empire situated on land he acquired northwest of the World's Fair grounds. Atop its elegant domed roof he mounted the world's largest searchlight drawing thousands visiting the fair to his tent city. But his vision to create the ideal City Beautiful and his fortune were short-lived. After incorporating University City in 1906, acting as its first mayor, purchasing additional property for development, and opening two banks, Lewis left St. Louis in 1912 for California. He was bankrupt.

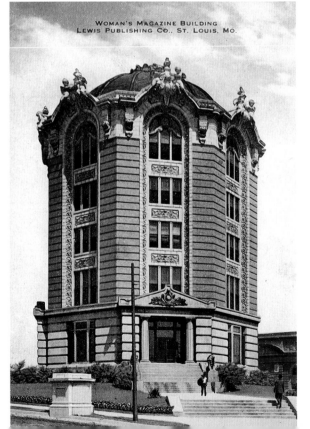

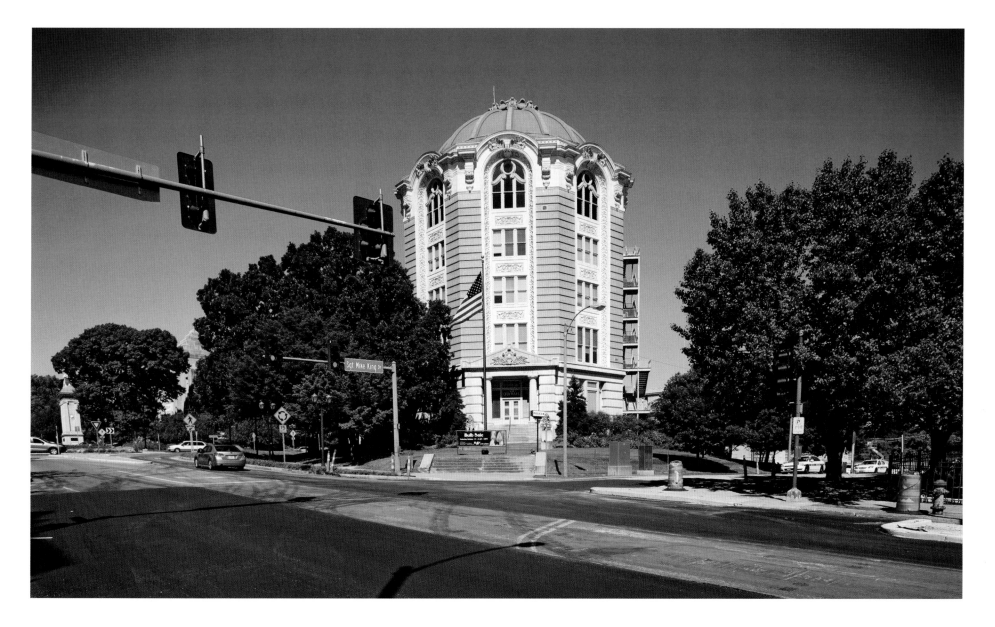

ABOVE: The ornate, octagonal Magazine Building designed by Henry C. Chivers is today the University City Hall. The impressive Lion Gates that Lewis commissioned from sculptor George Zolnay remain the city's iconic logo. Other elements of Lewis' vision also survive: the University Heights subdivision, which he developed between the campus of Washington University and his publishing complex and the trolley tracks that he saw laid in 1910 have recently been replaced, restoring travel to and from Forest Park. They are part of the vibrant revitalization of an originally six-block (but expanding) business district of shops, galleries, a theater, sidewalk cafes, international restaurants and markets bordered on the west by University City's Lion Gates. This initiative, led by Joe Edwards of Blueberry Hill Restaurant, with its St. Louis Walk of Fame and sculpture of St. Louisan and Rock 'n' Roll legend, Chuck Berry, have resulted in the Delmar Loop being named "One of the 10 Great Streets in America."

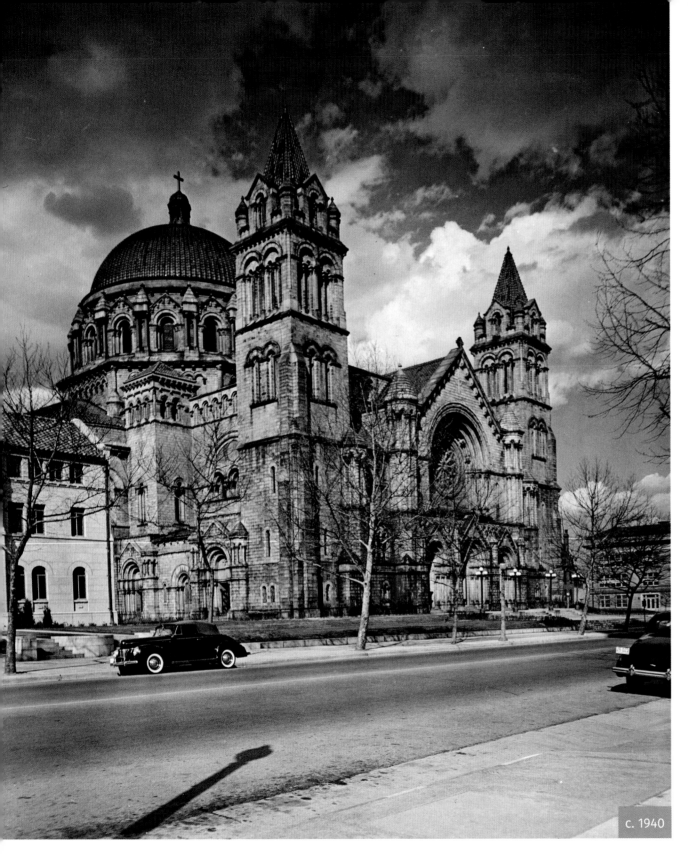

c. 1940

NEW CATHEDRAL OF ST. LOUIS
Pope John Paul II led prayers here

LEFT: In 1896, Archbishop John Kain purchased this site to replace the Old Cathedral on the riverfront as the spiritual center of the Catholic Archdiocese of St. Louis. The population was moving west with the streetcars and grand mansions were rising along Lindell Boulevard, from Grand Boulevard west to the Union Avenue entrance to Forest Park. The new cathedral would be a temple of the Lord to match them. Begun in 1907, construction on the New Cathedral was finally completed in 1914. The style, probably influenced by London's Westminster Roman Catholic Cathedral (1903) is both Byzantine and Romanesque with soaring arches and a 227-foot central dome, minor domes, and two glorious rose windows. Archbishop John Glennon selected a design submitted by Barnett, Haines, & Barnett of St. Louis, magnificently encompassing the eastern and western heritage of the Catholic Church.

BELOW: The cathedral four years shy of its finishing date.

1910

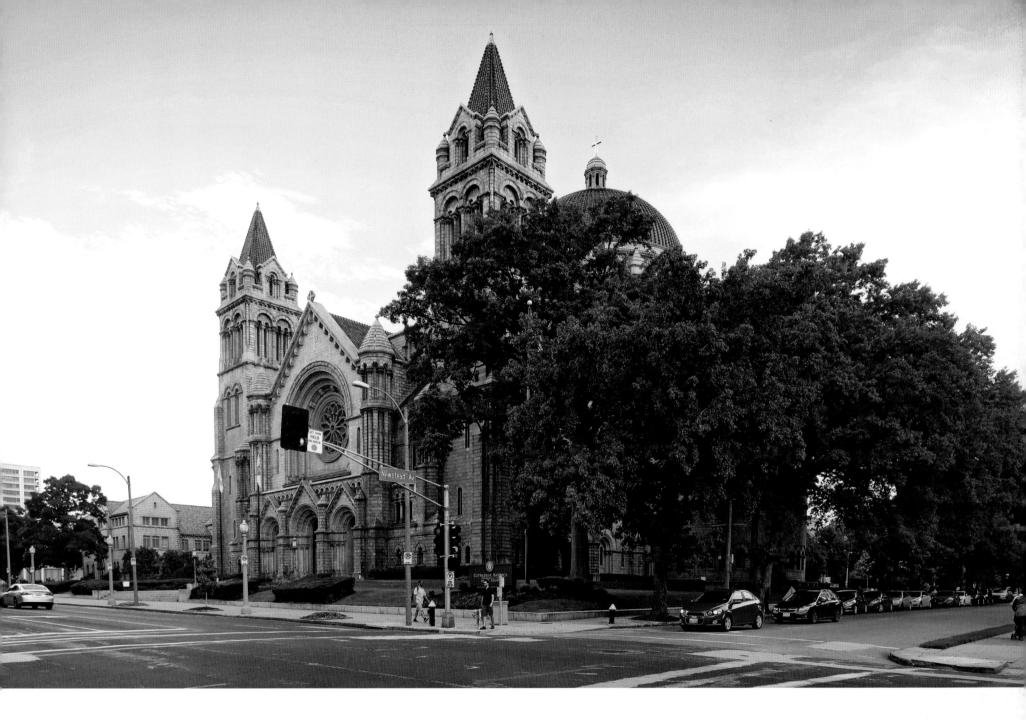

ABOVE: Along with the West End's private places and Euclid Avenue shopping district, the New Cathedral, (as it's known to distinguish it from the Old Cathedral downtown) with its granite-clad walls and green-tiled dome is a major attraction for St. Louisans and visitors from around the world. The Central West End is an upscale neighborhood of mansions, hotels, luxury apartments, townhouses, and courtyard apartment buildings. Little expense was spared in the New Cathedral's decoration. Some interior walls are clad with marble. Sidewalls and the entire ceiling are covered with 83,000 square feet of mosaics, composed of some 41.5 million tesserae, one of the world's largest collections, installed by Tiffany, Gorham, and the Ravenna Mosaic Company over 70 years. Having passed the century mark the Cathedral Basilica of St. Louis is an enduring city landmark. Pope John Paul II led an ecumenical prayer service here during his 1999 visit to the U.S. It remains the spiritual center of the Catholic Archdiocese of St. Louis.

PORTLAND PLACE

Where the urban elite retreated to

c. 1905

LEFT: Richardsonian Romanesque gates designed by Theodore Link mark the entrance to Portland Place. Established by the wealthy elite as urban islands, and protected from noise, pollution, and riffraff by restrictive covenants, private "places" were a St. Louis phenomenon. The rules dictated minimum building expenses, property upkeep, even cleaning schedules (e.g., front steps are to be scrubbed twice weekly). The problem was, the city kept growing west, and zoning was a thing of the future. No amount of neighborhood covenants could prevent industry from setting up shop upwind. Residents of earlier private places moved west into Portland Place to escape just such problems, and they were determined to avoid those mistakes.

BELOW: Designed by Julius Pitzman, the planner of most of the other private "places," Portland Place (along with Westmoreland Place) was established in 1888. Subject to the usual strictures and fees, residents also embarked on a plan to control the surrounding environment. For those issues they could not dispatch through their social influence, they sued their wealth, buying up adjacent railroad yards and installing luxury hotels in their place. The planners had learned as well, instead of the vulnerable single streets, they now grouped private places together and sited them near pre-existing public parks. Today, both Portland and Westmoreland places are superbly maintained, and entire books have been devoted to their architecture.

INDEX